animation in the home digital studio

PLEASE ASK FOR THE CD ROM AT ISSUE
DESK.

Focal Press Visual Effects and Animation

Producing Independent 2D Character Animation: Making and Selling a Short Film
Mark Simon

Stop Motion: Craft Skills for Model Animation
Susannah Shaw

Guide to Computer Animation: For TV, Games, Multimedia and Web
Marcia Kuperberg

Essential CG Lighting Techniques
Darren Brooker

Digital Compositing for Film and Video
Steve Wright

Producing Animation
Catherine Winder and Zahra Dowlatabadi

The Animator's Guide to 2D Computer Animation
Hedley Griffin

**Focal
Press**

Visit focalpress.com to purchase any of our titles.

animation in the home digital studio: creation to distribution

Steven Subotnick

Focal Press OXFORD AMSTERDAM BOSTON LONDON NEW YORK PARIS
SAN DIEGO SAN FRANCISCO SINGAPORE SYDNEY TOKYO

Focal Press is an imprint of Elsevier Science.

Library of Congress Cataloging-in-Publication Data

Subotnick, Steven.
 Animation in the home digital studio : creation to distribution / Steven Subotnick.
 p. cm. – (Focal Press visual effects and animation series)
 Includes index.
 ISBN 0-240-80474-0 (pbk. : alk. paper)
 1. Computer animation. I. Title. II. Series.

 TR897.7.S83 2002
 006.6'96–dc21

 2002035227

British Library Cataloguing-in-Publication Data
A catalogue record for this book is available from the British Library.

The publisher offers special discounts on bulk orders of this book.
For information, please contact:

Manager of Special Sales
Elsevier Science
200 Wheeler Road
Burlington, MA 01803
Tel: 781-313-4700
Fax: 781-313-4880

For information on all Focal Press publications available, contact our World Wide Web home page at: http://www.focalpress.com

10 9 8 7 6 5 4 3 2 1

Printed in the United States of America

To A, H, and N

table of contents

preface ix
acknowledgments xiii
note on the cd-rom xv

chapter 1
a personal approach 1
> how I came to animation 2
> definitions of animation 2
> contributing animators 5

chapter 2
a selection of animators 13

chapter 3
the digital studio 33
> the evolution of animation tools 34
> why I use digital tools 39
> my digital studio 41
> sound production tools 47
> setting up your own studio 50

chapter 4
money and time 53
> how much does it cost? 54
> how long does it take? 61
> ways to manage money and time 63

chapter 5
developing ideas 67
> what is an idea? 68
> developing ideas 70
> a case study 74

chapter 6
working methods 81
> three basic principles of animation 82
> the importance of animation techniques 84
> define your goals 89
> consider length and final format 90
> improvising and planning 95

the production process 106
summary 107

chapter 7

technical examples 109

scanning examples 110
Flash examples 119
stop-motion examples 135
sound examples 140
summary 150

chapter 8

showing your work 151

distribution options 152
output examples 158
building a personal web site 167
summary 173

chapter 9

resources 175

learning about animation 176
making animation 187
seeing and showing animation 196

appendix

cd-rom contents 203

index 205

preface

When you engage the medium at such a fundamental level—the single frame—you truly understand that all filmmaking is an illusion, a manipulation of time, space, and shape. Animation is the most honest cinematography.
Bryan Papciak

Because animators are always tethered to technology they can be compared to doctors, who scientifically attend to the logical needs of a patient through physics, electronics, chemistry, and psychology; but I like to compare them to mad scientists, along the lines of Doctor Frankenstein, who serve no therapeutic or utilitarian end beyond astonishment and running amok.
George Griffin

Technology has caught up with our desire to visualize and express time, rhythm, and movement. These qualities are an integral part of art in the future. Thus, understanding animation is a critical part of that future.
Christine Panushka

How do you think of animation? Is it funny? Serious? Entertaining? Educational? Poetic? Does it involve drawing? Sculpting? Dancing? Singing? Acting? Does animation have anything to do with the Thirty Years' War? Dostoevsky? Abandoned insane asylums? Opera? UNICEF? Animation is all of these and more. It is a wonderfully flexible and eclectic art form that combines qualities of cinema, literature, the visual arts, theater, and dance. The magic of bringing the inanimate to life has attracted people from many different backgrounds and interests to this medium. Ladislas Starewich, considered the father of puppet animation, came to animation from an interest in entomology. Pioneer animator Alexander Alexeieff invented the pinscreen in order to emulate his earlier work as an engraver and book illustrator. Kathy Rose is a dancer and performance artist who began animating as a way to explore her interests in both drawing and movement. William Kentridge is a South African artist whose animated films grew out of an interest in recording the process of drawing.

In the past, most animation was shot on film, which made it difficult for the average person to make animation without investing in specialized equipment and film training. But as a result of developments in digital video and personal computing, it is now possible and practical to make animation with the aid of home computers. This shift makes production accessible to many more people—an opportunity to make animation a more widely practiced and appreciated art. It is possible that in the coming years we will see animation used as an expressive medium by individuals in the same way that painting, music, and writing have always been studied and practiced.

Moving images and multimedia presentations are major forms of mass communication in our culture. We are bombarded with newscasts, sitcoms, miniseries, feature films, commercials, web advertising, streaming entertainment, even animated highway billboards.

In these forms of mass communication, animation is ubiquitous; most commercials use some form of animation, some of the most popular TV shows are animated, any list of successful films will include animated features, and the distinction between live-action and animated motion pictures is becoming less clear as digital special effects become more sophisticated. Even our toys and appliances contain animation, including video games, web sites, informational kiosks, and electronic appliances. But for the most part, this great wash of moving images serves only three purposes; the first is to convince us to buy a product (advertising), the second is to entertain or amuse us (TV shows, movies, and games), and the third is to impart information about a subject (news, documentaries, and instructional screens). Although there is no question that animation can be successfully used for the purposes of selling products, entertaining, and disseminating information, the importance of animation as a personal art may be less obvious.

Each of us is like a lens through which the experiences of an individual lifetime are focused and concentrated. When we pay attention to this aspect of ourselves, we may feel a desire to express some of our thoughts and feelings, as well as to see how others have sought to express similar thoughts and feelings. To give concrete form to a thought or a feeling is to try to understand what is meaningful about it. This is where the arts come into our lives. We appreciate great works of art because they are objects or performances that help us to have a meaningful experience, and we make our own art because we feel a need to make or discover our own meaning. Song, dance, music, storytelling, drawing, painting, sculpture, and theater are a few of the forms in which people have worked at self-expression, and animation can also serve this need. Primarily because of technical and budgetary obstacles, animation has not been practiced as widely by individuals as other personal art forms, but the purpose of this book is to show that the individual practice of animation is now more possible than ever before.

Recent developments in high-speed data transfer and digital video, and increased processing power in home computers, have brought digital filmmaking within the reach of people working on small (or even tiny) budgets. Film is now just an option, no longer a requirement, for the animator. Why is this important? First, because more people will now be able to make their own animation as a personal art form. Second, because wider practice not only would benefit those individuals interested in making their own animation, but also would enrich the entire medium. The more people there are involved in making and looking at animation, the greater the chances for the development of general animation literacy and aesthetic sophistication. As with any cultural phenomenon, animation is advanced by participation and dialog.

In a sense, I am writing this book for the amateur. By *amateur*, I mean someone who works for love rather than for money, whose main motivation is a drive for personal satisfaction and artistic fulfillment. This drive may consume only a few hours a month, one day a week, or if circumstances allow, more time. This book is for anyone—the non-artist, the student, as well as the professional artist—who wants to make animation.

This is a book about making animation with the aid of a computer. It is an attempt at explaining the entire process, from becoming familiar with animation as an art form, through inspi-

ration and idea development, to methods of production and distribution. The result is a guide to producing your own animation with digital tools.

I have divided this book into three sections. The first section answers the questions "What is animation and why use digital tools?"; the second section answers the question "How can I make animation with digital tools?"; and the third section answers the question "Where can I find more information about animation?"

It is not necessary to read this book in order, chapter after chapter. Rather, it is intended to be used as a reference during animation creation. Chapter 7 may be most useful if you are ready to start production on an animation. Chapter 5 may be most useful if you are just starting to think about your ideas. Chapter 2 may be most useful if you are interested in seeing more animation. Chapter 9 may be most useful if you are ready to move beyond the information covered in this book.

acknowledgments

I deeply appreciate the generosity of the animators who have contributed their words, images, and animations to this book; they are an inspiring and educational presence. Tim Miller's illustrations add clarity, warmth, and charm to the text. I also thank my friends and colleagues at RISD and Harvard who have given me technical advice, in particular, Tammy Dudman. I also thank Amy Kravitz, Yvonne Andersen, and Dan Wyner for reading the manuscript; my father, Morton Subotnick, for his help testing the CD-ROM; and my editor, Amy Jollymore, for all her assistance and advice.

note on the cd-rom

Accompanying this book is a CD which contains two collections of animation. One collection is called "Technical Exercises"; these are the fifteen animations described in Chapter 7. With the CD and Chapter 7 in hand, you can examine both the results and the specific processes of animation production. The other collection on the CD is called "Gallery of Animators"; these are sixteen short clips made by a number of active animation artists. In addition to the clip, each page provides a biography, photograph, and list of selected films made by the contributing animator.

This CD will work on either a Mac or a PC (Windows). Make sure that the computer's speaker volume is turned up and that QuickTime 5 or later is installed. A QuickTime 5 installer is included on the CD (if prompted during the installation process, be sure to enable all file types, including AIFF).

On a Macintosh, insert the CD and double-click the CD icon named "Animation Studio." Then double-click the file named "Animation" to start up the CD and see the examples and gallery.

On a PC, insert the CD and open "My Computer" from the Start menu or by double-clicking its icon on the desktop. Double-click the icon named "Animation_Studio." Then double-click the file named "Animation_.exe" to start up the CD and see the examples and gallery.

chapter 1

a personal approach

When I was four years old, I wanted to be a horse when I grew up. Being an animator is the next best thing.

Amy Kravitz

how I came to animation

My involvement with animation grew from a need to find the right art form for my interests and personality. I have always loved to paint and draw, and I began my college years as an art major. But I became increasingly frustrated by the struggle to create a single compelling image until I finally stopped painting altogether and left art school to reconsider the direction of my studies. Because I wanted to explore other interests besides painting, I transferred to a university. University studies were liberating; I loved to read through the course catalog (as thick as a telephone book). But I missed making images, and I wondered how to return to visual art without feeling the constriction I felt making static images. I saw filmmaking, and especially animation, as a pathway. Animation was related to painting and drawing, but differed in important ways. Both involved making images, but whereas in a painting my goal had been to create a frozen, timeless image, in animation I learned to think in terms of motion, change, and sequences of images. I found this shift both liberating and exciting. I loved that filmmaking and animation involved so many things; images, movement, sound, and editing were all equally important. But most important, film offered me a way to return to painting and drawing with greater freedom and new meaning. Making a painting had required finding a single image that would somehow stand for all the thoughts that went into it. Animation, on the other hand, was a performance in time; the image became a journey rather than a destination.

After finishing undergraduate school, I enrolled at California Institute of the Arts to study animation with Jules Engel. I found Cal Arts beneficial because Jules created a supportive environment that encouraged students to see animation as an art form. Because he encouraged every student to recognize and develop his or her unique talents and contributions to the medium, I felt I had the ability to shape the medium of animation in addition to learning about it. At Cal Arts I also recognized the value of finishing work. I made a number of films there, and each time I completed a project, I felt more confident and inspired to make the next one.

Since graduating from Cal Arts, I have continued to make independent animated films, combining teaching, commercial, and commissioned animation for my livelihood. I enjoy animation; it is an art form that combines qualities of drawing, painting, dance, writing, storytelling, music, and sound. Its possibilities are almost limitless. I also feel comfortable exploring a variety of subjects and styles in animation, ranging from humor to horror, from visual choreography to historical events. My goal is to make work that explores more deeply the poetic and emotional power of animation.

definitions of animation

At its most basic level, animation is an image that changes over time. The element of time is the crucial ingredient in any definition of animation. Each art form has its own medium

through which it communicates, but all can be grouped into two fundamental divisions: arts based in space, and arts based in time. Examples of the former include drawing, painting, sculpture, and architecture. Examples of the latter include music, dance, theater, and animation.

A painting exists on a two-dimensional surface such as a canvas or a wall; the image cannot be separated from its surface. The painting occupies a certain space, but exists outside of time. The image presented by the painter is still, frozen, emblematic; it is the culmination of a thought process. By contrast, animation exists in time. When we view animation, we see an image that begins at a certain moment, changes over a specific length of time, and then ends. Before and after the projection, there is no image or sound. Also unlike painting, animation exists separately from a particular surface; the same animation can be projected on a projection screen, on the side of a building, or on a computer monitor. So animation is a time-based event that happens again each time it is played.

Change is a measure of time. We experience the passing of time by the changes that take place in ourselves and our environment. Time-based art forms use the element of change as their primary vehicle of expression. Imagine time as a canvas. Each time-based art form will paint on that canvas with a different set of tools. A musician changes pitch, dynamics, rhythm, and tempo to paint a sound picture on the time canvas. A dancer changes body position, using physical shape, placement, direction, and gesture to paint a movement picture in time. An animator changes the qualities of an image, using line, color, composition, and texture to paint a moving picture in time.

Cinema—also called movies, film, or motion pictures—is the art of moving images. All cinema is based on the illusion of movement that occurs when a series of images are exchanged quickly enough that the human eye no longer sees them as separate images, but as a single motion. The images that make up the sequence are recorded on a medium such as film, videotape, or optical disc and then replayed on a monitor or projected onto a screen. In this sense, all cinema is animation. But cinema is commonly divided into two major categories: live-action, which includes fiction, documentary, and some experimental works; and animation, which includes cartoons, feature animations, some experimental works, and special effects. Where live-action and animation diverge is in the illusion of reality. In general, live-action cinema creates the illusion that what we see on the screen is real, while animation generally does not. In live-action, film or video cameras capture action as it happens in the world or on a movie set. These real-time recordings are then edited down to create a simulation of the original event, so viewers feel that they are witnessing the essence of the real thing. In animated cinema, by contrast, a sequence of pictures is built one at a time from materials that are clearly not alive. The materials are obvious; drawings, paintings, and sculptures, for example, are moved incrementally frame-by-frame to create the illusion that they are moving, but as viewers we are aware that we are looking at moving artwork. Awareness of the illusion is part of the attraction of animation. Special effects are a third category that overlaps both live-action and animation. The technique of special effects is frame-by-frame image manipulation, like animation; but the goal of special effects is the complete illusion of reality.

Animation is an art of movement. In this, it is related to such activities as dance, athletics, and clowning. Many animators have a well-developed kinesthetic sense, the ability to feel

the quality of a movement the way that a painter feels the quality of color, or a poet feels the quality of a word. Each of us has this sense, although it may not always be developed. Animators develop their kinesthetic sense by observing movement in the world around them and by discovering their own innate sense of movement. If you watch people walking, you will see that people move in slightly different ways; some people may walk loosely, with arms and legs moving far out from their bodies, and others may walk in clipped steps, tightly wrapped around the core of their bodies. Or watch the movement of birds in flight; a swallow swoops and turns in small, quick spins, but a hawk glides and circles in wide, slow arcs. Each of us has our own innate sense of movement, which can be developed by being aware of our own bodies in motion. Some animators dance, play sports, or take acting classes. However it is developed, this sense reveals itself in visual choreography, in character acting, and above all, in timing.

Timing is the art of moving in meaningful ways. To understand how timing works in animation, consider someone waving to you from a distance. Why is the person waving? If you look at the timing of the waving, you may get a clue. Are they waving gently and smoothly? This might mean "bon voyage." Or are they waving frantically? This might mean that the ship is sinking. How does an animator create these different kinds of waves? The animator learns how to break down the action into a sequence of positions that show the significant stages of the movement, and then the animator determines how long each position should be held on the screen. These positions will be different depending on the quality of the action. For example, a gentle wave might consist of a sequence of fairly evenly spaced arm positions close together; to make the wave smooth and slow, each position might be held on the screen for two frames. On the other hand, a frantic wave might consist of unevenly spaced arm positions wide apart from each other, and the positions may be held on the screen for different lengths to create a more stuttered movement. With practice, an animator can recreate different qualities of movement by controlling timing.

Animation is also the art of combining image and sound. Sound dramatically influences how a viewer looks at images. Here are some examples. A loud sound occurring on a specific frame can make the image on that frame more noticeable than the images on surrounding frames. A sound can draw the viewer's attention to a particular part of the screen. Sound effects or voice recordings that are in sync with an image will make the image seem more real, and different musical compositions can impart different emotional qualities to a sequence.

Sound for animation can be divided into three broad categories: music, sound effects, and voice. Musical sounds can be long sequences that provide an emotional floor for a scene, or they can be short punctuations that draw attention to particular moments. Sound effects can include the sounds of short actions such as footsteps, as well as ambient environmental sounds such as waves crashing on the seashore or city traffic. Voice can include dialog spoken by characters or off-screen narration.

Sound can be created before the picture is made or after the picture is complete. Lip sync is an example of prerecorded sound; a character's dialog may be recorded first to allow the animator to create the animation in sync with the recorded words. Sound effects are

often recorded after the animation is complete, either in a program that allows for frame-accurate sound and image editing, or by simply recording live while the animation is playing.

Animation can be narrative or non-narrative. Like all cinematic works, every animation consists of recorded images that will always play in the same order and at the same rate. In some cases, this structure of beginning, middle, and end will be used to tell a story; characters will be introduced and a plot will unfold, leading to some sort of resolution. In this sense, animation is related to storytelling and theater. In other cases, the structure of beginning, middle, and end can be used to develop a visual theme; for example, a shape describes a gesture across the screen, more shapes join in the movement, creating variations on the original movement, and finally the original shape is alone again. This type of animation is related to abstract forms such as music or dance. Other animations may chronicle an event: for example, the quiet stillness at the beginning of a thunderstorm, the intensity of wind and rain in the middle, and the clearing sky at the end. In this regard, animation can be related to documentary.

Animation is an eclectic art. Animators have come from many backgrounds, and their diverse experiences have enriched the technical possibilities of animation. Illustrators such as Emile Cohl and Winsor McCay helped to create animation techniques related to illustrations, comics, and cartoons. Ladislas Starewich, a biologist by training, developed the first puppet animation techniques through his fascination with animating beetles. Alexander Alexieff, originally an engraver of book illustrations, developed the pinscreen to simulate the look of an animated etching. Len Lye developed techniques for making images directly on film, without the need for a camera. John and James Whitney developed early techniques for creating mechanical and digital tools for animating—the start of computer animation. The list goes on. The reason for this incessant invention and adaptation is that animators have diverse interests and often must create their own tools to match their interests. There is no correct way to create animation except the way that best suits the animator's needs.

contributing animators

Following is a list of sixteen animators who have kindly contributed samples of their work and their thoughts to this book. They represent a range of approaches to animation and differing degrees of involvement with digital production. Throughout the book are quotes from each of them concerning their work. I also include images from their projects in the color plates, as well as short clips of their animation on the accompanying CD as examples of their individual approaches to animation.

Yvonne Andersen (b. 1932)

Yvonne Andersen is an independent animator, author, and teacher. She attended Louisiana State University to study music, but changed her major to art. After school, she moved to Provincetown, Massachusetts, where she met her husband, poet Dominic Falcone. The two opened the Sun Gallery in 1954, where they organized shows of contemporary work by

young artists, as well as happenings and film screenings. The film screenings eventually led to filmmaking—a combination of live-action and animation in collaborative projects made with artist Red Grooms. Later, Yvonne and Dominic opened the Yellow Ball Workshop, where they trained children and adults to make their own animated films. The Workshops eventually evolved into a number of books for independent film and video animation and became the basis for the animation program at Rhode Island School of Design. Today, Yvonne continues to teach and to make independent films using scripts written and performed by Dominic.

Selected Films:
Fat Feet (1966)
I Saw Their Angry Faces (1977)
We Will Live Forever (1994)

George Griffin (b. 1943)

George Griffin is an independent animator with a substantial filmography. Much of Griffin's earlier animation is hand-drawn in a direct, cartoon-like style, featuring a square-headed, almost diagrammatic character who muses on the nature of his experiences and on the qualities of animation itself. Ideas are paramount; his films are like animated essays in which he thinks through his topics. These topics cover a broad range, including the history of animation (*Lineage*) and the process of a child's bedtime (*A Little Routine*). Griffin's soundtracks often include narration or dialog that explores the idea of the film verbally, sometimes working with the image and sometimes working against it.

Selected Films:
Head (1975)
Lineage (1979)
A Little Routine (1994)

Michael Dudok de Wit (b. 1953)

Michael Dudok de Wit was born and educated in Holland. After school he studied etching at the Art College of Geneva, and animation at Farnham, England, where he made his first film, *The Interview*. After animating for a year in Barcelona, he settled in London in 1980. Working freelance with different studios, in particular with the production company Richard Purdum Productions, he directed and animated many commercials for television and cinema. In 1992 he created his short *Tom Sweep*, followed by *The Monk and the Fish*, which was made at the Folimage studio in Valence, France. This film, drawn with ink brush and watercolor, won numerous awards. His most recent film, *Father and Daughter*, won the Grand Prix for short fiction in Annecy and an Oscar. Michael also illustrates children's books and teaches animation at art colleges in England and abroad. Characteristic of his drawing style is his use of strong shadows and simple but atmospheric landscapes.

Selected Films:
Tom Sweep (1992)
The Monk and the Fish (1994)
Father and Daughter (2000)

Christine Panushka (b. 1955)

Christine Panushka is an internationally known award-winning artist, filmmaker/animator, and educator. Her films have been screened in Japan, Italy, France, Germany, Brazil, Switzerland, Holland, England, Poland, Canada, and the United States. They have won numerous awards, including the Grand Prize at the Aspen Filmfest and a Golden Gate Award at the San Francisco International Film Festival. Her work explores the female psyche and uses stillness and small gestures to describe internal emotional and spiritual states. Critics have described her work as "completely original and capable of affecting both cerebral and sensual complexities." Named an Absolut Visionary in 1996, she conceptualized, directed, and curated "Absolut Panushka," the second issue in a series of content-based web sites sponsored by Absolut Vodka. She received her M.F.A. in 1982 from the California Institute of the Arts.

Selected Films:
The Sum of Them (1984)
Nighttime Fears and Fantasies (1986)
Singing Sticks (2001)

Amy Kravitz (b. 1956)

Amy Kravitz has made animated films and taught animation for most of her life. Her work is internationally recognized, winning awards and critical acclaim for technical excellence, innovation, and her powerful ability to communicate through abstract movement and imagery. Her work attempts to induce genuine experience through the usually vicarious medium of film. She directed *River Lethe, The Trap*, and *Roost*, among other works. She holds an A.B. in anthropology from Harvard University and an M.F.A. from Cal Arts in experimental animation. She is a professor of animation at Rhode Island School of Design, where both her innovative teaching methods and her students' work have received international attention.

Selected Films:
River Lethe (1984)
Trap (1988)
Roost (1998)

Piotr Dumala (b. 1956)

Piotr Dumala was born in Poland and studied sculpture and animation at the Academy of Fine Arts in Warsaw. His award-winning animated films include *Lagodna* (*Gentle Spirit*), *Nerwowe Zycie Kosmosu* (*Nervous Life of the Universe*), *Wolnosc Nogi* (*Freedom of the Leg*), *Franz Kafka*, and *Crime and Punishment*. Dumala's films are personal, with a poetic and surreal graphic style, deeply influenced by literary sources. He creates his artwork using direct under-the-camera techniques: for example, by scratching and painting onto prepared blocks of plaster. Dumala teaches animation at the Film, Television, and Drama School in Lodz, Poland, and is a guest professor at The Animation House at Konstfack in Eksjö, Sweden.

Selected Films:
Little Black Riding Hood (1983)
Gentle Spirit (1985)
Crime and Punishment (2000)

Baerbel Neubauer (b. 1959)

Baerbel Neubauer studied film and stage design in Vienna at the Academy of Arts. She has made close to thirty animated films since 1980, and has worked in various media, including 35 mm film, 70 mm IMAX film, and QuickTime movies for the Internet. In recent years she has been making semi-abstract animation painted directly on film stock. These films have received international recognition and prizes at international animation film festivals, short film festivals, and experimental film festivals. As a result, she has been invited to present her work at various festivals and schools in the United States, Europe, and Japan. She has made commercials in her own style, written articles about animation, and served as a jury member and a selection committee member at leading international animation festivals. Baerbel has also taught animation at workshops, schools, and universities, including the Royal College of Art and Rocky Mountain College of Art and Design.

Selected Films:
Roots (1996)
Moonlight (1997)
Firehouse (1998)

Dave Fain (b. 1960)

Dave Fain received his B.F.A. in film/animation from the Rhode Island School of Design in 1983 and his master's degree in experimental animation from the California Institute of the Arts in 1992. His professional credits include staff writer on the *Spongebob Squarepants* animated series; animating, writing, and directing for the *Action League, Now!* segments of the Nickelodeon series *KaBlam!*; animation for the title sequence of the feature film *The House on Haunted Hill*; and stop-motion animator for *Davy and Goliath II: Pet Cemetery*, a segment for Fox Television's *Mad TV*. His personal films include *Oral Hygiene* and *Panopticon*. He currently works as animation supervisor for Warner Bros. Online, creating new Looney Tunes cartoons for the Internet.

Selected Films:
His Name Was Henry (1983)
Oral Hygiene (1991)
Panopticon (1992)

Wendy Tilby (b. 1960)

Wendy Tilby studied visual arts and literature at the University of Victoria before attending the Emily Carr Institute of Art and Design, where she majored in film and animation. With the success of her student film, *Tables of Content*, Tilby was invited to join the National Film Board of Canada in 1987. Her first production for the Film Board, *Strings*, won many international awards, including an Academy Award nomination in 1991. Her latest release, *When the Day Breaks* (co-directed with Amanda Forbis), has received numerous honors,

including the Palme d'Or for short film at the Cannes International Film Festival and the Grand Prix at Annecy, Zagreb, and Hiroshima International Animation Festivals. Tilby has taught animation at Concordia University in Montreal, and from 1999 to 2001 was a visiting lecturer at Harvard University. She is currently collaborating with Amanda Forbis on a new film for the National Film Board.

Selected Films:
Tables of Content (1986)
Strings (1991)
When the Day Breaks (1999)

Sheila Sofian (b. 1962)

Sheila Sofian's films are a hybrid of documentary and animation. Her recent film, *Survivors*, is an animated documentary on domestic violence. Sofian received her bachelor of arts degree in film and animation at the Rhode Island School of Design, and her master of fine arts degree from the California Institute of the Arts. She has received grants from the Guggenheim Foundation, the Jacob K. Javits Fellowship, the Pennsylvania Council on the Arts, the Women in Film Foundation, and the Pew Fellowships in the Arts, as well as a residency at the MacDowell Colony. Her freelance work includes animation for the feature film *Closetland* and for MTV, titles for the feature film *10 Things I Hate about You*, and *The Strip*. Her award-winning films have been shown at the International Festival of Non-Professional Cinema in France, the Hamptons International Film Festival, the Chicago International Film Festival, the Cork Film Festival in Ireland, the Zagreb World Festival of Animated Film, and the Festival of Animated Film in Stuttgart, Germany, among others. Her work has been televised on WHYY's *Independent Images*, WYBE's *Through the Lens*, and WTTW's *Image Union*. Sofian was head of the animation program at the University of the Arts in Philadelphia for five years. She is currently head of the animation program at College of the Canyons in Santa Clarita, California.

Selected Films:
Faith and Patience (1991)
Survivors (1997)
A Conversation with Harris (2001)

Amanda Forbis (b. 1963)

Amanda Forbis was born in Calgary, Canada, and attended the Emily Carr Institute of Art and Design in 1988. She then joined the National Film Board of Canada as animation director on an educational animated film titled *The Reluctant Deckhand*. In 1995 Wendy Tilby invited her to Montreal to co-direct the animated film *When the Day Breaks*, which has since received over thirty international awards and was nominated for an Academy Award in 1999. In addition to leading animation workshops for children, Amanda has collaborated with Wendy on television commercials and created trailers for the Harvard Film Archive. They are currently working together on a new project.

Selected Films:
The Reluctant Deckhand (1995)
When the Day Breaks (1999)

Bryan Papciak (b. 1967)

Bryan Papciak worked for over seven years as a director and cinematographer, primarily at Olive Jar Studios in Boston, but also at Attik Design in New York City, and most recently at Scout Productions in Boston. Bryan specializes in experimental cinematography and mixed media television commercials. His work has won many awards at film and television festivals worldwide. In addition to working commercially, Bryan also teaches in the animation department at Rhode Island School of Design. Bryan formed Handcranked Film Projects along with Jeff Sias, Dan Sousa, and Jake Mahaffy as a means of exploring the arts through non-commercial, experimental cinema. Bryan's recently completed short film, *Met State*, is a 16mm pixilated portrait of an abandoned insane asylum. *Met State* has won the Best Experimental Film Award at the World Animation Celebration 2001, the Silver Plaque for Experimental Film at the Chicago International Film Festival 2001, and the Best Cinematography Award at the New England Film & Video Festival, 2001. Bryan is currently working on an experimental film portrait of Saint Ria, an obscure, apocalyptic saint who lived in fourteenth-century Italy.

Selected Films:
Met State (2001)

Dan Sousa (b. 1974)

Dan studied animation, painting, and illustration at the Rhode Island School of Design, where he produced his first two films, *Lull* and *Carnal Ground*. After a brief period of freelancing and teaching at the School of the Museum of Fine Arts in Boston, he worked at Olive Jar Studios, where he directed and animated several commercial shorts. During that time he also produced his film *Minotaur*. Currently, Dan is teaching at the Art Institute of Boston and has started working on his next animated film.

Selected Films:
Lull (1993)
Carnal Ground (1994)
Minotaur (1999)

Tim Miller (b. 1975)

Tim Miller started working on animation in high school, where he created several unauthorized tutorials in the margins of his English and math textbooks. It was there in the halls of frustration that he began experimenting with bouncing balls and exploding rocks. Tim studied illustration at the Maryland Institute College of Art, and then went on to Rhode Island School of Design (RISD), where he finished his bachelor of arts degree in animation. At RISD he was exposed to experimental filmmaking and began to find his place in the world of animation. During his senior year, he used animation to form a unique relationship with his artmaking process. His film, *Tide Pool*, was created after a year of animated dialogues, arguments, and emotional investment. Tim now lives in San Francisco, where he is surrounded by supportive friends and one cat.

Selected Films:
Tide Pool (2001)

Roque Ballesteros (b. 1976)

Roque Ballesteros is a graduate of the Rhode Island School of Design in film/animation/video. He has worked his way up in the commercial world from intern to director at such award-winning studios as Olive Jar Studios, Curious Pictures, and Wild Brain. His original series, *Joe Paradise*, was awarded 1st Place Internet Action Adventure at the World Animation Celebration 2000, as well as being nominated at other festivals in Ottawa, London, Rotterdam, and at Resfest 2000. The show is airing on Sony's broadband entertainment site, Screenblast.com. Currently, Roque is dividing his time between working as an animation director for an independent live-action short, and teaching part-time at the Art Institute International. Roque lives with his wife, Sonia, in San Francisco.

Selected Films:
Knot (1998)
Joe Paradise (2000)

Mike Overbeck (b. 1978)

Mike grew up in Hingham, Massachusetts, the youngest of three brothers. He describes his family as a very scientific community. His father graduated first in his class at MIT, where he later got his Ph.D., and then went on to work on the Chicago Pile Experiment, reading out the neutron count during the first nuclear chain reaction. His oldest brother went to Cornell as an engineer and works for an Internet service provider in Tokyo. His other brother was a physics major at the University of Rochester and does programming for some telescope or satellite or something at Harvard University. Thanksgiving dinner conversation usually focuses on solar systems, quarks, and subroutines. Mike took a different path; he liked to draw pictures. He also fell in love with cartoons and was fascinated with their technical aspect. But even as Mike pursued art whole-heartedly, he was always interested in science. Mike went to the Rhode Island School of Design in 1996, where he finally learned how to create animation and let his imagination run wild. At school he made two films: *Atlas Gets a Drink* and *Tongues and Taxis*. Making these films helped improve his skills as an animator and a storyteller. They also got him into film festival competitions, where he found the small international community of like-minded animated filmmakers. Since school, Mike has worked on a Cartoon Network pilot and made some political animations for the Fox News Channel.

Selected Films:
Atlas Gets a Drink (1999)
Tongues and Taxis (2000)

> *What is animation? Isn't it everything that you do? Not painting, not drawing, not music, not dreaming, not writing. Is it a visual dialog between your desire and your possibilities? Is it a discovery of a hidden inner creative process using the hidden power of different substances?*
>
> Piotr Dumala

chapter 2

a selection of animators

> *The wonderful thing about animation is that we can actually experience other people's interior rhythms and visions.*
>
> Christine Panushka

In the following pages, a number of significant contributors to animation are listed in chronological order by year of birth. This chapter is not a history of animation; rather, it is an idiosyncratic selection based on my work as a teacher. Over the years, I have shown films by these animators to my students. My selection criteria are both subjective and objective. On a subjective level, I pick films that move me in some way—for their visual style, subject matter, soundtrack, or some other quality. On an objective level, I pick films based on the filmmaker's historical significance, as an example of a specific technique, as a unique approach to filmmaking, or for general excellence. For each entry, I include the name and dates of the animator and a brief description of why I show that animator's work to my students. This description is followed by a list of two or three films; the titles listed are important works by the animator, but in most cases there are more films available, so use my selections as a starting point for getting to know each artist's work. There are many more wonderful animators than I am able to include in these few pages. For a more complete history of animation, read *Cartoons*, by Giannalberto Bendazzi. Other resources for seeing animation are listed in Chapter 9, where you will find lists of magazines, web sites, and festivals that present the work of animators both past and present.

The best way to see animation (especially work by contemporary animators) is to attend an animation festival. In addition to showing a fine selection of work on a big screen, festivals often serve as gathering places for directors and aficionados of animation. Closer to home, many colleges, universities, and museums organize screening events for the public. You also have the option of renting or purchasing your own copies of animation from catalogs and stores (either on VHS or DVD), thereby building your own library of animation to which you can refer whenever you like. Finally, there are a number of web sites that stream animation (see Chapter 9).

Emile Cohl (1857–1938)

Emile Cohl was a French animator, considered by many to be the father of the animated cartoon. His film *Phantasmagorie* was shown at the Theatre de Gymnase in Paris, France, in 1908. His graphic style was simple and elegant; the backgrounds employed the minimum drawing necessary to describe a scene, and his characters were often simple shapes with stick figure arms and legs. His films focused on fantasy, humor, plot, and character.

Selected Films:
Phantasmagorie (1908)
Merry Microbes (1909)
Twelve Feats of Hercules (1910)

Winsor McCay (1867–1934)

Winsor McCay is one of the best-known early American animators. Winsor McCay started as an illustrator, and then began performing in vaudeville, using his ability to draw very

quickly and accurately as part of his act. One drawing led to another, and eventually McCay animated characters. He started with *Little Nemo in Slumberland*, and then went on to incorporate other animations into his routine. Winsor McCay eventually left the theater, but continued to make animated films, finishing several more over the next decade.

Selected Films:
How a Mosquito Operates (1912)
Gertie the Dinosaur (1914)
The Sinking of the Lusitania (1918)

Ladislas Starewich (1882–1965)

Ladislas Starewich was a Russian animator, considered to be the father of puppet animation. He came to animation from an unexpected source—entomology. Because he could not film live beetles, Starewich preserved a number of the insects and animated them by reattaching their legs to their bodies with bits of wax. His success prompted him to make another film, again with beetles, but this time acting in a story. The animation was so realistic that some viewers thought Starewich had trained live beetles. He went on to animate many more films using a variety of human, animal, and fantastical characters.

Selected Films:
The Cameraman's Revenge (1912)
The Insects' Christmas (1913)
The Mascot (1933)

Hans Richter (1888–1976)

Hans Richter was a German artist who came to animation from abstract painting. In 1921, he made an abstract animated film, *Rhythmus 21*, using a series of cut out rectangular black and white shapes. Richter went on to experiment with other uses of cinema, freely mixing live-action, special effects, and animation in his exploration of formal ideas. Richter's purpose in filmmaking always was to extend and expand the possibilities of his work as a total artist, rather than to pursue a specific interest in animation as an art unto itself.

Selected Films:
Rhythmus 21 (1921)
Film Study (1926)
Ghosts Before Breakfast (1927–1928)

Berthold Bartosch (1893–1968)

Berthold Bartosch, a Czech, is known for his film *The Idea*, which is based on the graphic novel of the same title by Frans Masereel. *The Idea* is a visually beautiful film with a political message. As a result of its socialist viewpoint, the film was not distributed after it was completed. Bartosch made the film by himself in a tiny Paris apartment. He constructed an animation stand that allowed him to photograph his artwork in layers, each on its own sheet of glass. This setup is called a multiplane; it allows the filmmaker to animate particular elements (characters, for example), without disturbing the backgrounds.

Selected Films:
The Idea (1932)

Lotte Reineger (1899–1981)

Lotte Reineger was a German animator who worked primarily in Paris. Her films were made using silhouette cutouts, a passion of hers from childhood. She cut paper into various shapes—people, animals, scenery—and placed them on sheets of glass. The glass was lit from below so that the cutouts appeared as black silhouettes against the light. Using this multiplane technique, Reineger made animation for feature films, commercials, television, and theatrical productions. Her film *The Adventures of Prince Achmed* is considered to be the first animated feature-length film.

Selected Films:
The Adventures of Prince Achmed (1926)
The Little Chimney Sweep (1935)
The Gallant Little Tailor (1954)

Oskar Fischinger (1900–1967)

Oskar Fischinger was a German artist and animator best known for his abstract animations based on musical forms. In the 1930s Oskar Fischinger left Germany and settled in Hollywood, where Walt Disney hired Fischinger to design the look of his feature film *Fantasia*. But Fischinger left the studio after a few months and turned to painting as his main artistic activity. He made several more films, and in 1947 he finished his last and one of his finest films, *Motion Painting No. 1*.

Selected Films:
Spiritual Constructions (1927)
Study No. 8 (1932)
Motion Painting No. 1 (1947)

Alexander Alexeieff (1901–1982) and Claire Parker (1906–1981)

Alexander Alexeieff was born in Russia and moved to Paris, where he worked first as a set designer and later as an engraver of book illustrations. Claire Parker was born in the United States and moved to Europe to study art. She later became both Alexeieff's artistic collaborator and his wife. Alexeieff became attracted by the idea of animating his engravings, so he invented the pinscreen, a board with a myriad of tiny holes, each of which contains a small, thin metal pin. When the pins are pulled out, they cast longer shadows; when the pins are pushed in, they cast shorter shadows.

Selected Films:
Night on Bald Mountain (1933)
The Nose (1963)
Pictures at an Exhibition (1972)

Len Lye (1901–1980)

Len Lye was born in New Zealand and moved to London. He went to work for the General Post Office (GPO) in London, where he made public service films by painting and drawing

directly on clear film stock. After World War II broke out, Lye moved to New York City, where he continued making experimental films with direct techniques. Later, kinetic sculpture became increasingly important to his work. Lye's work influenced many animators to experiment with direct animation techniques and to explore the possibilities of pure movement as a form of expression.

Selected Films:
Colour Box (1935)
Particles in Space (1957)
Free Radicals (1958)

Jiri Trnka (1912–1969)

Jiri Trnka was a Czech animator with a background in painting, illustration, and the carving of wooden puppets, a Bohemian tradition. Trnka produced both short films and feature puppet animations from his studio, drawing on literature, Czech legends, and fairy tales as his sources. He also used film to tell allegorical tales, as in *The Hand*. This, his last film, tells the story of a sculptor who is forced to make monuments for a giant hand instead of the pots he would rather make for his beloved flower.

Selected Films:
The Emperor's Nightingale (1948)
Old Czech Legends (1957)
The Hand (1965)

Norman McLaren (1914–1987)

Norman McLaren was born and educated in Scotland, and later moved to England. At the GPO in London, along with Len Lye, McLaren made animated public service films using the experimental technique of painting directly on clear film stock. In 1941 McLaren went to work at the Canadian Film Board, where he served as the "Animator Laureate" of Canada, hiring promising young talents, encouraging their development, and inspiring them by example. Over the years, McLaren made many exploratory films, experimenting with a wide range of formal ideas and techniques, including pixillation, direct sound, direct animation, and optical printing.

Selected Films:
Begone Dull Care (1949)
A Chairy Tale (1957)
Pas de Deux (1967)

John Hubley (1914–1977) and Faith Hubley (1924–2002)

An American, John Hubley got his start in animation working for Walt Disney on *Snow White and the Seven Dwarfs*, but eventually went to work for United Production of America (UPA). UPA's style was influenced by the flat, abstract graphics of modern art, and explored a variety of subjects. UPA's films were a distinct break from the Disney studio style, which attempted to emulate the physical reality of a three-dimensional world. Later, John and his wife, Faith, set up their own studio in New York City. Their collaborative film work, which

won several Academy Awards, explored social and psychological themes in a gentle and whimsical style. They based their films on soundtracks constructed from adults' and children's conversations about complex subjects. For example, they recorded their own children at play, discussing imaginary creatures or fantasies about growing up.

Selected Films:
Rooty Toot Toot (1952)
The Hole (1962)
Cockaboody (1972)

Jules Engel (b. 1915)

Jules Engel was born in Hungary, but moved to the United States early in life. He started working at the Disney Studio, where he designed the Chinese and Russian dance sequences for *Fantasia*. While he was at Disney he met Oskar Fischinger, who became both a friend and an inspiration. Later, Engel became one of the principal artists at UPA, working on films such as *The Tell Tale Heart* and *Gerald McBoing Boing*. Jules Engel later founded his own studio, Format Films. In the 1960s Engel moved to Paris, where he worked as a painter and a documentary filmmaker. After his return to the United States, Engel founded the experimental animation program at the California Institute of the Arts and became a major force in teaching new generations of animation artists. Jules Engel's abstract animations are elegant, playful, and beautifully choreographed, related in spirit to abstract painting and dance.

Selected Films:
Coaraze (1965)
Train Landscape (1974)
The Meadow (1992)

Fjodor Chitruk (b. 1917)

Fjodor Chitruk is a Russian animation director whose work has influenced subsequent generations of Soviet animators. Early on, he became interested in developing an alternative to the realism of Walt Disney's animated features. Instead of emphasizing three-dimensional modeling and realistic backgrounds, Chitruk's films are graphic, stylized animations that deal with human and social issues through narrative and allegory. In addition to filmmaking, Chitruk has been influential as a teacher and as the president of the USSR Animation Commission.

Selected Films:
History of a Crime (1961)
Film, Film, Film (1968)
The Lion and the Bull (1983)

John Whitney (1917–1995) and James Whitney (1922–1982)

John Whitney and his brother, James, were Americans who are known for their experimental films. John pioneered computer animation and developed a life-long interest in the relationship of music to image. After he and James made a number of experimental films

together, they both went on to create films individually. James Whitney used films to explore mystical imagery (mandalas) while John Whitney continued to explore the possibilities of computer-generated imagery and the relationship of sound to image.

Selected Films:
Film Exercises (1944)
Lapis (1965)
Permutations (1968)

Borge Ring (b. 1921)

Borge Ring is a Dutch independent and commercial animator. His films are stories about the pain and pleasures of family life, especially the process of growing up and growing older. Ring started out as a commercial animator, and then began making personal films, winning an Oscar for *Anna and Bella* in 1986. Ring draws and paints his animation in a full and fluid style, influenced by the animation of the Disney studio. His films are stories about characters based on people and situations in his own life. As a result, his films are both personal and universal in their appeal.

Selected Films:
Oh My Darling (1978)
Anna and Bella (1984)
Run of the Mill (2000)

Robert Breer (b. 1926)

Robert Breer is an American artist whose films explore the formal nature of film and animation. Breer uses drawings, cutouts, live-action, and photographs to make the viewer conscious of the qualities of the film itself. For example, *A Man and His Dog Out for Air* starts with a line drawing of a man walking a dog. Breer animated the drawing straight ahead, without planning the movement, resulting in a film that chronicles the development of the drawing. Other films, such as *Gulls and Buoys*, are highly dependent on editing for the development of their ideas.

Selected Films:
A Man and His Dog Out for Air (1957)
Gulls and Buoys (1972)
Fuji (1974)

Giulio Gianini (b. 1927) and Emanuele Luzatti (b. 1921)

Gianini and Luzatti are an Italian team who made a number of cutout animated films. Luzatti came to animation from a background in theater design and ceramics, and Gianini from graphic design and photography. Their films are deeply influenced by music, drawing on classical Italian compositions for both timing and subject matter. For example, their film *The Thieving Magpie* uses the music of Rossini to determine the pacing and timing of their interpretation of the musical narrative. The cutouts are richly colored and textured, and the animation is expressive and imaginative.

Selected Films:
An Italian in Algiers (1968)
Pulcinella (1973)
The Thieving Magpie (1974)

Yoji Kuri (b. 1928)

Yoji Kuri is a Japanese artist who has made comics, painting, sculpture, and animation. Much of Kuri's animation has been commissioned to run on Japanese television as a series of independent shorts. This arrangement has provided an outlet for his highly original work. His films are often provocative, using surreal and deliberately crude drawing styles. *Love* shows a woman chasing a reticent man through an environment, repeating over and over again that she loves him. Kuri has used a variety of animation techniques and styles, and has drawn inspiration from both Japanese and Western sources.

Selected Films:
Human Zoo (1962)
Love (1963)
The Midnight Parasites (1972)

Jan Lenica (1928–2001)

Jan Lenica was a Polish artist and filmmaker known for his work in film, illustration, poster design, and set design. Lenica lived in Paris from 1963 to 1986. Later, he moved to Germany where he taught animation, graphics, and poster design. He began making animated films with Walerian Borowczyk. After their collaboration ended, Jan Lenica went on to make films on his own using a combination of drawing and cutouts. Lenica's allegorical films are noted for their strong black and white graphic style and tragic-comic narratives that explore themes such as social alienation.

Selected Films:
Labyrinth (1962)
Rhinoceros (1963)
A (1964)

Raoul Servais (b. 1928)

Raoul Servais is a painter, designer, animator, and teacher who has influenced generations of animators in Belgium as well as abroad. Servais' films are allegorical (as in *Chromophobia*), or darkly surrealistic (as in *Harpya*). *Chromophobia* uses stylized drawn animation techniques to tell the story of an army of monochromatic soldiers who march against anything containing color. *Harpya* combines live-action, pixillation, and animation to tell the story of a man whose life becomes dominated by the insatiable hunger of a bird-woman whose life he has saved.

Selected Films:
Chromophobia (1965)
Goldframe (1969)
Harpya (1978)

Osamu Tezuka (1928–1989)

Osamu Tezuka was a seminal figure in the development of Japanese animation and comic book art. He was involved in the early development of Japanese feature animation, helped launch Japanese TV animation in the 1950s and 1960s, and is considered the father of *Manga*, or Japanese comic books. His influence on Japanese popular culture is recognized in a museum in Osaka dedicated to his work. Throughout his career, he made a number of inventive animated shorts. *Jumping*, for example, shows an anonymous character's point of view as it makes increasingly exaggerated and absurd leaps.

Selected Films:
A Story of a Street Corner (1962)
Jumping (1984)
Broken Down Film (1985)

Yvonne Andersen (b. 1932)

Yvonne Andersen is one of the contributing animators to this book. She is an American independent animator, author, and teacher. After college studies in Louisiana, she moved to Provincetown, Massachusetts, where she met her husband, poet Dominic Falcone. The two opened the Sun Gallery in 1954, where they organized shows of contemporary work by young artists, as well as happenings and film screenings. Her films have utilized a variety of techniques, including pixillation, cutouts, and puppet animation. Her films are notable for their strong graphic visual style and poetic structure.

Selected Films:
Fat Feet (1966)
I Saw Their Angry Faces (1977)
We Will Live Forever (1994)

Jan Svankmajer (b. 1934)

A Czech, Jan Svankmajer is known for his surrealistic animated films made with objects, clay, and puppets. Svankmajer works in Prague, where he is active as a surrealist artist in a number of mediums, including sculpture and live-action filmmaking as well as animation. His animations are notable for their unsettling imagery of inanimate objects brought to life and his use of sound and editing to disorient the viewer's expectations. Svankmajer has been influenced by his native city of Prague, by the paintings of Archimboldo, and most importantly, by the ideas of Surrealism. In turn, he has influenced a large number of filmmakers and animators, including the Brothers Quay.

Selected Films:
Jabberwocky (1971)
Dimensions of Dialog (1982)
Faust (1994)

Paul Fierlinger (b. 1936)

Paul Fierlinger was born in Japan to diplomat parents, was educated in Czechoslovakia, and finally escaped to the United States in 1968. Fierlinger uses dialog, narration, and an

illustrative drawing style to tell stories about people. His style is direct and representational, less about the formal possibilities of animation than about the lives of his subjects. He works like a reporter, using his animations as a vehicle for conveying biographical information. Fierlinger's subjects range from his autobiography to situational sketches from the lives of others.

Selected Films:
It's So Nice to Have a Wolf Around the House (1980)
Drawn from Memory (1991)
Marsh People (1997)

Derek Lamb (b. 1936)

Derek Lamb is a writer, producer, director, animator, and teacher. He has worked as executive producer at the National Film Board of Canada, and has made independent films. He has also made films with such organizations as UNICEF and the World Health Organization. His work is hallmarked by social consciousness and a dedication to human rights. *Every Child*, for example, was based on UNICEF's list of children's rights, specifically, the right of every child to a nationality. The film interprets this idea by presenting a story of a baby no one wants. Through a series of funny but poignant scenes, the child is shunted from house to house until it ends up in a garbage dump.

Selected Films:
The Great Toy Robbery (1963)
Every Child (1980)
Karate Kid (1989)

Paul Driessen (b. 1940)

Paul Driessen is a prolific Dutch animator who came from a background in graphic design and illustration. He learned the craft of animation by making commercials and by working on the Beatles' film *Yellow Submarine*. Since then, he has been making independent animated films in Canada and in Holland. Driessen's films are based on ideas. For example, *David* is based on the idea of a main character who is so small that he is invisible, and *Spotting a Cow* is based on the idea that the film itself will document the development of the film's idea. Driessen uses an economical visual style that is both delicate and witty.

Selected Films:
David (1977)
On Land, at Sea, in Air (1978)
Spotting a Cow (1983)

Yuri Norstein (b. 1941)

Yuri Norstein is a Russian master of cutout animation. Together with his wife, Francesca, who makes the artwork for the films, Norstein has directed and animated a series of expressive and poetic films for both children and adults. His animations have included history, literature, and personal memory as subject matter. The design of his films is richly textured and layered. His animation of a character often involves overlapping semitransparent

cutouts, and his scenes are shot on an animation stand that allows layers of his multiplane setup to move independently up and down as well as sideways (north, south, east, and west in an animator's parlance).

Selected Films:
Crane and Heron (1974)
Hedgehog in the Mist (1975)
Tale of Tales (1979)

Paul DeNooijer (b. 1943) and Menno DeNooijer (b. 1967)

Paul and Menno DeNooijer are a Dutch father and son team who have made a series of animated films that are essays on the nature of photography, filmmaking, and animation. Their work uses pixillation and still photography of the filmmakers in different situations. For example, *At One View* shows pixillation of father and son sitting in chairs next to a fire in a hearth. The fire burns in speeded-up time while the actors move more slowly in animated time, presenting still photographs of each other's heads in front of their faces. They often use narration as a running commentary beneath the animation.

Selected Films:
Nobody Had Informed Me (1989)
At One View (1989)
I Should See (1990)

George Griffin (b. 1943)

George Griffin is one of the contributing animators to this book. He is a prolific American animator who has worked as an independent filmmaker, commercial filmmaker, and teacher. Much of Griffin's earlier animation is hand-drawn, featuring a square-headed, almost diagrammatic character in films that often reflect on the nature of animation itself. Ideas, self-consciousness, and ironic humor are paramount in Griffin's films, covering a broad range of topics, including the history of animation (*Lineage*) and a child's bedtime (*A Little Routine*). His soundtracks often include narration or dialog that explores the idea of the film verbally, sometimes working with the image and sometimes working against it.

Selected Films:
Head (1975)
Lineage (1979)
A Little Routine (1994)

Suzan Pitt (b. 1943)

Suzan Pitt is an American artist whose animated films are poetic narratives. In *Asparagus*, her first major film, Pitt explores the development of a female character's sense of identity. *Joy Street* again follows the progress of a female character, this time from despair to hope. Her visual style is both naturalistic and fantastic, consisting of richly colored painted backgrounds and fully rendered characters. Her techniques include traditional cel painting as well as cutout, object, and puppet animation. Besides filmmaking, Pitt has worked as a painter, set and costume designer, and teacher.

Selected Films:
Asparagus (1979)
Joy Street (1995)

Pierre Hebert (b. 1944)

Pierre Hebert is a Canadian animator, artist, and writer who has worked at the National Film Board of Canada. His animation is consistently experimental, often utilizing direct on-film techniques. *Op Hop—Hop Op*, for example, was an early animation scratched directly on film. Hebert also developed a way to make his scratched films part of a live performance along with dancers and musicians. In these performances, Hebert scratches on a loop of film as it runs through the projector, responding to, and in turn influencing, the improvisations of the other performers. Hebert extended his animation into a feature-length format in *La Plante Humaine*, a film about the power of television to influence our view of the world.

Selected Films:
Op Hop—Hop Op (1966)
La Lettre d'Amour (1989)
La Plante Humaine (1997)

Nobuhiro Aihara (b. 1945)

Nobuhiro Aihara is a Japanese artist whose films are primarily abstract and lyrical, exploring the natural environment and personal experience. He developed the term "outdoor animation" to describe his method of animating the cycles of nature. Aihara draws and paints his abstract and gestural shapes on paper and has also combined still photography in his films. His animation is smooth, flowing, and meditative, often moving in circular forms reminiscent of mandalas. Aihara lives in Japan, and is currently professor of film at the Kyoto College of Art.

Selected Films:
Wind (2000)
The Third Eye (1999)
Ki-Moving (1994)

Caroline Leaf (b. 1946)

Caroline Leaf was born and educated in the United States. After college, she went on to make films for the National Film Board of Canada. She uses a variety of direct techniques, including animating underlit sand or wet paint on sheets of glass under the camera, and scratching images directly into film emulsion. Leaf's films are narratives based on short stories and folk tales. *The Owl Who Married a Goose*, for example, uses sand animation to retell an Inuit folk tale, and *The Street* uses paint animated on glass under the camera to retell a short story by Mordechai Richler.

Selected Films:
The Owl Who Married a Goose (1974)
The Street (1976)
Two Sisters (1990)

Priit Parn (b. 1946)

Priit Parn is an Estonian animator who uses traditional cel techniques to tell his stories. His films are surreal, combining symbolic characters, social commentary, and complex narratives that are both entertaining and absurd at the same time. One of his earlier films, *Breakfast on the Grass*, follows the parallel lives of several characters living in Soviet society; in the end, all the characters converge on a park and become the painting by Manet. *1895* is a rumination on history; it is a biography of twin characters whose lives run in parallel with the development of cinema.

Selected Films:
Breakfast on the Grass (1987)
1895 (1995)
Night of the Carrots (1998)

Bill Plympton (b. 1946)

Bill Plympton is an American animator whose films are cartoons designed to entertain adults. Originally a political cartoonist, Plympton has brought to animation his sense of satire and outrageous humor. Plympton's characters are men and women drawn illustratively in colored pencil against white or very simple backgrounds. His animation uses an economical style that is in part a practical decision, since he works independently of any government or private sponsor.

Selected Films:
Your Face (1986)
I Married a Strange Person (1998)
Mutant Aliens (2000)

Stephen and Timothy Quay (b. 1947)

Stephen and Timothy Quay (known as "the brothers Quay") are twins born and educated in the United States. They moved to England where they completed their education at the Royal College of Art and began making animation. At this time, they were exposed to and influenced by the films of Jan Svankmajer. Their films are nonverbal, surreal, and dreamlike, using puppets and objects in richly textured sets. The Quays use lighting, composition, editing, and sound to help create the atmosphere of their films. *Street of Crocodiles* is based on the story by Polish author Bruno Schulz. The film shows a male puppet character exploring a surreal, dilapidated street of shops in which strange machines throb and hum while tailors with empty heads perform mysterious tasks.

Selected Films:
Cabinet of Jan Svankmajer (1984)
Street of Crocodiles (1986)
Rehearsals for Extinct Anatomies (1987)

Kathy Rose (b. 1949)

Kathy Rose is an American dancer, animator, filmmaker, and performance artist. Early in her career Rose turned from dancing to animation as a way to explore her interests in both

drawing and movement. She made a number of improvisational animated films that started with a title, a group of characters, and a situation. Rose animated these characters straight ahead—that is, going from one drawing to the next without a detailed plan of where the animation would end. Kathy Rose now works as a performance artist and weaves her interests into stage productions in which she dances with her own projected films.

Selected Films:
The Doodlers (1975)
Pencil Booklings (1978)

Paul Glabicki (b. 1951)

Paul Glabicki is an American artist who works in a number of mediums, including animation. His films are collages of geometric animations and sound. For example, *Object Conversations* is a series of hand-drawn diagrammatic animated sequences of several objects, such as scissors, chairs, and a barbell. In earlier films, the imagery was entirely hand-drawn and monochromatic; he then began incorporating color and the computer as an image-making tool, including both 3-D as well as 2-D computer graphics. Glabicki's animation is characterized by formal interests, precision, detail, and subtle wit. His work goes beyond animation, extending into drawing, painting, and installation. In addition to his work as an artist, Glabicki teaches at the University of Pittsburgh.

Selected Films:
Film, Wipe, Film (1983)
Object Conversations (1985)
Under the Sea (1989)

David Anderson (b. 1952)

David Anderson is an English filmmaker who has made a number of animated films that explore poetic imagery, the subconscious workings of the mind, and allegory through a variety of animation techniques. For example, *Dreamland Express* uses a mixture of drawn and cutout animation mixed with live action to portray the journey from wakefulness to sleep as a train trip. *Door* is about an imagined time in the future after nuclear war has destroyed civilization. It uses a mixture of puppet animation, puppet sets, pixillation, and live-action to create a visual analog to a narration track written by Russell Hoban.

Selected Films:
Dreamland Express (1982)
Deadsy (1989)
Door (1990)

Michael Dudok de Wit (b. 1953)

Michael Dudok de Wit is one of the contributing animators to this book. He was born and educated in Holland, and studied etching at the Art College of Geneva, and animation at Farnham, England. After animating for a year in Barcelona he settled in London in 1980, where he directed and animated many commercials for television and cinema. His most recent film, *Father and Daughter*, won an Oscar and the Grand Prix for short fiction in

Annecy. Characteristic of his drawing style is his use of strong shadows and simple but atmospheric landscapes. In *Father and Daughter* his characters are drawn as small figures in large environments, but they are nevertheless highly expressive because of his strong sense of timing, choreography, and composition.

Selected Films:
Tom Sweep (1992)
The Monk and the Fish (1994)
Father and Daughter (2000)

Igor Kovalyov (b. 1954)

Igor Kovalyov was born and educated in the Ukraine and then worked at Pilot Studio in Moscow. Later, he moved to the United States, where he works on both commercial and personal projects. His animated films use the technique and look of traditional cel animation to tell nonverbal stories that are fractured and ultimately absurd, communicating by inference rather than direct statement. Each character seems to be either desiring something or concealing something from the other characters. *Hen, His Wife*, for example, tells the story of a husband who slowly realizes (to his horror and her shame) that he is married to a hen. Kovalyov directs his characters as if they were dancers, using stylized and repetitive movement. Objects and people move in fluid slow motion, and then suddenly burst into sudden action or dissolve into the background.

Selected Films:
Hen, His Wife (1990)
Andrei Svislotsky (1991)
Bird in the Window (1996)

Janet Perlman (b. 1954)

Janet Perlman is a Canadian animator whose films are idiosyncratic, tongue-in-cheek parodies. *Cinderella Penguin* is a standard version of the traditional tale told with the twist that every character is a penguin. *My Favorite Things That I Love* presents a series of extremely kitschy and sickeningly sweet scenes featuring images of cute bunnies with big watery eyes, and large mustachioed Viking supermen with phallic rocket ships rising in the background. Perlman's animations are drawn and animated on paper and cel in a style that is both deadpan and absurdly funny.

Selected Films:
Why Me? (1978) co-directed with Derek Lamb
The Tender Tale of Cinderella Penguin (1981)
My Favorite Things That I Love (1994)

William Kentridge (b. 1955)

William Kentridge is a South African artist who began using animation to record the process of making drawings, and later extended this interest to making animated films by drawing and erasing charcoal under the camera. The animation imagery is monochromatic, heavily shaded, and representational, with characters and objects moving freely in space and time

as they follow Kentridge's thought process. His subject matter is a mixture of personal and social reflection, often featuring a middle-aged white man and his personal experiences set against the backdrop of racially divided South Africa.

Selected Films:
Johannesburg, 2nd Greatest City after Paris (1989)
Felix in Exile (1994)
Shadow Procession (1999)

Christine Panushka (b. 1955)

Christine Panushka is one of the contributing animators to this book. She is an American artist, filmmaker/animator, and educator. Her work explores the female psyche and uses stillness and small gestures to describe internal emotional and spiritual states. Critics have described her work as "completely original and capable of affecting both cerebral and sensual complexities." Named an Absolut Visionary in 1996, she conceptualized, directed, and curated Absolut Panushka, the second issue in a series of content-based web sites sponsored by Absolut Vodka. She received her M.F.A. in 1982 from the California Institute of the Arts.

Selected Films:
The Sum of Them (1984)
Nighttime Fears and Fantasies (1986)
Singing Sticks (2001)

Pjotr Sapegin (b. 1955)

Pjotr Sapegin was born in Moscow and was educated as a theater designer. Later, he moved to Norway where he began making animated films. Sapegin's films use a combination of materials, mostly clay, either as three-dimensional puppets or as two-dimensional reliefs on the glass sheets of a multiplane. The films are based on a variety of sources, including Greek myths, Norwegian folktales, and original screenplays. His stories and characters exhibit gentle and ironic humor. His film *One Day a Man Bought a House*, for example, is the story of a man who tries repeatedly and unsuccessfully to kill a rat living in his new home. The rat mistakes these efforts as expressions of love, and eventually works up her courage to return the man's affections.

Selected Films:
Mons the Cat (1995)
One Day a Man Bought a House (1998)
Snails (1999)

Piotr Dumala (b. 1956)

Piotr Dumala is one of the contributing animators to this book. He was born in Poland and studied sculpture and animation at the Academy of Fine Arts in Warsaw. Dumala's films are personal, with a poetic and surreal graphic style, influenced by literary sources. He creates his artwork using direct under-the-camera techniques; for example, by scratching and painting onto prepared blocks of plaster. Dumala teaches animation at the Film,

Television and Drama School in Lodz, Poland, and is a guest professor at The Animation House at Konstfack in Eksjö, Sweden.

Selected Films:
Little Black Riding Hood (1983)
Gentle Spirit (1985)
Crime and Punishment (2000)

Amy Kravitz (b. 1956)

Amy Kravitz is one of the contributing animators to this book. She is an American animator who has made films and taught animation for most of her life. Her work is internationally recognized for its attempts to induce genuine experience through the usually vicarious medium of film. The animations are richly layered abstractions that evoke emotional responses through a sense of movement, sound, and environment. She directed *River Lethe*, *The Trap*, and *Roost*, among other works. She is a professor of animation at Rhode Island School of Design, where both her innovative teaching methods and her students' work have received international attention.

Selected Films:
River Lethe (1984)
Trap (1988)
Roost (1998)

Nick Park (b. 1958)

Nick Park is an English animator known for his clay animated characters, Wallace and Gromit, and for his work with Aardman Animation Studio in England. Wallace is a bumbling amateur inventor, and Gromit is his nonverbal but highly intelligent dog. Park's animation is based on writing, acting, and gags, drawing on the tradition of classic comedy and thriller films for inspiration.

Selected Films:
A Grand Day Out (1989)
Creature Comforts (1989)
The Wrong Trousers (1993)

Mark Baker (b. 1959)

Mark Baker is an English animator whose films tell stories based on physical locations. For example, *Hill Farm* follows the daily routine of a farmer, his wife, and their hired hand, as well as the animals (both wild and domestic) that live there. The routine is temporarily disturbed by the arrival of campers and hunters. Both his characters and backgrounds are colorfully rendered as highly stylized shapes arranged in strong compositions.

Selected Films:
Hill Farm (1988)
Village (1993)

Baerbel Neubauer (b. 1959)

Baerbel Neubauer is one of the contributing animators to this book. She was born in Austria and studied film and stage design in Vienna at the Academy of Arts. She has made close to thirty animated films since 1980. Many of her films are made with direct techniques by painting on clear film stock or exposing film directly to create animated contact prints. The relationship of image to sound is an important component of Neubauer's work, resulting in films that are both energizing and meditative at the same time. Baerbel has also taught animation at workshops, schools, and universities, including the Royal College of Art and Rocky Mountain College of Art and Design.

Selected Films:
Roots (1996)
Moonlight (1997)
Firehouse (1998)

Chris Sullivan (b. 1960)

Chris Sullivan is an American animator and performance artist whose films are poetic narratives that examine the lives of people living on the fringes of society. For example, *Landscape with the Fall of Icarus* tells the story of a priest whose church has burned down. The priest is unable to find a place to live and is obsessed by guilt and visions of death and the Devil. The film freely mixes various drawing styles and moves back and forth between reality and hallucination in order to represent the priest's descent into madness. *Consuming Spirits* uses a combination of drawn and cutout animation to tell the story of a child taken by the authorities from a neglectful home.

Selected Films:
Landscape with the Fall of Icarus (1992)
Consuming Spirits (2002)

Wendy Tilby (b. 1960) and Amanda Forbis (b. 1963)

Wendy Tilby and Amanda Forbis are contributing animators to this book. Wendy Tilby is a Canadian animator who studied animation at the Emily Carr Institute of Art and Design. She was invited to join the National Film Board of Canada in 1987, and her first film at the Film Board, *Strings*, was nominated for an Academy Award in 1991. Her latest release, *When the Day Breaks* (co-directed with Amanda Forbis), has received the Palme d'Or for short film at the Cannes International Film Festival. Her first two films are gentle and incisive studies of the relationships of strangers brought together by circumstances. Both were made by animating paint on glass under the camera, and are notable for their attention to details of character, action, and environment. Amanda Forbis was born in Calgary, Canada, and attended the Emily Carr Institute of Art and Design in 1988. She then joined the National Film Board of Canada as animation director on an educational animated film titled *The Reluctant Deckhand*. In 1995 Wendy Tilby invited her to Montreal to co-direct the animated film *When the Day Breaks*. They are currently working together on a new project.

Selected Films by Wendy Tilby:
Tables of Content (1986)
Strings (1991)
When the Day Breaks (1999)

Selected Films by Amanda Forbis:
The Reluctant Deckhand (1995)
When the Day Breaks (1999)

Michaela Pavlatova (b. 1961)

Michaela Pavlatova is a Czech animator whose films are concerned primarily with human relationships, especially the difficulties of love and marriage. Her work presents the attractions, frustrations, and disappointments of relationships in a gently satirical and humorous way. The films are animated on paper and cel. Examples of Pavlatova's visual inventiveness include her use of word bubbles as a visual element in *Words, Words, Words*, and connecting multiple scenes through a single imaginary space in *Repete*.

Selected Films:
Words, Words, Words (1991)
Repete (1995)
Forever and Ever (1998)

Jonas Odell (b. 1962) and Stig Bergqvist (b. 1962)

Jonas Odell and Stig Bergqvist are two of the four founders of FilmTeknarna Studio in Sweden. They use drawing and cel animation to tell stories based on their own writing and character design. *Exit* and *Otto* are both narrative films. *Revolver* is a short film with a non-narrative structure made up of a series of surrealistic scenes animated in black and white, all loosely related to each other by a visual detail or general theme. For example, a scene of a fisherman hauling in a net containing fish and a baby is followed later by a scene of man trying to catch a slippery fish in a canning factory.

Selected Films:
Exit (1989)
Revolver (1993)
Otto (1997)

Joanna Quinn (b. 1962)

Joanna Quinn is a Welsh animator whose work is critical of political and social status quos. For example, *Girls' Night Out* turns the table on male voyeurism by presenting a group of women watching a male stripper, and *Britannia* presents a picture of a diminishing English empire as a whining dog trying to hold onto a scrap of the globe. She creates full animation drawn on paper and cel, and her animation is notable for its fluid movement, dynamic timing, and strong illustrative abilities.

Selected Films:
Girls' Night Out (1987)
Body Beautiful (1990)
Britannia (1993)

Koji Yamamura (b. 1964)

Koji Yamamura made his first animation film in 1977, when he was thirteen years old. Ten years later in 1987, he graduated from Tokyo Zokei University, and in 1993, he founded Yamamura Animation, Inc. From his studio in Tokyo, Koji has produced animated series for Japanese television, commercials, and a number of independent films. His gentle, whimsical, and colorful style appeals to both children and adults. His works have been shown in more than twenty-five countries and have been awarded various prizes. He is a member of the board of directors of the Japan Animation Association (JAA) and is a member of the International Animated Film Association (ASIFA).

Selected Films:
Imagination (1993)
Your Choice (1994)
Mt. Head (2002)

> *The physical act of drawing and painting is sometimes blissful, sometimes boring, but what really makes me happy is the desire and effort to make something which feels whole.*
>
> Michael Dudok de Wit

chapter 3

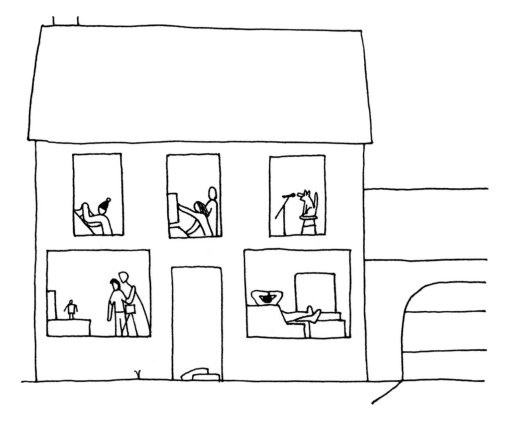

the digital studio

I was first interested in making documentaries but became seduced by animation at art school. I was excited by the graphic and narrative possibilities. Also, the solitude and control (like having your very own theatre and being in charge of sets, costumes, music . . . EVERYTHING!). But I still work much like a documentary filmmaker in that I like to gather images and ideas rather haphazardly—then find order in the chaos.

Wendy Tilby

the evolution of animation tools

Animation is a young art. It has only been around since the invention of motion picture technology—just over 100 years ago. This is because animation requires machinery for recording and playing back moving images, and these machines did not exist before the end of the nineteenth century. Animation was born with motion pictures, and was tied to the technology of film production through most of the twentieth century. But as we move into the twenty-first century, mechanical film technology is giving way to digital electronic technology, and animators today may never touch a piece of film. This shift from the mechanical, chemical medium of film to the digital, electronic medium of computers is the greatest change in animation technology since its birth.

Prior to the invention of film, animation was a curiosity. During the nineteenth century, a number of people in the United States, England, France, and Germany experimented with optical toys that created the illusion of movement. One of the earliest (and simplest) of these devices is the Thaumatrope. The Thaumatrope consists of a disc attached to two strings. An empty cage is drawn on one side of the disc; on the other side is drawn a bird. When the strings are pulled, the disc spins, and the bird appears to be in the cage. Another of these devices is called the Phenakistiscope (Figure 3-1). This device consists of a disc that spins freely around its center on a pencil or a stick. One side of the Phenakistiscope is painted black. A series of images are drawn on the other side of the disc, each image represent-

Figure 3-1 The Phenakistiscope, an early animation device. (Illustration by Tim Miller.)

ing a stage in a movement. There is no beginning and no end to the movement; the disc can be spun endlessly with no break in the movement. Each image is separated from its neighboring image by a slit cut out of the disc at regular intervals. To operate the Phenakistiscope, the viewer holds the disc up to a mirror with the drawings facing the mirror. By spinning the disc and looking through the slits, the drawings appear as a continuous motion rather than as a series of individual pictures.

These optical toys work because of a principle called "the persistence of vision," which means that the eye retains an image for a fraction of a second longer than the image is actually presented. If one image is replaced quickly enough by another image, we cannot distinguish between them and our brain interprets the two as a single *moving* image. Persistence of vision is how the Thaumatrope puts the bird in the cage, and how the Phenakistiscope creates a cycle of continuous movement from individual pictures. The slits in the Phenakistiscope are a crucial part of its design; without these, the device would not be able to present discreet pictures to the viewer. Essentially, the viewer is looking at one static image followed by black, followed by another static image, followed by black, and so on. If the disc spins quickly enough, our brains cancel out the black and combine the static images into a continuous motion.

The development of motion picture technology followed this same principle. A strip of film consists of a series of individual frames, each frame containing a discreet image. The film projector holds a frame stationary for a fraction of a second and projects the image onto the screen. Then the projector's light is blocked by a rotating disc (called the shutter) while the film is advanced to the next frame. The shutter then opens again and the next image is projected onto the screen. This process is repeated over and over very quickly so that the eye interprets the projected images as a single, moving picture. Early on, it was determined that sixteen frames per second was the necessary rate for achieving the illusion of movement. This frame rate remained the standard for silent film until the 1920s, when the frame rate was increased to twenty-four frames per second to accommodate the needs of optical soundtracks.

Motion pictures are the result of two important inventions: transparent celluloid film and the motion picture camera and projector (Figure 3-2). George Eastman developed celluloid film at the end of the nineteenth century. The celluloid was cut into long strips 35 millimeters wide, punched with regular perforations along its edges, and coated with a photographic emulsion. This became the medium for holding the images. The camera and its counterpart, the projector, were developed at about the same time by Thomas Edison in the United States and the Lumiere brothers in France, although it was the Lumiere brothers who made the invention practical by reducing the equipment to a portable size. The Lumiere's first public film projection in 1895 is the date normally used to mark the birth of the cinema. Motion pictures catapulted animation into a popular art form.

By the middle of the twentieth century, motion pictures had become a stable medium. Additional developments (for example, widescreen image format and stereo sound) did not fundamentally change the nature of the technology. Film continues to be an important presentation medium, but the electronic medium of video and computers is gradually replacing it. Video began as an extension of radio. The idea was to create a technology that could

Figure 3-2 Motion picture film and projector. (Illustration by Tim Miller.)

transmit images through the air in the same way that radio transmits sounds. As early as the 1920s, inventors were successfully transmitting images over short distances, and in 1929, the BBC in London began broadcasting 30 minutes a day. In the early 1940s, the National Television Standards Committee (NTSC) was formed in the United States to establish technical standards for television. By the end of the 1950s, television sets had become a common household appliance for viewing entertainment, educational programming, and advertising.

Up until recently, video was an analog medium. An analog medium uses a continuous physical variable to represent data. In video, this meant that images and sound were recorded in real time onto magnetic tape as a continuous flow of fluctuating electronic signals. Because analog video required continuous signals, it was a natural medium for recording continuous, real-time events, but it could not easily record the short, discontinuous images necessary to create animation. It was not until the arrival of digital electronics that video became a practical medium for making animation. Digital electronics store data as numerical variables rather than as physical variables. Because the nature of its data is discreet, a digital electronic medium is better suited to storing and replaying the discreet images required for animation.

When we talk of an electronic digital medium, we are basically talking about computers. Computers have a long history that stretches back centuries, but for our purposes, the relevant history of computers begins in the 1970s with the development of personal computers. IBM and Apple were the first companies to make popular home computers, and

Figure 3-3 Mini DV camcorder and FireWire connectors. (Illustration by Tim Miller.)

their designs continue to dominate the market today in the form of the PC and the Macintosh. At first these computers were used primarily for typing and record keeping. But as the technology progressed, desktop computers became increasingly powerful. As their capabilities grew, so did the uses for the machines. Individuals, schools, and businesses began to use desktop technology for graphic design, page layout, sound production, and image-making of all sorts, including animation. Since then, the shift from film to digital production has been gaining momentum, both for the individual working alone as well as for the professional working in the marketplace. There are several reasons for this shift. The most fundamental factor is the increase in processing speed; as the computer became faster at executing commands, it became capable of doing more things in the same amount of time. Also, the trend toward miniaturization has meant that more computer capability fits into a smaller box, thereby expanding the definition of what a desktop computer is. Recently, the development of digital video, the FireWire standard, and DVDs has greatly aided the production of animation on the computer.

Digital video (called DV for short) refers to several things. DV tape is the recording medium and DV camcorders are the recording tool for digital video (Figure 3-3). DV records images in a digital format, which offers tremendous advantages over analog video. For animators, DV offers the ability to work with individual frames, and digital images can be manipulated in a computer. Finally, there is no loss of quality no matter how many times the images are copied.

FireWire® (Apple Computer) is a standard for transferring data (for example, digital video) at high speeds from one device to another (see Figure 3-3). (It is also known as the IEEE

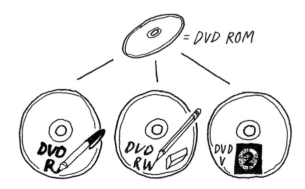

Figure 3-4 DVD formats. (Illustration by Tim Miller.)

1394 standard on the PC, and i.Link by the Sony Corporation.) It consists of a card, a port, and a cable. This standard enables animators to use equipment made by different hardware manufacturers, and quickly and easily transfer digital data between them.

DVD is another emerging format that may ultimately replace tape altogether. DVD stands for "digital versatile disc." A DVD looks like a CD, but a typical CD can store only about 650 MB of information, whereas a typical DVD can store close to 5 GB of information. The physical DVD is called a DVD-ROM. The DVD-ROM can be used in two basic ways (Figure 3-4). The first way is simply to use the disc as a storage medium to back up your files. For this purpose, you can either choose a disc that can only be written once (called a DVD-R), or a disc that can be written to more than once (called a DVD-RW). The second way to use DVD-ROMs is to store video. When the DVD-ROM is used for this purpose, it is called a DVD-V. DVD-Vs can be played on a dedicated player called a set-top player, or they can be played on a computer with a DVD drive. To make a DVD-V you need special software that can convert video or animation to the proper format. The DVD-V standards are still developing, so not all players are completely compatible yet.

Another product of digital electronic technology is the Internet, or Web. The Web is a network of computers connected to each other via telephone lines, cable lines, and satellite transmissions. Any computer equipped with a modem, an Internet service provider, and browser software can access the Web. The Web was first developed in the 1970s, and has grown rapidly into a worldwide medium for communication, research, entertainment, and shopping, as well as a way to view, distribute, and advertise animation.

Digital tools are developing rapidly. Late-breaking news in these areas can become old history within six months. We can expect these technologies to continue improving in terms of speed, quality, affordability, and flexibility. This is good news for the independent animator.

why I use digital tools

When I started making animation in the early 1980s, most independent animation pro-
duction was based on film technology. As an independent animator setting up my own
studio, I invested in 16 mm film equipment and I needed the services of laboratories and
studios to perform functions too specialized or expensive for me to do myself, such as film
processing, sound mixing, and negative cutting. Each of these services required money,
time, and scheduling. There were also disadvantages with film technology. First of all, there
was a lag time in feedback. In order to see how animation looked, I had to shoot film, send
it off for processing, and then wait for it to come back. This entire process might take several
days to a week. Changes were also difficult to make. Once something was shot, it could
not be altered without reshooting. Also, a number of specialized pieces of equipment were
required, such as a Steenbeck for editing and a projector for viewing films.

The digital studio offers advantages in these areas. There is no waiting for film to be processed
before seeing the animation; the images are there as quickly as they are made, and the com-
puter offers more flexible decision making because sequences can be altered and manipu-
lated. With so many functions in one box, the animator requires far fewer outside services.
Digital tools also allow for a more flexible working environment; computers can be set up
almost anywhere, and laptop computers even allow for taking the studio on the road. It is also
easier to share work with others—not everyone has a film projector, but most people have
computers. With standard file formats, CDs, and the Web, it is relatively easy to exchange
image and sound files. Distribution options have also increased. In addition to established
film/video festivals, the Web and digital video are inspiring people to create new and inno-
vative distribution outlets for animation. Finally, digital storage means that copies are identi-
cal to the original file, so copies of animation do not degrade the quality of the image.

Here is a list of some of the differences between a film and a digital studio:

Film Studio	Digital Studio
to draw animation: • pencil, paper, light box, peg bar, peg hole punch	to draw animation: • pencil, paper, light box, peg bar, peg hole punch, or • drawing tablet, software
to shoot animation: • motion picture film camera, tripod or camera stand, strong lights, light stands, light meter, film stock, laboratory to process and print film	to record flat animation: • scanner, peg bar to record dimensional animation: • mini DV camcorder, lights, light stands
to record music and sound: • tape deck, microphone, headphones	to record music and sound: • CD/DVD drive, or • music synthesis software, or: • microphone, or • digital recorder, or • tape deck, microphone, headphones

Film Studio	Digital Studio
to edit picture and mix soundtracks: ● sound transfer service to transfer tape recording to magnetic film, Steenbeck to edit magnetic film, splicer, cores, leaders, sound mixing service to mix sound to picture	to edit picture and mix soundtracks: ● sound editing software ● picture editing software
to finish to final format: ● negative cutting service, laboratory to make answer print and release prints, film-to-tape transfer service, tape duplication service	to finish to final formats: ● to disk: software ● to tape: software and mini DV camcorder ● to DVD-V: software and DVD burner ● to Web: software and web site ● to film: (same as a film studio)
screening options: ● film/video festivals, theaters, schools, homes ● on film or videotape	screening options: ● film/video festivals, theaters, schools, homes, showcase web sites, personal web sites ● on film, videotape, disc, or the Web

There are disadvantages to a digital studio. Here are my main complaints. First, computer equipment must be periodically upgraded as new technology replaces older equipment and software. This requires potentially large outlays of cash every two to five years. Second, sitting at a computer for hours on end causes physical strain. Among the possible ailments are carpal tunnel syndrome, neck pain, and eye strain. Also, there are creative problems that arise as side effects of digital tools. There is a danger in becoming overwhelmed by the many choices offered by software applications—getting lost in what the software can do instead of staying focused on the original intention. Also, computers disconnect us from real materials; all images and sound end up as numbers stored in circuits. This can be a loss to those who derive pleasure and ideas from handling materials. Compared to film, working digitally often means accepting a loss of image quality—a typical computer screen has only a fraction of the resolution of film. Finally, digital images are different from film images. The reflected film image projects a soft but clear beauty compared to the harsher, brighter light of the digital image. This is an aesthetic issue that will be less important as people become more used to digital imagery, but it is a fact.

In spite of my complaints, I feel the advantages of digital production far outweigh the disadvantages for the animator. Some of my complaints can be dealt with by changing the way I sit when I work. By taking frequent breaks and stretching, I can greatly reduce the chance of developing painful posture problems, eye strain, and carpal tunnel syndrome. I can avoid the trap of being distracted by too many software options by doing as little as possible to an original image. If retaining a tactile relationship with physical materials is important, then I can simply use the computer as a recording device, using it to digitize handmade artwork rather than creating the images with software. And although it is true that the digital image is different than the film image, one is not necessarily better than the other.

my digital studio

Over the years, I have gradually replaced my film equipment with a Macintosh computer, other digital hardware, and various software applications. I will describe the details of my home studio in its current state (Figure 3-5). It includes what I used to make the projects for this book, and it allows me to define many of the basic terms you are likely to come across when building your own studio. As you read through this section, remember that computer hardware and software are evolving. Many of the details may change by the time you read this book. But fortunately, the general principles are likely to remain constant.

To make the examples on the accompanying CD, I used Macromedia Flash and a drawing tablet to draw animation directly into the computer, Adobe PhotoShop and a scanner to digitize flat artwork, and Adobe Premiere and a mini DV camcorder to capture stop-motion animation. To create music in the computer, I used a MIDI composition program and Quick-Time Pro Player. To record and edit voice, sound effects, and music, I used Pro Tools Free

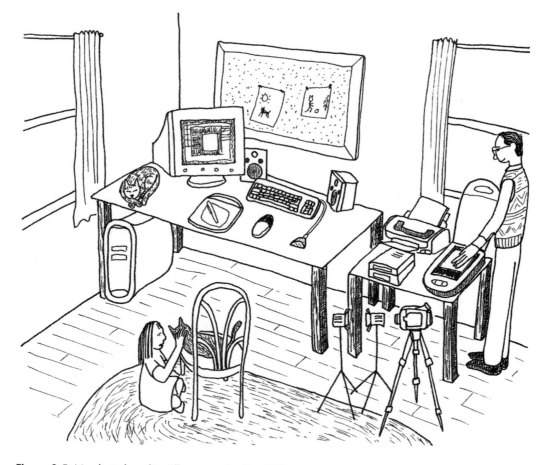

Figure 3-5 My digital studio. (Illustration by Tim Miller.)

and a desktop microphone. To output my animations to videotape, I used Premiere and a mini DV camcorder. For output to CD-R and DVD-R, I used Premiere, Toast Titanium, and a CD/DVD drive. For output to DVD-V, I used DVD Studio Pro. For output to the Web, I used GoLive, an Internet connection, and my personal web site.

my computer

My computer is the heart of my digital studio, and is used for creating, recording, editing, and distributing animation. As I write this book, I am using a Mac G4 running at 450 kHz, with 750 MB RAM and a 20 GB hard drive. On the front of the computer are a CD/DVD ROM drive and a Zip drive. On the back of the computer are two USB ports and two FireWire ports, a built-in modem, an Ethernet port, and audio in and out ports. The monitor is a 17" CRT display.

Here is a definition of some of these terms:

- *". . . running at 450 kHz . . ."* This is a measurement of the computer's processing speed. Processing speed, also called clock speed, is measured in kilohertz (kHz). The higher this number, the more quickly the computer will execute its tasks. The faster the computer can perform its operations, the better the chance that your animation will play smoothly. Therefore, buy a computer with the fastest processing speed you can afford.
- *". . . with 750 MB RAM . . ."* This is the computer's memory, measured in megabytes (MB). Random-access memory (RAM) is how much information the computer can work with at one time. This information includes any software applications and projects you have open. The higher this number, the longer the project you can work on at one time. Buy a computer with the maximum amount of RAM you can afford. RAM is also fairly easy to add later on.
- *". . . and a 20 GB hard drive."* This is a measurement of the computer's storage capacity. RAM is cleared every time you shut off the computer, so to keep your projects for later use, you must save them to the hard drive. The hard drive also stores all your software applications. Hard drive capacity is measured in gigabytes (GB). Generally, you don't have much choice when buying a computer; it will come with a hard drive of a given size. But it is quite easy to add more hard drive storage capacity later on.
- *". . . CD/DVD ROM drive . . ."* This is a device that allows the computer to read the information on a CD or a DVD. CD stands for compact disc. One CD can store about 650 MB of information; that information can include software, animation files, or audio files. One DVD (digital versatile disc) can store about 5 GB of information. Like CDs, DVDs are used for all kinds of information storage, but they are particularly good for storing digital video, which includes a lot of data. ROM means read only memory. This is another way of saying that the drive can read the information on these discs, but it cannot save information to the discs. A drive that can save (or write) to CD and DVD as well is called a read/write (RW) drive. To write to a CD or DVD, you would need to purchase blank recordable discs.
- *". . . Zip drive . . ."* Zip drives accept Zip discs. These are another type of storage media, like CDs and DVDs. Unlike CD-R and DVD-R, Zip discs can be reused again and again. One Zip disc holds either 100 MB or 200 MB, depending on the drive.

- *". . . USB ports . . ."* These are places to connect USB cables. USB stands for Universal Serial Bus. It is the standard for connecting peripherals such as printers to your computer.
- *". . . FireWire ports . . ."* FireWire® (Apple Computer) is a standard for transferring data (for example, digital video) from one device to another. It is also known as the IEEE 1394 standard (on the PC), and i.Link (Sony Corporation). With FireWire, you can connect a DV camera, extra hard drives, or an external CD/DVD RW drive to your computer. Use a FireWire connection anytime you need high-speed data transfer. You won't need a separate FireWire port for each piece of equipment because FireWire devices can be daisy-chained.
- *". . . built-in modem . . ."* The modem connects your computer to the telephone line so you can access the Internet. In addition to the modem, you will also need an Internet service provider (ISP) and a web browser (Netscape Navigator and Internet Explorer are the two most common). ISPs are the businesses that connect you to the Internet. ISPs include America OnLine (AOL), Earthlink, and others. Modems are the cheapest way to access the Internet, but they are also the slowest. The other two options are DSLs and cable connections. DSL stands for Digital Subscriber Line; it is a service ordered through an ISP. Cable refers to a cable connection, usually offered by the same company that offers your cable TV. Both DSL and cable offer much higher Internet connection speeds, but they are also more costly.
- *". . . Ethernet port . . ."* This is a connector for high-speed networking. It can be used for communicating between computers in the same location, or for connecting to a high-speed Internet connection such as DSL or cable modem.
- *". . . audio in and out ports . . ."* These are the places to connect microphones and speakers. The microphone would be plugged into the audio in port; the speakers would be plugged into the audio out port. These ports (also called "jacks") are standard on most computers and usually are designed to accept small plugs called stereo mini-RCA plugs.
- *". . . monitor is a 17" CRT display . . ."* CRT is short for cathode ray tube. These are the large, bulky monitors commonly used with computers and in television sets. CRTs are gradually giving way to flat LCD monitors (LCD is short for liquid crystal display). My monitor measures 17" diagonally. For graphics work, you will want a monitor that measures at least 15".

a comparable PC computer

Although I happen to use a Mac, I could use a PC instead. Because the majority of major software and hardware packages run on both systems, the choice between Macs and PCs boils down to a question of familiarity and comfort. That said, there are differences between the two platforms. One of the differences is in the number of system configurations possible. The Mac is made only by Apple Computer, so the number of configurations is limited to a few different desktop and laptop systems. PCs are made by many manufacturers, and PC configurations vary widely, depending on what a particular manufacturer specializes in and what a particular customer wants. Rather than give a particular manufacturer's model, it is best to list some general features to look for in a PC. These features would create a system roughly comparable to a G4:

- a tower case with expansion slots for future added cards
- a power supply (~300 W)

- a fast processor, for example, the Intel® Pentium® 4 processor running at 1 GHz or faster
- 512 MB RAM or more
- 30 GB or larger hard drive
- AGP graphics card
- IEEE 1394 (FireWire) ports
- USB ports
- Ethernet port
- Windows operating system

equipment and hardware

In addition to the computer, I used the following equipment and computer hardware:

- **Drawing tablet:** This is a flat plastic tablet connected to the computer through the USB port. It comes with a plastic "pen" that draws on the computer screen when the pen moves across the tablet. This device is useful when drawing animation directly into the computer. I used a 6" by 9" Wacom tablet (many people are happy with the smaller 4" by 5" model).
- **Scanner:** A scanner captures flat images made outside the computer. The animator can create various kinds of flat artwork (drawings, paintings, collages, cutouts, etc.) and scan them into PhotoShop. In PhotoShop the bit-map images can be registered and adjusted before being imported into a program such as Premiere for final editing. A basic scanner can capture an area up to 8.5" by 11".
- **Mini DV camcorder:** I used a mini DV camcorder to capture stop-motion animation one frame at a time, and to record finished animations to videotape. The camcorder connects to my computer with a FireWire cable and can be controlled by Premiere.
- **Video/audio cables:** RCA cables are used to connect most home audio and video equipment. These are available over the Web or at any electronics store that sells audio and video equipment.
- **Tripod:** I used the same tripod I used with my film camera to mount the DV camcorder when I shot the puppet animation. Tripods should be stable and adjustable. They are available from suppliers of photographic equipment.
- **Lights:** I used a lighting kit for lighting stop-motion sets (left over from my film studio). But high-quality lights are less important with video; you can get good results with any sort of adjustable lamps or clip lights on a stand.
- **Desktop microphone:** I used a simple and inexpensive desktop microphone that is plugged directly into the stereo mini RCA jack on the back of the G4. Although the sound quality was poor compared to a more expensive mic, it sufficed for simple examples of audio recording.
- **Desktop speakers:** Again, I used inexpensive desktop speakers. These were an improvement over the computer's built-in speaker, but were still fairly low quality. If I had used higher-quality audio equipment, I would have wanted to upgrade the speakers as well.
- **Printer:** I used an inkjet printer to print images and text. Inkjet printers are cheap and produce very good graphic prints, but the ink cartridges are expensive. If your printing needs are limited to text, consider a laser printer instead.

- **CD/DVD RW drive:** The CD/DVD RW drive stores copies of my work files, either on CD or DVD-R. With this equipment I could also make copies of finished animations for distribution in the DVD-V format.

software

Here is a list of the software I used:

- **Mac OS X:** This is the operating system my computer was running. An operating system is a suite of software applications that run in the background whenever your computer is turned on. They serve as the translator between your software applications (PhotoShop, etc.) and the computer hardware. If you have a PC, the operating system will be a version of Windows (Windows 98, Windows 2000, Windows XP).
- **Adobe PhotoShop:** This is an image editor that gives you the option of working with layers. Each layer is like a piece of transparent film laid over a background image, and each layer can be drawn on or edited independently of the others. Layers can be used by animators to create a sequence of animated images because each layer can be saved independently.
- **Adobe Premiere:** This is a video and sound editor that is relatively simple to learn. With the Cleaner EZ plug in, Premiere helps to prepare the project for output to a number of formats.
- **MacroMedia Flash:** This program allows you to draw frame-by-frame animation with or without a soundtrack. Flash uses vector graphics, which means that the images are described mathematically as points and lines.
- **Digidesign ProTools Free:** This is a multitrack sound recording, editing, and mixing program. Digidesign makes a full professional version of the program called ProTools (without the "Free"). The full version includes a sound card that is installed in your computer. Together, the card and the software allow the animator to create high-quality soundtracks. However, Digidesign has also provided a scaled-down demo version of the program that does not require the special card. The demo version is free, and can be downloaded from their web site (www.digidesign.com). If Digidesign continues to offer this demo version, it is an excellent way to introduce yourself to their software. The idea is that you will eventually want to purchase the full version.
- **DVD Studio Pro:** This software allowed me to encode (convert) my animation files into a format suitable for creating a DVD-V. The DVD-V can be played on a computer or on a DVD-V set-top player as an alternative to videotape.
- **Roxio Toast Titanium:** This is the software I used to burn CD-Rs and DVD-Rs. It can make CDs that run on both Macs and PCs (DVDs are automatically saved in a format readable by both types of computers).
- **Adobe GoLive:** I used this software to build and maintain my web site. Another popular choice is Macromedia Dreamweaver.
- **Making More Music:** This is one in a series of CDs developed by composer Morton Subotnick (my father). This series is designed to introduce children and adults to the process of composing music, and can be used by a musical novice to create original music. Once the music is created, it can be saved as a MIDI file and then converted into a sound file in a program such as QuickTime Pro.

- **QuickTime Pro:** Pro is the full version of Apple's Basic QuickTime Player. It is available as an upgrade for a small fee through Apple's web site. Pro offers the ability to import, edit, and output files and work with a number of different formats.

The studio described in the previous sections allowed me to create animation with soundtracks for playback on my hard drive, on CD or DVD ROM, DVD-V, on videotape, and on the Web. In the rest of this chapter, I will discuss some possible alternatives and additions to the studio.

an alternative: the lunchbox sync

The Lunchbox Sync is a frame-by-frame video capture device (Figure 3-6). The great advantage of the Lunchbox is that it is dependable and easy to use. It is a small box (in the shape of a lunchbox) that captures and outputs both video and audio. These simple features can be used to accomplish a number of animation tasks, including syncing animation to a soundtrack, making animatics, and testing animation timing. The Lunchbox is normally not used with a computer, but instead is connected to a video deck to record animation directly to tape. The cost of a Lunchbox setup rivals the cost of a computer system, but if you are interested in the Lunchbox as an alternative to a computer-based studio, visit www.animationtoolworks.com.

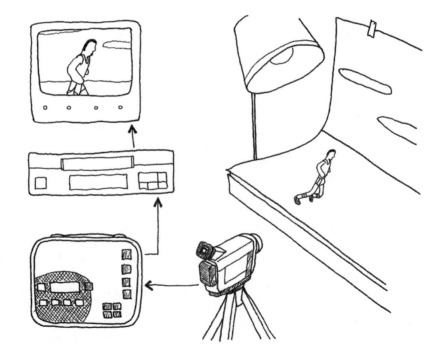

Figure 3-6 The Lunchbox Sync. (Illustration by Tim Miller.)

sound production tools

I used the simplest possible sound equipment to make the examples for this book using only a desktop microphone and speakers. This sufficed for rudimentary sound production, but sound is fully half of a viewer's experience, and you may want to produce higher-quality sound. If you move beyond desktop equipment, your first purchase will be a sound card. With a sound card installed, you will be able to connect audio equipment (for example, microphones, mixers, and speakers) to your computer. Sound cards have specialized jacks and ports to accommodate the different cables used by various types of audio equipment. The term "jack" generally refers to the connector for an analog audio cable, and "port" generally refers to the connector of a digital audio cable (Figure 3-7).

- **RCA:** The most common cable used in home stereo systems and home video equipment; usually comes in pairs (one for the right channel and one for the left channel)
- **Stereo mini RCA:** A smaller version of the standard RCA, increasingly common in home audio and video equipment; the two stereo channels are normally combined into one cable
- **1/4" phono:** A higher-quality cable used in place of RCA to connect many types of professional audio equipment
- **XLR:** A high-quality cable used for connecting a microphone to audio equipment
- **MIDI:** Actually a data cable rather than an audio signal cable, this is used to transmit MIDI data between MIDI devices (keyboard, synthesizer, computer, etc.)

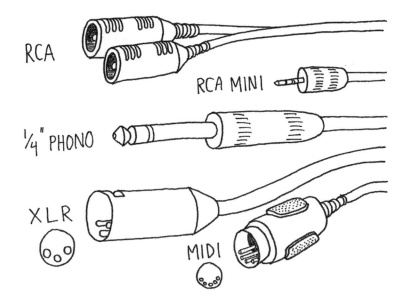

Figure 3-7 Audio cables. (Illustration by Tim Miller.)

types of sound equipment

- **Sound card:** Sound cards come in two basic varieties: those with jacks and ports built in to the card and those with external "break-out boxes" containing the jacks and ports. The all-in-one sound cards tend to be cheaper and have fewer connection options, and the cards with break-out boxes tend to be more expensive and have more connection options.
- **Microphone:** The quality of the microphone you use will dramatically affect the quality of your recordings. There are many types of microphones designed for a variety of recording situations. Most animation sound production involves controllable recordings in a studio. For this type of recording situation, a good choice is a general-purpose cardioid mic. A cardioid mic is sensitive to a wide area in front, and less sensitive to sounds far away from or behind the mic.
- **Mic preamp:** Microphones produce a weak audio signal, so if you don't have a mixer with a built-in amplifier, you will probably need a microphone preamplifier to boost the mic's audio signal before it goes into the computer's sound card.
- **Mixer:** A mixer is useful if you are planning to connect multiple audio sources to your computer at the same time. Mixers have a number of input channels for different audio sources (microphones, electric guitars, etc.), each with its own volume controls.
- **MIDI keyboard:** A MIDI keyboard is useful if you are a musician and want to perform your own music. Use the keyboard to control MIDI synthesizer software, which can simulate a number of different instruments.
- **Portable audio recorder:** You can record directly into your computer, saving the recording to the hard drive, or a portable audio recorder can be used to record sound away from your computer. The cheapest and most durable choice is a cassette tape recorder. A more expensive, but higher-quality choice is a DAT (digital audio tape) recorder. In either case, you will also need headphones, a microphone, cables, and batteries. Another option is a digital voice recorder. Audio quality is not as good as a portable audio recorder and recording time is limited, but it is small, portable, relatively inexpensive, and does not require a microphone or headphones. Look for a voice recorder with a USB interface so that you can download the audio files directly to your computer.
- **Speakers:** You will want to listen to your sound on speakers that approximate the way your intended viewers will hear your sound. For example, if you are distributing animation over the Web, your computer's built-in speaker or a pair of inexpensive desktop speakers are a good choice. On the other hand, if you are planning to screen your animation in a theater, you will want professional quality speakers that plug into your sound card or amplifier.

types of sound software

There are two basic types of sounds on the computer: digitized and synthesized. Digitized sound is recorded and digitized, but synthesized sound is generated by the computer itself. There are also two types of sound files: waveform and MIDI. A waveform file is a digital recording; the higher the resolution of the recording, the closer the reproduction will be to the original sound. MIDI stands for Musical Instrument Digital Interface. A MIDI file includes a set of instructions for how a synthesizer will generate a sound (loudness, pitch, etc.). Waveform files include AIFF and WAV files. MIDI files are always in the MIDI format.

There are a number of types of sound software applications, and each type performs a specialized function.

- **Multitrack recording and editing:** These applications allow you to record sound onto separate tracks, edit the tracks, adjust volumes, and mix them into a finished file
- **Waveform editing:** These applications allow you to alter the quality of an individual sound, for example, by changing pitch, length, or loudness of a recorded sound
- **MIDI sequencing:** These applications allow you to record, edit, and mix tracks containing MIDI data
- **Music composition:** These applications allow you compose music as a series of MIDI notes; some are based on traditional musical notation, but others are based on different techniques (such as working with loops of continuous sound)

example sound setups

Sound work can be done inexpensively with a CD/DVD drive, basic sound and music software, desktop speakers, and a desktop microphone.

- a CD/DVD drive (to capture audio from discs)
- MIDI music software (to create your own compositions)
- Quicktime Pro (to convert MIDI files into AIFF or WAV files)
- sound editing software (for example, Premiere or ProTools Free)
- desktop speakers
- desktop microphone with a stereo mini plug (read your computer's documentation to make sure the mic's plug is compatible with the jack on the back of your computer)

If recording audio into your computer is important, then you might want to add the following items to the basic sound setup. This additional equipment will allow you to record voice, sound effects, and music with greater fidelity.

- high-quality microphone
- mic pre-amp
- sound card
- mic stand
- pop filter
- mic cable
- sound editing software (for example, Pro Tools LE or Cakewalk)
- high-quality speakers

If music is a major part of your creative work, then you may need to expand your audio setup to allow for higher-quality audio production, and more complex audio recording and mixing scenarios. For example, the addition of a mixer will allow you to record multiple audio sources (mics, instruments) simultaneously into separate tracks in the computer.

- high-quality sound card (for example, Digidesign's Digi-001 System)
- sound editing software (for example, Pro Tools full version, or Cakewalk)
- mixer for multiple audio inputs and outputs

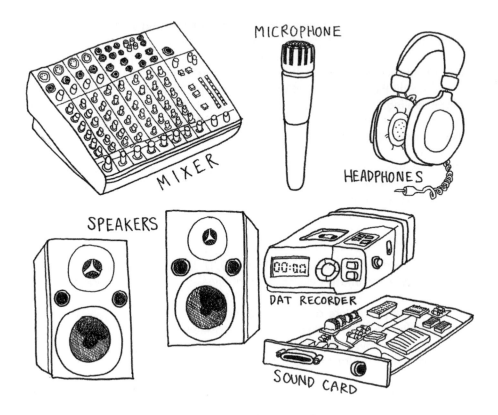

Figure 3-8 Audio recording equipment. (Illustration by Tim Miller.)

- additional microphones, cables, and stands
- MIDI instruments (for example, a keyboard or sampler)

You may need to record sound away from your computer. If this is the case, you will need a portable recorder and microphone, as well as a way to get the audio into the computer. You can record onto cassette tape, digital audio tape (DAT), or a digital voice recorder. (See Figure 3-8.)

- cassette deck, or
- DAT deck, or
- digital voice recorder with a USB or FireWire port for connecting to the computer
- microphone and cable for cassette or DAT deck
- headphones for cassette or DAT deck
- audio cables to connect the cassette or DAT deck to the audio inputs on your sound card

setting up your own studio

When you are ready to begin setting up your studio, try to answer these questions first.

1. What are my goals? Answering this question honestly will help you to clarify and prior-itize your purchases. If all you want to do is draw animation directly in the computer, don't rush out to buy a DV camera, but do consider buying a drawing tablet.
2. What software do I want to run? This question leads directly from the previous one. Buy only the software you need. In other words, don't change your work to fit the software capabilities; instead, pick software that most closely matches the way you already like to work. And once you pick the software, don't feel compelled to learn everything there is to know about the application. Find what it can do for you and use it for that; it's OK to leave other features untouched.
3. Are there hidden costs? Don't overlook hardware changes you have to make in order to use certain equipment. For example, if you do plan to buy a camcorder but don't already have FireWire ports in your computer, you will need to include the cost of purchasing a FireWire card for your system.
4. Do I need a Mac or a PC? In most cases, the type of computer you choose will depend on what you are most comfortable with. Beyond this, you will know which computer you need by asking yourself what you want to do with it. Do you want to run a particular software application? In that case, read about the software to find out what hard-ware configuration it requires. Again, all of the software used in this book runs on either computer.
5. How much do I want to spend? If the costs are adding up to an amount beyond your budget, look for alternative ways of achieving your goals. Start by looking at the hard-ware and software you already have. Is it possible to make animation with the tools at hand? If not, do a little research on the Web and look for free or cheap alternatives to the mainstream programs mentioned in this chapter (see Chapter 9).

Digital tools are transforming the animator's studio and methods of production. Although not every aspect of this change is for the better, much of it is. In particular, faster feedback, more flexible working methods, and greater independence offer the independent animator advantages over film production techniques. And because many of us already own or plan to own a computer, digital tools are putting the potential for animation production in the hands of many more people than ever before.

> I came to animation through the film program in art school, and I loved it immediately. I was attracted to the intimacy and simplicity of working alone and by the limitless potential of the medium. I am delighted and puzzled and infuriated by the enormously complex and often tedious process of creating such tiny works.
>
> Amanda Forbis

chapter 4

money and time

> *The most common questions I am asked: "So do you do every single drawing or does the computer do all that for you?" and, "How do you not go nuts?"*
> Mike Overbeck

Other than your creative impulses and ideas, your most important resources are money and time. You will need money to pay for any computer hardware, software, equipment, supplies, or services necessary to make your animation, and you will need enough time to make the animation.

Although the bad news is that you will always want more money and time than you have, the good news is that you can make compelling animation on almost any budget and with even small amounts of time, because animation is a fairly predictable and controllable process. The key to success is in knowing ahead of time how much money and time you can afford to spend on a project so that you can make realistic plans. In this chapter, I will discuss the main categories of animation costs, present some specific purchasing options, and explain how to calculate the time it will take to make animation. With this information, you will be better able to design your animation to fit your resources.

how much does it cost?

There are five main budget categories to consider when estimating the cost of a project. The first and most important is the computer, second is other computer hardware and related equipment, third is the cost of software, fourth is the cost of supplies, and last is any outside services your project requires (usually related to distribution). Much of the following information is based on products, services, and prices available at the time this book was written. Because the hardware and software tools are evolving, specific items and prices will become outdated. But the basic concepts and categories will remain relevant, and you can use the technical details and prices listed here as a guide to help you understand the functions and relative costs of equipment. When you are ready to make a purchase, do some research (by word of mouth, on the Web, in books and magazines, and by personal testing) to decide what is best for you and to get the best price.

computer costs

The two basic choices in computers are the Mac or a PC. The choice between the two should be made according to what software you want to use and which system you feel most comfortable with. It can be helpful to look at a comparison of the main features of the two platforms.

Macintosh	PC
● made only by Apple Computer	● made by many manufacturers
● runs on one operating system	● runs on several operating systems
● works with all major software applications	● works with all major software applications
● only a few configurations available	● wide variety of configurations available
● cannot custom build own system	● can custom build own system

Macintosh	PC
• fixed configurations and fixed prices do not vary from vendor to vendor	• prices vary depending on configuration, and on how much building you do yourself
• simple to set up; usually just plug in and go	• setup can be complex; may require assistance
• by default, well designed for graphics, audio, and video work	• you or a reseller must design a configuration for graphics, audio, and video work

When buying a Macintosh, the choices are fairly simple. You will want the newest, most powerful machine you can afford. All Macs will come with some degree of audio/video/DVD capability, but more money will buy more power and more features. The only reason to choose a laptop is to work on the road; otherwise a desktop model is the better choice because it offers more computer for your money and has more space for expansion cards. You can make animation on any Macintosh model. The iMac is the home consumer version of the Mac, ranging in price from $800 to $1,400. As of this writing (summer 2002), the cheapest iMac ($800) runs on a 500 MHz G3 processor, and includes at least 256 MB RAM, a 20 GB hard drive, a CD read-only drive, a 56 K modem, two USB ports, and two FireWire ports. It comes with the latest version of the Mac operating system, a keyboard, mouse, and a 15" monitor built in to the computer. The G4 is the professional version of the Mac; it ranges in price from $1,700 to $3,500. At this point, the top-of-the-line G4 runs on two 1 GHz G4 processors and comes with a minimum of 512 MB RAM, an 80 GB hard drive, a 56 K modem, a DVD/CD read-and-write drive, two FireWire ports, two USB ports, and an Ethernet port. It comes with the latest version of the Mac operating system, a keyboard, and a mouse. You will need to buy a monitor separately for the G4.

Buying a PC system is more complex because there are more options available. Again, I would recommend a desktop system over a laptop system. Beyond that, the basic choice is between buying a ready-made system and building your own system from parts. You can ask a dealer to put a system together for you, in which case you would rely on the dealer's expertise and parts in stock to help you design your system. A dealer also can sell you a support plan so that you have technical help if you run into trouble. Buying a system through a dealer is a good choice if you are not confident about working with computers. At this writing, one good option for a ready-made system is the Compaq Presario. The Presario price depends on how it is configured, but for about $1,300 it includes a 1.8 GHz Pentium 4 processor, 512 MB RAM, an 80 GB hard drive, a 56 K modem, a DVD read-only/CD read/write drive, USB and FireWire ports, and an Ethernet port. If you are technically confident and inclined to build your own system, you can potentially save money by putting your own computer together. But you will have to troubleshoot your system by yourself. Here is a list of the main components you might find in a PC. This list is only a guide to help you understand what goes inside a PC; it is not intended as a buying or building guide. If you are planning on building your own PC, do some research and ask questions. There are a number of resources on the Web and in books to help you with the process; one good one is www.pcmech.com.

- **Case with power supply:** This is the box that will hold all your components. Look for a mid- to full-size tower case with at least enough space for two hard drives and bays for CD, DVD, and Zip drives. A power supply rated at 300 watts or more should support all the components you'll need for video and audio production. An example is the ATX mid-size tower case, which sells for about $100.
- **Processor (also called the CPU):** This is the brain of the computer, which crunches the numbers involved in computing tasks. One of the fastest and most expensive processors right now is the Pentium 4 running at 2 GHz, which currently sells for about $600.
- **Motherboard and chipset:** The motherboard holds the processor and all the main computing circuits related to the processor. The motherboard includes the chipset, which is sometimes called the heart of the computer because it transmits data to and from the processor. One choice for the Pentium 4 is the ASUS P4T P4 board with the i850 chipset. This board sells for about $200.
- **Cooler and fan:** Processors heat up as they work, so you will need a cooler (also called a heat sink) and a fan. The best coolers are made from copper; an example is the Thermalright SK6 cooler, with a fan, for about $35.
- **AGP graphics card:** This is a card containing a graphics processor (GPU) that is dedicated to displaying images on your monitor. As of this writing, two examples are the GeForce3 TI/450 for about $200, and the Matrox G450 eTV for about $250.
- **Hard drive:** This is the internal disc that stores your operating system, software applications, and project files. Size is important, but so is speed and reliability. An example is the Maxtor DiamondMax D540X 120GB drive for about $250.
- **RAM:** This is the amount of memory your computer has; the more memory, the more data the computer can work with at any one time. You will have to match the types of RAM chips you buy to the motherboard you own. A 32MB upgrade will cost about $50.
- **Sound card:** This is the card that processes sound; it also should include connectors for different types of audio cables. An example is the Audiophile 24/96 for about $200. For more serious sound work, an example is Digidesign's Digi-001 for about $1,000.
- **IEEE 1394 and USB cards:** IEEE 1394 (another name for FireWire) is the high-speed data connection necessary for working with digital video. USB (universal serial bus) is the standard for connecting most peripherals to the computer. Adaptec sells the USB/1394 Combo Card Kit for $130, which includes both USB and IEEE 1394 ports.
- **CD/DVD-RW drive:** As of this writing, there are not many internal DVD drives for the PC, although this will likely change soon. In the meantime, an example of an external CD/DVD drive is the Boa DVD-RW CDRW FireWire (it comes with an IEEE 1394 card) for about $500.
- **10/100 Ethernet card:** This card is for networking with other computers and connecting to the Internet through high-speed DSL or cable. An example is a 3Com Etherlink card for about $50.
- **56K modem:** This is for connecting to the Internet through a standard phone line. An internal 56K modem from 3Com Corporation will cost about $90.
- **Keyboard and mouse:** A keyboard and mouse from Logitech Inc. costs about $90.
- **Operating system:** The latest operating system for the PC, Windows XP, costs about $200.

hardware and equipment costs

- **Monitor (also called the display):** This can either be an older style CRT (cathode ray tube) or a newer LCD (liquid crystal display). LCDs are likely to replace CRTs because they are quieter, cooler, sharper, and take up less space, but LCDs are still more expensive than CRTs. Whichever type of monitor you choose, you will want one that measures at least 17" diagonally so that you have a large enough visual area to work in. An example of a 17" CRT is NEC's Multisync FE750 for about $250. An example of a 17" LCD is NEC's 1700-V for about $700.
- **Drawing tablet:** This is a flat plastic device and software for drawing directly into the computer. Along with a special digitizing pen, the tablet is designed to simulate the feel and control of drawing and painting with traditional media. Although it doesn't come close to the experience of a real pencil or brush, a drawing tablet is an improvement over a mouse. Wacom makes the Intuos series of tablets, which come in several sizes, ranging from 4" × 5" (about $200) to 12" × 18" (about $750). Bigger is not necessarily better; try different sizes to decide which feels the most comfortable. Drawing tablets that double as LCD screens are beginning to appear as well. The great advantage of these devices is that you draw right on the image you are creating. This makes the experience a bit closer to drawing on paper.
- **Scanner:** Look for a scanner with high resolution and color depth and good optics. Resolution is measured in dots per inch (dpi) horizontally and vertically. Color bit depth is a measure of the scanner's sensitivity to color and brightness variation in the scanned image. Epson makes a good 8.5" × 11" scanner for under $200.
- **Printer:** The two basic choices for printers are laser and inkjet. In general, laser printers are best for text or bulk printing, and inkjet printers are best for small print quantities and for making photo-quality prints. Inkjet printers are inexpensive, but the ink cartridges are pricey. A simple Epson inkjet printer will cost about $100, and the ink cartridges will cost about $30 each.
- **FireWire drive:** An extra hard drive can be very useful if you run out of room on your internal hard drive, or if you want to store a project on its own drive for safety or easy transport to another computer. A FireWire connection is important for speed. Typical external FireWire hard drives cost about $250 for about 60 GB; the same money will buy more storage space in the future.
- **CD/DVD-RW drive:** If your computer does not have a CD or DVD R/W (read/write) drive built in, you will eventually want one for storing and distributing your work. The drive must have a FireWire connection to speed up data transfer. Currently, the La Cie CD/DVD-RW drive costs about $700.
- **Cables:** Don't forget to check whether or not you need to buy cables to connect your hardware to your computer. USB cables cost about $10, and FireWire cables cost about $20.
- **Mini DV camcorder:** A mini DV camcorder is used for capturing stop-motion animation and for recording finished animation to videotape. Your camcorder should have a FireWire connector as well as analog video and audio out connectors (either RCA or S-Video, depending on your video equipment). The Sony DCR-TRV27 is an example of a mid-range camcorder; it sells for about $900. In a higher price range, a good choice is Sony's VX2000 for about $2,500.

- **Tripod:** A good quality tripod will not move once it has been locked in place. A tripod is essential when shooting stop-motion animation with a camcorder. An example is the Bogen 3036 (with a tripod head) for about $300.
- **Lights:** For video, you don't need fancy lights. You can use something as simple as clip lights from the hardware store, or buy some adjustable floor and desk lamps.
- **VHS deck:** This is the familiar 1/2" video deck most of us have in our homes to watch movies on videotape. For the time being, VHS is still a good choice for distributing animation, but DVD will probably replace VHS as the standard viewing format. If you do plan to buy a VHS deck, consider looking for S-Video capability, which is a higher-quality video signal than the usual composite signal. An example is the Mitsubishi HS-U776 for about $250.
- **Sound card:** A sound card allows you to connect various sound devices to your computer. M-Audio's Audiophile 2496 ($230) comes with RCA jacks to connect analog audio devices, as well as MIDI connectors to attach keyboards or other MIDI instruments. For editing, it comes with a scaled-down version of Cakewalk. To connect a microphone to the Audiophile card, you will also need to buy a pre-amp such as the M-Audio DMP3 dual mic pre-amp ($250). Digidesign's Digi-001 Computer Recording System ($1,000) consists of a sound card and an external box (called a break-out box) with jacks for different types of audio connectors, including XLR for microphones, analog audio, and MIDI. For editing, it comes with a scaled-down version of Pro Tools.
- **Portable audio tape recorder:** For recording audio away from your computer, there are two tape recording choices: a cassette deck or a DAT deck. An example of the first choice is the Marantz PMD 222 cassette deck for about $450. An example of a DAT deck is the Tascam DA-P1, which costs about $1,400.
- **Microphone:** For best results, get a good-quality microphone with an XLR connector. A good all-around choice is the Shure SM57 for about $200. Don't forget a mic stand (for example, an Atlas stand for about $30) and XLR mic cables (about $20 each).
- **Headphones:** These are necessary for monitoring the recording process because they isolate the sound of your recording from the general sound of your environment. Buy headphones that cover your entire ear. A Grado SR60 model costs about $70, or Sony's MDR-V600 model costs about $130.
- **Speakers:** Active (or powered) speakers have on/off switches with built-in amplifiers, but passive speakers must be connected to an external amplifier. Most people will choose active speakers unless they have a sophisticated audio setup. An example of desktop style speakers is the compact Yamaha MS101 powered speakers for about $150. An example of larger, more professional speakers is the Fostex PS3.1 powered speakers with subwoofer for about $350.
- **Mixer:** This piece of audio equipment allows you to connect several audio sources to your computer's sound card, including microphones, DAT decks, and electronic instruments. A good example is the Mackie 1202VLZ for about $500.
- **Animation punch:** This tool punches animation peg holes in paper, and costs about $500. If you want to use this traditional method of registering animation drawings, you can avoid the cost of a punch by buying prepunched paper. Both the punch and prepunched paper are available from Cartoon Colour in the United States or Chromacolour in Canada.
- **Light box:** Light boxes are not necessary unless you are drawing very precise animation that requires tracing from previous drawings. Light boxes can be purchased from Cartoon

Colour or Chromacolour, or they can be made from of a piece of glass or clear plastic propped up on books.

- **Video Lunchbox Sync:** As mentioned in Chapter 3, the Lunchbox is a tool for creating video animation without the need for computer equipment. If you do purchase a Video Lunchbox (about $3,000), you will also need a video camera, a camera stand, and a video recording deck.

software costs

I am emphasizing standard applications that will run on either the Mac or the PC. The advantages of these programs are that they are functional and dependable, they are likely to be supported in the future, and there are a number of tutorial books and articles available for many of them. However, they also tend to be expensive. It is possible to find cheaper alternatives, particularly for the PC. If you are looking for cheaper alternatives, first check Chapter 9 and then do your own research by asking other people for their advice, reading trade magazines, and researching on the Web.

- **Macromedia Flash** costs about $400. This is a vector image animation program designed for making animations that will play over the Web. Flash is a great tool for drawing animation directly into the computer.
- **Adobe PhotoShop** costs about $600 if purchased separately. PhotoShop is the standard in image editing software and is well designed and full-featured. It is very useful for preparing scanned images for animation.
- **Adobe Premiere** costs about $600 if purchased separately. Premiere is an editing program for video and sound. With the Cleaner EZ plug-in, Premiere is also a very good program for preparing animation for output to disc, tape, or the Web.
- **Final Cut Pro** costs about $1,000; it runs on the Mac only. This is a more expensive and more powerful alternative to Premiere for editing and outputting video and animation to a variety of media.
- **Adobe AfterEffects** costs about $650 if purchased separately. AfterEffects is a powerful compositing tool. It works a bit like PhotoShop, but for motion sequences instead of still images. AfterEffects is very useful for creating special effects and for combining animation and video clips in various ways.
- **Adobe Illustrator** costs about $400 if purchased separately. Illustrator is a vector image drawing and editing program.
- **Adobe Digital Video Collection,** which contains PhotoShop and Premiere, as well as After-Effects and Illustrator, costs about $1,200. If you intend to buy at least two of these applications, consider buying this collection instead, as you will get all four products for the price of two.
- **Procreate Painter** costs about $400. Painter is a bitmap drawing and painting application that includes animation features as well. Painter is good at imitating the look and feel of traditional media on the computer.
- **DigiDesign ProTools Free** is a free download from the DigiDesign web site. ProTools is a sound recording and mixing application. ProTools Free is a scaled-down version of the full professional program, but it still has plenty of features for the average user. The idea behind the offer is to introduce users to the software, with the hope that they will then buy the full version. Cakewalk costs about $200. Cakewalk is another sound program,

designed specifically for recording and creating music, although it can be used for creating voice and sound effects tracks as well. If you are a musician, Cakewalk may be a better choice than ProTools.

- **Alternatives to ProTools and Cakewalk** include Steinberg's Cubase VST ($300) for both Mac and PC for 16- or 24-bit audio recording and MIDI music editing, as well as Cubase VST/32 ($550), a higher-resolution version of the same software. Bias' multitrack recording and editing software, Deck ($400) and Deck LE ($100), are for the Mac only.
- **Web design software** such as Macromedia Dreamweaver or Adobe GoLive costs about $300. These programs are web page editors for people who don't want to program in HTML. They are full-featured and relatively easy to use. A simpler, more limited web design application is Netscape Composer, which comes with Netscape Internet Browser software.
- **Discreet's Media Cleaner** is an excellent program for preparing animation, video, and audio for a variety of output options. The full program by itself costs about $600, but a streamlined version comes bundled with Premiere.
- **DVD-V authoring software** such as DVD Studio Pro for the Mac costs $1,000, and DVDit! for the PC costs $600.
- **CD burning software** such as Roxio's, Toast for the Mac, and Easy CD Creator for the PC costs about $100.
- **Making More Music** ($30) is a CD-based MIDI music composition program made by composer Morton Subotnick (my father) that runs on both PCs and Macs. It is designed to enable children (and adults) to make their own musical compositions. Making More Music can output MIDI files, which can be converted into AIFF or WAV files in the QuickTime Pro Player or similar software. Other music-making software includes Acid Pro ($400) or Acid Music ($60) for creating music from loops (on the PC only).
- **Sound editors** allow you to alter the quality of recorded audio; for example, Bias makes Peak ($350) and Peak LE ($100) for the Mac, and Syntrillium Software makes Cool Edit Pro ($400) for the PC. Sonic Foundry makes Sound Forge ($400) and Sound Forge XP ($60), also for the PC.
- **Stop Motion Pro** ($180) is a frame-by-frame video capture program dedicated to making stop-motion animation. It runs only on the PC.
- **Digicel Flipbook** is a 2D animation program that runs only on the PC. There are several versions of the software, ranging from the entry-level package ($100) to a full version ($600).
- **WinProducer2** ($100) is an inexpensive alternative to Premiere for importing and editing video and audio for output to DV or DVD. WinProducer is made by InterVideo, and runs only on a PC.

costs of supplies

- **Art supplies:** If you draw your animation directly into the computer, you won't need any art supplies. But if you create artwork outside the computer, you may need supplies such as paper, drawing and painting tools, puppet-making and set-building materials, and collage materials.
- **Animation supplies:** These are specialized materials used in traditional animation production that are not required in most cases, but may make production easier. They include

items such as punched animation bond and acetate cels, peg bars, field guides, and exposure sheets. There are two major North American suppliers, Cartoon Colour in the United States, and Chromacolour in Canada.

- **Computer supplies:** These supplies include items such as CD and DVD blanks and inkjet cartridges.
- **Audio/video supplies:** This list includes mini DV tapes, VHS tapes, cassette tapes, and DAT tapes.

costs of services

- **Internet service provider (ISP):** Most people will want an ISP to connect to the Web. AOL and Earthlink are both examples of ISPs, which provide people with access to the Web through a modem and a home phone line for about $25 a month. These companies offer additional features, including free space on their computers to build a small personal web site. For about $50 a month, you can upgrade your connection to DSL, which improves the speed of data flow over the phone line. Another high-speed connection option is to sign on with a cable TV company as your ISP. These connections cost about $50 a month in addition to the basic cable connection fees.
- **Web host:** You may want a larger, more visible web site than you can build on an ISP-provided free site. In this case, you will need a web host. A web host will provide you with as much web site space and support as you are willing to pay for. You can expect to pay about $30 a month for 300 MB of disk space (an average amount for a personal web site). See Chapter 9 for help in shopping for a web host.
- **Duplication service:** If you are going to distribute your work on CD, DVD, or tape, you may need the services of a duplication house to make copies in bulk. Prices can range from $5 to $10 per copy for quantities of around 100; this price goes down as quantities go up. These businesses can often make a transfer from one format to another (DV tape to VHS or NTSC to PAL, for example). You can expect to pay between $50 and $100 per hour for this service.
- **Transfer house and film laboratory:** If you are going to transfer your animation from a digital format to motion picture film, you will need the services of a specialized transfer house and film laboratory. The transfer cost can range from 25¢ to $1 per frame (there are 24 frames per second in film), and often there are additional film laboratory costs involved. Different businesses use different techniques. At these prices, you will want to carefully evaluate the quality of the transfer by looking at other jobs the service has done.

how long does it take?

You can spend as little as a few hours making a very short animation, or you can spend years making a long work. Much depends on your schedule. Are you lucky to get in an hour a week, or do you have a couple of days a week free? Also, different materials will require different amounts of time to animate. For example, drawing directly into the computer will usually take less time than drawing on paper because you won't need to scan artwork. The length of your project is another factor. You might start by making animations that last under a minute, experimenting with technique and subject matter as you go. As

you build confidence and knowledge, you can increase the length of your animations accordingly.

Figuring out how long it will take to make an animated project is a two-part process. The first part involves determining how many hours it takes to make the project, and the second part involves estimating the number of hours you have available per week to work on the project. To figure out how many hours it will take to make a project, first calculate the time it takes to make one image, and then estimate the total number of images you will need to make. Multiply the time it takes to make one image by the total number of images required to find out how long it will take to make the project. Divide the total number of hours it takes to make the project by the number of hours per week you have available, and you will get a realistic answer to the question.

scenario 1

"I have already made a twelve-panel storyboard. I plan to animate on paper and then scan in my artwork. I will make the soundtrack after I finish the animation." (See Chapter 6 for a discussion of storyboarding).

To estimate the length of time it will take to make this project, start by making an animatic. To do this, scan in each storyboard image and then import them into Premiere, Flash, or some other program that can play the images as a sequence. Hold each image on the screen for as long as you think the action represented by that image will last. The length of the animatic will approximate the length of the finished animation. A less precise but much faster way to estimate the project's length is to count the number of images in the storyboard and multiply them by one second; thus, a twelve-panel storyboard would approximate a 12-second animation.

Next, time yourself making a few sample pieces of artwork in the technique you are going to use (charcoal, marker, etc.), and take them through the process of scanning, cleaning up, and importing into Premiere. Divide the total time it took to do this by the number of drawings in the sequence. For example, if a sequence of ten images took one hour to finish, divide 60 minutes by ten images (6 minutes an image). Now you know the screen time of the project (12 seconds), and the time it takes to finish one image (6 minutes). Next, figure out how many images you need. At thirty frames per second in video, there will be 360 frames in 12 seconds. Let's say that you are animating on two's (two frames per image). This means you will only need 180 images instead of 360. Last, multiply the total number of images you must make (180) by the time it takes to make one image (6 minutes), and you will get an estimate of how long it will take to make the artwork. In this case, the answer is about 18 hours.

The time it takes to make the sound will depend on your sound design, but let's say that you are going to record someone playing a music track on the piano, and then you will add a few sound effects taken from a sound effects CD (see Chapter 7 for a discussion of copyright). Estimate that this type of soundtrack would take a couple of days to put together; that is, one day to record the piano and import the sound effects, another day to mix the soundtrack and add it to the animation. So all together, this project would take about 32 hours to finish.

Last, you need to estimate how much time you have each week to work on the project. For example, if you have one day a week free (about 8 hours), it would take you about four weeks to finish the animation.

scenario 2

"I will animate in Flash to a 30-second prerecorded music track."

In this case the animation will be 30 seconds long, which is 900 frames; on two's this means 450 drawings. Time yourself making a short sequence of animation in Flash and divide the time it takes to make the sequence by the number of drawings to get an average length of time for one image. For example, if it took you 36 minutes to make twelve drawings, it takes you about 3 minutes to make one image. To figure out the length of time it will take to animate the entire sequence, multiply 3 minutes times 450 drawings—about 24 hours.

scenario 3

"I have a written script. I will record myself reading it, and then animate it in Flash."

Estimate the length of the soundtrack by timing yourself reading the script at a leisurely pace. That will be close to the actual screen time. After this, follow the same steps outlined in the previous section.

scenario 4

"I don't have a soundtrack or a storyboard; I just want to start animating in Flash and see where it goes."

Time how long it takes to make one image and then ask yourself how long you would like the animation to be. Then you can estimate according to the previous examples.

Here is a summary of calculating how long it will take to make animation.

1. Estimated screen time (in seconds) multiplied by the frame rate (thirty frames per second in video, for example) = total number of frames in your project
2. Total number of frames (from step one) divided by your animation rate (two frames per image, for example) = how many images you will make, total
3. Total number of images (from step two) multiplied by the time it takes to make one image = total time you will spend animating
4. Animation time (from step three) divided by the number of hours per week you can work = how long it will take to finish the project

ways to manage money and time

With some extra thought and planning you can often make an animation for less money, in less time, and with less frustration. Project length, animation technique, and output options

will all affect the time it takes and the cost of the project. If you find that your project is too consuming, here are some tips that may help you save money or time.

- **Make a schedule.** I cannot emphasize enough the importance of regular working habits; there is no greater guarantee for success than an established work routine. The length of time of each work session is far less important than the regularity of the work sessions. For example, 15 minutes a day adhered to with discipline will far outweigh 15 hours at a stretch at irregular intervals. By setting aside a regular time in your life to work on the animation, you will benefit in a number of ways. First, you will have an idea of how long the process will take. Second, you will break down a large task into a series of smaller tasks. Third, you will be establishing a special time and place to work; this can become a recreational haven in your life. In order for a schedule to work, however, you must follow two important rules: a) be realistic (make the schedule work for your life), and b) be disciplined (stick to your schedule).
 I have worked at a number of different jobs, including full-time office work, freelance commercial work, and teaching. Each of these jobs created different obstacles and opportunities for making my own animations. For example, while working in an office full-time, I made animation mostly on the weekends and in the evenings. There wasn't much time, but it was a dependable schedule. When I worked as a freelance animator I found it almost impossible to get any personal work done during a commercial job, but this lifestyle can allow for large blocks of free time between commercial jobs. Teaching has given me the most time for my artwork. Like office work, teaching allows for evening and weekend work during the academic year, but also offers more free time during vacation periods.
- **Make a plan.** If appropriate, use a storyboard to previsualize your project. At the very least, define your goals as clearly as you can before you start. The more you plan, the less time you will spend correcting mistakes.
- **Make your project shorter.** A longer project takes longer to make, and longer animations take up more disc storage space and memory. Longer projects can also be more expensive to make. For example, to accommodate a larger file you may need to buy an extra hard drive to save your work files, or change your presentation storage format from CD to DVD. These changes add up to higher costs that may be avoided by limiting the length of the project.
- **Simplify your technique.** For example, you might choose to draw directly in Flash instead of scanning in animation drawn on paper. This would save the cost of a scanner and software such as PhotoShop and Premiere. It might also speed up your animation process.
- **Simplify your design.** Draw only what is necessary to convey your idea. For example, reduce the amount of detail in your character so that you won't have to redraw it every frame.
- **Reduce the number of characters.** Every character in your animation is a character you must draw. Ask yourself if they are all necessary.
- **Draw smaller images.** The size of your drawings will have an impact on the time it takes to draw your animation as well as the amount of computer storage space and processing speed it will take to display it. The smaller your drawings, the more quickly you will make them and the more quickly they will play back on the computer.
- **Don't scan at a higher resolution than you need.** The greater the resolution of your images, the larger your files will be, and larger files can mean higher expense. So match your

resolution to your intended presentation medium. For example, images scanned for web playback needn't be higher than 72 dpi.

- **Match your frame rate to your output option.** If you are showing your animation on video, you will animate for playback at thirty frames per second, but if the animation will play on the Web, you can only expect a frame rate of six to fifteen frames per second.
- **Use appropriate animation rates.** Most animators animate on two's instead of one's (the number of frames per image), if it doesn't compromise the quality of the animation. This cuts the number of drawings needed in half. In any case, you don't need to stick to only one frame rate in a project; you can increase the rate to one's or reduce the rate to three's or four's when it works for the animation.
- **Animate to an existing music track.** A soundtrack provides structure. With a soundtrack, you know how long the animation will last, and you can read the timings to create synchronized picture and sound. The soundtrack can be your own creation or it can come from a prerecorded source. Make sure you have the legal right to use any materials included in your animation (see Chapter 7 for a discussion of copyright issues).
- **Use layers.** To save time, animators often try to break an image into separate layers so that only the moving elements need to be changed. In handmade artwork, this can be done with sheets of acetate, glass, or paper. On the computer, this can be done with layers in programs such as PhotoShop, Flash, and AfterEffects.
- **Use software and hardware you already own.** Let's say you want to make a stop-motion animation with puppets. Instead of buying a new DV camera as a capture device, you may be able to use a still digital camera you already own.
- **Look for less-expensive software alternatives.** There are alternatives to the software listed in this chapter, and some of these alternatives are cheaper. Be sure to research the capabilities and compatibility of the software before deciding.
- **Pick an appropriate distribution format.** The computer offers a choice of output options. If you have a personal web site but don't yet own a DV camcorder, then the Web may be a cheaper distribution choice for you than videotape.
- **Design projects that are realistic for the time you have.** Remember that personal satisfaction is the goal, and much satisfaction comes from completing a project.

If I can impact someone with just one split second of my work, then the 438 work hours, 10,009 drawings, 27 pencils, and 2½ hours of sleep to get there are all worth it.

Roque Ballesteros

chapter 5

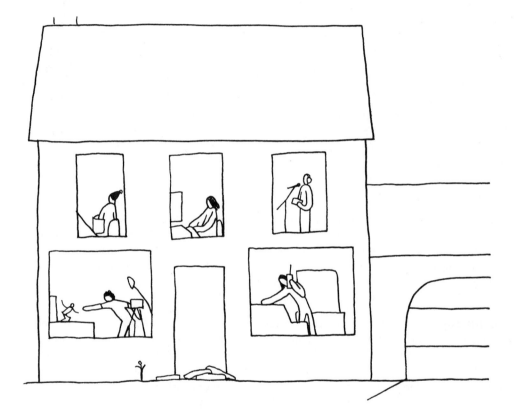

developing ideas

I work at animation like it is a sort of Rorschach adventure. I make drawings until I get one that seems to look back at me. Then I plan what should move in the scene, and what the sounds will be. I look forward to surprises and the unexpected.

Yvonne Andersen

what is an idea?

According to dictionary definitions, an idea is a notion, a thought, or a concept formed by our experiences. The word *idea* comes from the Latin stem, *ide*, meaning "to see." An idea is a mental image—an organized picture we create out of the chaos of experience. We are idea-makers by instinct, inheriting ideas from our predecessors and constructing ideas ourselves to find meaning, order, and purpose in our lives. Some of these ideas are large organizing principles for entire societies; for example, ethical monotheism is a basic religious idea that has shaped much of the course of Western history. In the political sphere, the ideas of "equality, fraternity, and liberty" developed in the French Revolution became the basis for attempts at political reorganization in the decades following 1789. Other ideas affect how we view ourselves as human beings. For example, Charles Darwin's thinking about the evolution of species changed how we see our place in nature, and Sigmund Freud altered our views on rationality with his ideas about the subconscious.

We make artwork because we are creatures of emotion as well as intellect, and our feelings and ideas are intertwined. An idea can provoke emotion; Darwin's idea of evolution caused feelings of outrage, disorientation, and fascination as people adjusted their views of themselves. Feelings can also lead us to ideas; for instance, a sense of awe has led people to form religious ideas throughout history. Artistic expression is a way to explore and communicate our feelings and our thoughts; we make art because we need to give our thoughts and feelings a form we can share with others.

The arts give physical form to ideas and feelings in particular media. A painter creates an image, a poet organizes words, a musician composes sounds, a dancer choreographs movement, a sculptor shapes an object, and a storyteller constructs a narrative. For example, Impressionism was a late nineteenth- and early twentieth-century artistic movement that developed the idea that art could reproduce sensory impressions. To this end, Monet used short, rapid brushstrokes of pure color laid side-by-side in his paintings to evoke the quality of reflected light. In his musical compositions, Debussy layered notes in lush harmonies and patterns to evoke the mood of a natural phenomenon or place. Monet and Debussy each found ways of making the ideas of Impressionism concrete in their particular art forms. Different artistic media are like different languages, each requiring its own method of expression; the idea and the medium are inseparable.

Like any art form, animation can be adapted to the expressive needs of the individual, and should not be confused with a particular style or technique. Animation is not only cartoons, or even drawings. It incorporates elements of all the visual arts (sculpture, photography, painting, etc.), as well as music, theater, dance, poetry, and storytelling. And animation is not only humor; it can be used to approach any subject in any manner. To give you a sense of the breadth of topics that can inspire an animator, here is a list of animated films and brief descriptions of their main ideas.

A Is for Autism, by Tim Webb
A glimpse into the condition of autism, with words, drawings, and music contributed by autistic children

Algorithms, by Baerbel Neubauer
Metamorphoses of color and form painted on blank film using handmade stamps and leaves, with rhythm and music

Bird Becomes Bird, by Lucy Lee
A little girl is captivated by the behavior of a bird on the cracking ice

Breakfast on the Grass, by Priit Parn
The interlocking story, like a narrative jigsaw puzzle, of four characters who end up in the famous Manet painting, with a repeated cameo appearance by "the artist," who looks suspiciously like Picasso

Feeling My Way, by Jonathan Hodgson
An account of the journey from home to work through the filter of the conscious and subconscious mind

Flying Nansen, by Igor Kovalyov
Explorer Nansen travels to the South Pole, where a woman awaits him

My Favorite Things That I Love, by Janet Perlman
A visual and musical medley of cuteness, kitsch, and nausea

Nosehair, by Bill Plympton
The eternal battle between man and his nosehair escalates into epic proportions

Roost, by Amy Kravitz
Describes, in abstract imagery, a desolate place in which new life kindles belief in God

The Devil's Book, by Steven Subotnick
A visual evocation of the book in which the Devil inscribes the names of the damned

The Monk and the Fish, by Michael Dudok de Wit
A monk finds a fish in the water reservoir of his monastery. He tries to catch it using all kinds of means and, as the film goes on, this becomes increasingly symbolic

Wormholes, by Steven Hillenburg
A fly attempts to land on a watch in Relativityland

your red notebook

An important precondition for developing your ideas is to believe that they are valuable, even when they are small. Think of your creative life as a garden. All seedlings look fragile at the beginning, but with attention, they can grow into mature and beautiful plants. So it is with ideas. An idea might seem insignificant and unpromising at first, but it may be the seed of an idea that will grow into a meaningful work of art. Practice valuing your thoughts because you may not know at the beginning whether or not you are on to something important. The best way I know to do this is to make a habit of recording your ideas, large and small. It doesn't matter how you record them or where you store them. Some people like sketchbooks, others collect images and objects, and others make written notes. Keeping a record has two

benefits: first, it helps you pay attention to your thoughts, and second, it creates a repository of ideas for later use. The writer Roald Dahl recorded his ideas in a red school exercise notebook. Whenever an idea for a story occurred to him, he scribbled it as quickly as he could into his notebook. Often his notes were just a few phrases, but from these simple beginnings developed many short stories and books (read Dahl's essay, "Lucky Break").

develop good work habits

Another important precondition for developing ideas is to develop regular work habits. Talent and inspiration are wonderful gifts, but there is no greater guarantee of success than consistency. The more frequently you practice, the more quickly you will progress. A daily schedule is best, even if it's only for a few minutes a day. If a daily schedule is too much, then try every other day. Whatever you do, do it consistently. With regular practice, the stream of your ideas will begin to flow faster and deeper.

developing ideas

The ability to develop ideas is a learnable skill. Imagine that you had to go out and search for your food in the forest. Survival would depend on becoming sensitive to your environment. You'd be hungry at first, but through trial and error you would slowly learn where to find edible plants and where to find the most abundant game. Imagine ideas as wild animals or plants; they roam through the underbrush or grow in corners of your mind. First learn how to hunt for and gather your ideas; then learn how to bring them home and work with them, turning them into products of human culture.

For clarity, I have broken down the process of developing ideas into five steps. In reality, these do not exist as separate activities; they are intertwined and overlap each other. But by isolating these steps, the process may become clearer, and this clarity can provide greater consciousness of new ideas so they can be collected and developed.

1. Observe
2. Select
3. Experiment
4. Evaluate
5. Clarify

observe

We all have mental filters that automatically discard impressions, thoughts, and feelings we deem unimportant or undesirable. These filters become so natural that we edit our thoughts and impressions before we even become aware of them. An important step in developing ideas is to become more fully aware of our experiences. An experience is a combination of the impressions we receive and our personal responses to those impressions. We receive impressions through our senses of sight, hearing, touch, smell, and taste, as well as other senses less commonly mentioned, such as the kinesthetic sense we have of our body. Our responses to these impressions include physical action, emotion, thought, memory, and

fantasy. Ideas arise from the interplay between our impressions and responses. For example, Marcel Proust developed the idea for his book *Remembrance of Things Past*, in part from memories of his childhood, which were evoked by the smell of baking cookies. Leonardo Da Vinci developed ideas for the composition of his frescoes by looking at the cracks in the plaster walls on which he painted. And Beethoven's *Pastoral Symphony* developed out of his love of nature and long walks through the countryside. The sources for our ideas are abundant; our first task is simply to observe them.

But observing this way is not always natural; it may take practice. Here is an exercise. Close your eyes and listen to all the sounds you hear. At first, try to hear your environment as a texture rather than as a list of recognizable sounds. Listen without focus, as if the sounds of your environment were an ocean wave washing over you. Then isolate a particular sound. Keep your focus on the quality of the sound itself, not the source of or reason for the sound. Describe the sound. Is it loud or quiet? Is it rough or smooth? Does it start and stop, or is it continuous? Try to describe the sound in as much detail as possible. One day you might focus on sound in this exercise, another day on smell, sight, or touch. Here is a different sort of observational exercise. When you read a book, take time to notice the quality of the paper, the style of the font, the amount of space between letters, words, and lines. Smell the book; feel the texture and weight of the book. Read the text out loud to hear and feel the words. Examine the construction of a phrase, a sentence, a paragraph. Exercises like these will help you remove the filters from your senses and sharpen your observational abilities.

select

Next, select what is important from the wash of impressions you receive. Selecting is recognizing what is important to you. If it's not obvious, practice observing your own physical reactions to impressions. How do you respond to a sound you hear, a color you see, a word you read, or a thought you have? Do your eyes widen? Does your pulse quicken? Do you get butterflies in your stomach? Do you feel a sense of peace or harmony? Are you excited? Revolted? Intrigued? These are all clues that you might be near something important. Your responses are based on an interplay of physical, mental, and emotional factors too complex to unravel, so you must trust your instincts. At this stage, you may not know why something elicits a response from you, but what matters is that you acknowledge its importance. Be honest. The more significant something is to you, the more important it may be to others as well. Animator and sculptor Len Lye once said, "Art is a question of you being me." I believe he meant that as individual beings, we can ultimately make art only for ourselves. But in doing so, we are really making art for others, too, because we all share similar feelings, hopes, and fears.

an artist is not a surgeon

To make artwork that is intriguing to you and to others you must take chances. This might mean exploring an idea you are afraid of. You might be afraid because you think others will find the concept stupid or ugly, or because you don't think you can accomplish what you have in mind. The worst that can happen is that you are right. But if the worst happens, what harm has been done? An artist is not a surgeon; if an artist fails no lives are lost—no one may even notice the failure. The best that can happen is that you succeed in

creating a work of art that speaks directly to others. In either case, the process of trying to communicate is what is ultimately important. Taking the risk in itself will help you to develop your ideas and deepen your creative life.

experiment

Experimenting involves playing with an idea to see where it might lead. At this stage, the play is not directed toward a specific end; rather, the goal is to brainstorm about all the different directions an idea might go. It is important to suspend critical judgment so that play can happen without restriction. The purpose of experimentation is to create choices, not to make choices. Artists experiment with ideas by playing with the elements of their medium. In animation these elements include image, sound, movement, character, and narrative.

image

Image consists of two things—the physical materials used, and the way the materials are manipulated. Anything can be animated—torn pieces of newspaper, pencil drawings, grass clippings, underlit beads, dry point etchings, oil paintings, ceramic sculptures, assemblages of rusty machine parts, and clay puppets. And there are an infinite number of ways to manipulate any specific material. If you are drawing on paper, for example, consider some of the different ways a human figure can be represented: as a stick figure, as a geometric abstraction, as an outline, as light and shadow, as areas of color, as a caricature, or as a realistic portrait. Look at paintings and drawings in books, galleries, and museums for inspiration.

sound

Sound for animation includes the three broad categories of music, effects, and voice. Musical instruments can be used to create all sorts of sounds. For example, you can play a particular piece of music on a piano, or you can try creating sounds by hitting the keys, the pedals, or the sounding board, or by opening the piano and striking the strings directly.

Effects are recordings of incidental sounds in the environment such as ocean waves crashing on the beach, city traffic, a door slam, footsteps, or fire crackling. These sounds can be used individually or they can be layered on top of each other to create new sounds. Sometimes the creation of the most realistic sound effect has nothing to do with the image that sound represents. For example, crumpled newspaper can be used to create the sound of fire.

Voice can include narration, monologue, dialogue, song, or abstract vocalization. Voice tracks can be like double-edged swords, however. On the one hand, when spoken words carry much of the communication in a project the animator can be quite free in the animation. On the other hand, depending on language may divert attention from the visuals and limit your audience.

movement

Experimenting with movement can generate ideas. Observe the walks of different animals. A sparrow hops around with a staccato rhythm. A snake slithers along a sinuous path. A

tortoise plods slowly and tentatively. Or think about the different ways rain can fall: a slow and gentle drizzle that floats in the air, a drenching downpour that falls straight down, or a gale that blows rain in all directions. Consider the different ways a character might sit down in a chair. A tired person might collapse in a heap, an anxious person might perch and fidget at the edge of the seat, and a relaxed person might drape himself over the chair. Thinking about qualities of movement can lead to ideas for characters, stories, or pure choreography.

character

Inventing characters can generate ideas for an animation. Characters come from many sources—from a person you have seen, from an actor's voice, from a literary character, or from a news report. Very often, one character will suggest other characters, a scene, or even an entire story.

narrative

The animator can experiment with narrative structure to get ideas for a project. Ideas for narratives can come from literary sources such as folktales, fairy tales, short stories, novels, and poems. Narrative ideas can also come from nonfictional sources such as newspaper articles, family histories, scientific reports, historical events, and conversations. Other sources include religious and mythic writings, dreams, and chance combinations.

When you are feeling stuck creatively, chance techniques are particularly useful. In her classes at Rhode Island School of Design, my wife, Amy Kravitz, sometimes uses the following exercise to get her students thinking about narrative. She brings in a stack of photographic postcards she has collected over the years, and she randomly hands out three picture postcards to each student. The students must put the three cards down in the order they receive them and imagine a story based on the random images they have received. The first image they get is the beginning of the story, the second image is the middle of the story, and the third image is the end of the story. The students might tell the story out loud, write down the story, or draw a storyboard. However you find your story, you will need to shape it with a beginning, a middle, and an end. Whether or not you are telling a story, your animation will contain these three basic structural elements. This is because animation is a linear art form; it has a definite start (the first frame) and a definite end (the last frame). The beginning is how the animation introduces itself, the middle is what happens after the introduction, and the ending is how the animation says good-bye.

evaluate

Next comes the process of making choices based on the results of experimental play. Evaluation means being critical about what to keep and what to discard, what to pursue and what to abandon. It is a process that is both objective and subjective at the same time. Evaluation is objective because it requires you to think honestly about the work you have done. You look at the drawings, collages, sounds, storyboards, and other products you have made and decide what your main ideas are. Then you must judge which of your experiments support these ideas and which are extraneous. But at the same time, evaluation is a subjective process. In addition to your analytical faculties, you must also trust your instincts. For

example, it might be that your brain says a particular image serves no useful function, but your gut feeling is that it is meaningful in some way. In this case, you must try to discover what your subjective reaction is trying to tell you. Spend some time experimenting further with that image to see if you can tease out why it feels meaningful. Maybe another idea that you haven't considered is buried in the image. It could be that this idea is the true center of your project, or perhaps it is an important idea that will get its own project later.

clarify

The last stage in developing ideas is clarifying the results of your evaluation. Make your ideas clear. One way to do this is to write down in one or two sentences the basic idea of the project, for example, "a series of visual gags based on tying shoelaces," or "a journey on foot from Chicago to New York," or "the story of two friends who become lovers." Sometimes thinking up a title can help clarify your idea. Another way is to describe your idea to someone else as succinctly as possible to find out if he or she understands. It may be helpful to make a storyboard; this will force you to visualize the animation in detail (see Chapter 6 for a discussion of storyboarding).

a case study

As I write this chapter, I am working on my own animated project. The working title of the film is *The Angel*. I would like to share it with you as a personal example of idea development.

My initial inspiration came from reading history books. In a history of modern Europe I came across a description of the Thirty Years' War. This war was the last and largest of the religious conflicts that resulted from the Protestant Reformation and the Catholic Counter-Reformation. I was struck by the devastation that thirty years of warfare visited on Central Europe (estimates are that the population of the German lands fell by over one third), as well as by the confusing mixture of spiritual and mundane motivations that fueled the conflict (armies were generally fighting either for Catholicism or Protestantism, but they also changed alliances for purely political reasons). I checked out more books about the Thirty Years' War and the Protestant Reformation from the library and read about the period in more detail.

One strange and ironic episode in 1618 in particular captured my imagination. This event, referred to as the Defenestration of Prague, sparked the conflict. A group of Bohemian nobles—protesting Imperial threats to their religious liberty—threw two Catholic Imperial ministers and their secretary out of a castle window in Prague. The men fell, seemingly, to their deaths. But in fact they landed in a dung heap, got up, and ran away.

After reading several histories, I began researching other literary sources. The two most inspiring were *Simplicissimus* and the Grimms' fairy tales. *Simplicissimus* is a comic novel written by Hans Jakob Christoph von Grimmelshausen about a simple peasant boy who

Figure 5-1 Sketches of visual references.

becomes entangled in the confusing and sometimes absurd conflicts of the Thirty Years' War. Grimmelshausen lived through the war and wrote the book as a response to his experiences. The Grimms' fairy tales are dark and violent, set in Germanic lands, and seem to take place in a timeless, premodern era. In particular, I was attracted to the story "Bearskin," which is about a soldier returning home from war who meets the Devil in the woods and is transformed into a beast. In addition to researching literary sources, I looked at visual art and sketched the houses, costumes, and objects from Europe in the seventeenth century (Figure 5-1). I looked at etchings of the Thirty Years' War by Jacques Callot, and at paintings made by a variety of seventeenth-century artists. I also looked at photographs of the landscape of Central Europe and Prague. In addition to researching history, stories, and images, I also listened to Baroque music.

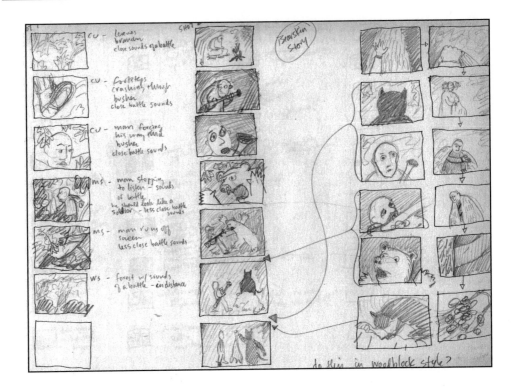

Figure 5-2 Initial story ideas.

After researching stories, images, and music, I began thinking about a structure for the film. I was interested in several aspects of the Thirty Years' War: the historical events (especially the Defenestration of Prague), the power of religious belief, the transition from medieval to modern Europe, the devastation of the Germanic lands, the art and music of the seventeenth century, and the landscapes of Central Europe. Because I didn't yet have a clear idea what direction the film would take, my first attempts at a structure were like stabs in the dark. I began by sketching storyboards of the Defenestration of Prague and the "Bearskin" tale (Figure 5-2). But these boards were too specific; they excluded too much that I was interested in. As an alternative, I imagined a father telling stories to his children at night. This permitted a variety of different stories to occupy the same film. But the father and his children were only vehicles for the stories; they had no intrinsic meaning in themselves.

I wanted more inspiration and ideas, so I looked at artwork by three of my favorite artists: Pablo Picasso, Cy Twombly, and Rembrandt Van Rijn. Looking at Picasso's artwork often sparks visual ideas because his art (aside from being beautiful) is inventive and playful with visual form. Twombly's paintings and drawings are so deeply personal (down to the individual marks and brush strokes) that they help me reconnect with my own personal mark-making, and his paintings often include literary or mythological references based on ancient Roman history (which I thought might be related to my interest in European history). Rembrandt's paintings, drawings, and etchings are inspirational for their beauty as well as

Figure 5-3 Initial sketch of a narrative landscape.

for their emotional and psychological depth. I came across one etching called *The Three Trees* that particularly caught my attention. At first glance, this etching is of three trees in a Dutch landscape, and on this level alone the image is successful—beautifully composed and rendered. But on closer inspection, I saw that the landscape included people as well—small and almost invisible in the heavy cross-hatching of the print. These people are involved in various activities and are oblivious of each other; some are fishing, some are traveling, one is looking at the sky, and there are even two lovers deep in the shadows beneath a tree. This print was a revelation to me. It made me realize that landscape itself could be the container for all the related ideas I wanted to explore. I played with this idea by sketching a number of narratives and characters in a single landscape (Figure 5-3).

Even though I knew that landscape would be important, I didn't yet know exactly how I would create it. I began by taking black-and-white photographs of the bare trees in the woods near my home. The photographs became more interesting after I cropped the images down into more concentrated compositions. I then mounted them all on punched paper and organized them into an animated sequence. After this, I felt inspired to draw again. In pen and ink, I drew a series of small landscapes. Drawing small enabled me to work quickly and magnified the idiosyncrasies of my handmade marks. As I drew these landscapes I found that some of my images were approaching abstraction, so I made several more purely abstract sequences of ink drawings that I could later cut into the landscape animation. I

Figure 5-4 Animating landscapes.

drew some of these abstractions with pen and ink. In others, I tried painting with rags dipped in ink; these were exciting because they included marks I made intentionally as well as accidental marks made by threads hanging off the rags. These rag drawings led me to experiment with making larger rag paintings of landscapes in color, keeping my palette limited to browns, greens, blues, and grays. I made several animated sequences of landscapes as well as some sequences of clouds, rain, and sky (Figure 5-4).

At this point I needed to step back from making animation and think about where all this was going. In an effort to become more objective, I showed my wife what I had made and asked her for her thoughts. She had two suggestions. First, she felt I needed to begin putting characters in the landscapes; and second, she told me that she pictured a chorus of angels in the sky looking down at the events on the earth. I imagined people, farms, towns, war, animals, insects, and mythical or religious beings. With the thought of a chorus of angels in mind, I returned to my table and began making more sequences of rag paintings. What emerged was not a chorus, but instead a sequence of two angels wrestling with each other. As a result of these paintings, I began thinking about the heavens as another landscape containing a heavenly conflict that paralleled the earthly conflict below. I also realized that if one angel defeated the other and threw it out of heaven, the fall from heaven to earth

Figure 5-5 A section of the working storyboard.

could parallel the fall of the Catholic ministers in the Defenestration of Prague. And just as the split in the religious world could not be closed, so the angel would not be able to return to heaven. From this point, the structure of the film fell into place. The fallen angel would try to return to heaven by traveling to the highest point in the landscape. I imagined the angel standing at the top of a mountain, looking back up at heaven, seeing other angels fighting each other through breaks in the clouds. I felt that the angel wouldn't care about the events on earth, but only about the events in heaven.

As it currently stands, my film begins with two angels wrestling in heaven; the defeated angel is thrown out of heaven and falls to earth near Prague in Bohemia. After rising from the dirt, the angel begins moving toward the highest visible point—the top of a nearby mountain. As we travel with the angel through the landscape, we see various things at vastly different scales: tiny insects, birds and other wild animals, storms, burning farms, bands of pillaging soldiers, and battles. The scenes of war remain in the distance or pass by without amplification. Moths, crows, leaves, rain, and people are all just so many aspects of the landscape. They are peripheral to the main action, which is the angel's journey to the top of the mountain, as close to heaven as it can get. The film ends with the angel at the top of the mountain. The last shot is of the sky, roiling with storm clouds and shafts of light, glimpses of other wrestling angels visible between breaks in the clouds.

I am working with a mixture of materials, including gouache, watercolor, acrylic paintings, pen and ink drawings, black-and-white photographs, and collages of natural objects (leaves, feathers, etc.). I am scanning the artwork into the computer at film resolution, and later plan to output to 35 mm film (Figure 5-5).

The idea for this film first developed from reading history for pleasure. This was the *observational* stage that led to an interest in learning more about the Protestant Reformation and the Thirty Years' War. In particular, I was attracted by the event that sparked the conflict, the Defenestration of Prague, which became my *selected* focus for exploration. Next, I *experimented* with various ways of constructing a narrative (folktales, bedtime stories, the literal historical event) and visually depicting the action (photographs, ink drawings, paintings, abstraction and representational imagery). I *evaluated* my experiment—for example, by judging that most of my narratives were too limiting; only the idea of placing the narrative elements in a landscape was inclusive enough. And finally, I *clarified* my idea by introducing the character of the angel and its journey through the landscape as the thread that would tie the film together.

> With animation I have the ability to express what I want in a direct, unfiltered way. It's like combining the immediacy of painting with the fluidity of music.
> Dan Sousa

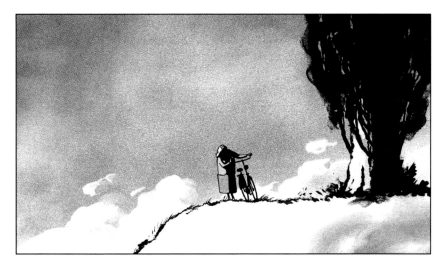

Plate 1: "Father and Daughter"—Michael Dudok de Wit

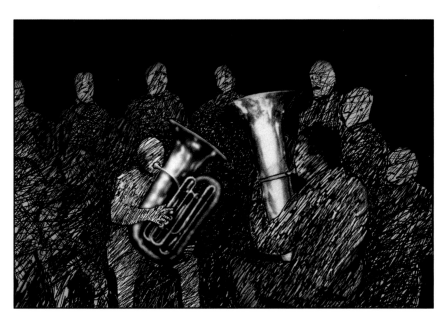

Plate 2: "Play Off"—Yvonne Andersen

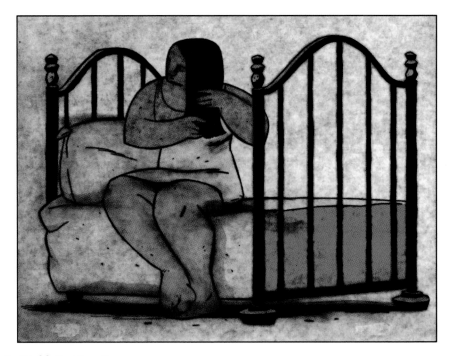

Plate 3: "Fable"—Dan Sousa

Plate 4: "Warnival"—Roque Ballesteros

Plate 5: "Teasing" — Tim Miller

Plate 6: "Tongues and Taxis" — Mike Overbeck

Plate 7: "Roost"—Amy Kravitz

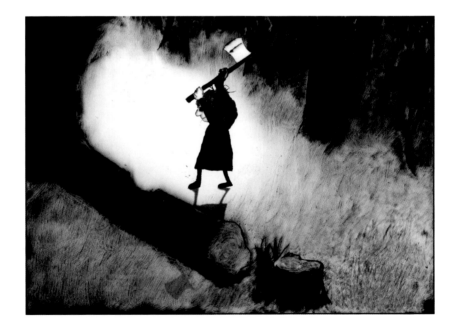

Plate 8: "Hairyman"—Steven Subotnick

Plate 9: "Passage"—Baerbel Neubauer

Plate 10: "Film Loop"—George Griffin

Plate 11: "Met State"—Bryan Papciak

Plate 12: "Oral Hygiene"—Dave Fain

Plate 13: "When the Day Breaks"—Wendy Tilby and Amanda Forbis

Plate 14: "Crime and Punishment"—Piotr Dumala

Plate 15: "Singing Sticks"—Christine Panushka

Plate 16: "Faith and Patience"—Sheila Sofian

chapter 6

working methods

Images and sound/music are my language, and animation is a beautiful medium to play and experiment with both. At twenty-four frames per second, it demands lots of work, but the results make it well worth doing.

Baerbel Neubauer

three basic principles of animation

Animation is the frame-by-frame control of images in time. The three most fundamental frame-by-frame principles are image change, registration, and timing. An image on the screen can change its size, its shape, or its surface qualities (color, texture, etc.). The illusion of movement is created by changing the relative position (or registration) of a sequence of images on the screen. And how an image moves (its timing) determines the feeling conveyed by the image's motion.

image change

Image change is the difference between any two images in a sequence of animation. In the most abstract terms, these changes can be in size, shape, or surface (for example, color, pattern, texture). Let's say that we are going to animate a collection of blocks of different sizes and shapes, and painted with different patterns. How the blocks are organized in time will determine the quality of their animation. For example, if we arrange them by size from smallest block to largest block, our animation will seem to show a block growing larger. On the other hand, if we arrange them by shape, starting with a tall rectangular block, progressing to a square block, and finally to a horizontal rectangular block, we will create the illusion of a block collapsing. Or imagine a single block with squares painted on it sitting in the middle of the screen. If we exchange it for a block with circles on it, and then a block with diamonds on it, we will create an animation of a block with a flashing surface (Figure 6-1).

registration points

A registration point is an imaginary point that follows the main path of action in a character or object. For example, the registration point of a pinwheel would be the center of the wheel. If you lined up all the images of the pinwheel so that their centers were in the middle of the screen, the pinwheel would spin in one place. On the other hand, if in each successive image you moved the center along a straight line from right to left, the animation would show the pinwheel moving across the screen as it spun. Another example might be a swinging pendulum. The pendulum consists of a weight at the end of a rope, and the rope is attached to a hook in the ceiling. In this case, the registration point is the hook— the fixed point from which all other movement follows.

This idea can be applied to human movement as well. A child turning cartwheels is similar to a pinwheel, and a child on a swing is similar to a pendulum. Complex movements might require using more than one registration point. The primary registration point follows the primary line of action, and secondary points follow secondary lines of action. A human

Figure 6-1 Changes in size, shape, or surface. (Illustration by Tim Miller.)

walking is an example of a complex movement; in this case, the animator might pick the center of the pelvis as the main registration point. Secondary registration points might be a knee joint for the bending of the leg and an ankle joint for the bending of the foot (Figure 6-2).

timing

Timing adds feeling to a movement. Imagine a tree falling in the forest. With proper timing, the tree's fall can convey a sense of the resistance of cracking wood, the tree's size and weight, and a feeling of the impact as it crashes to the ground. The event can be separated into a number of movements. First, there is the beginning of the action as the tree slowly begins to topple, then there is the middle part of the action as the tree falls more quickly, and finally the end of the action as the tree hits the ground. There are two ways to control timing. One is in the drawings themselves (using both image change and registration), and the other is in the number of frames each drawing is held on the screen (Figure

Figure 6-2 Registration points control position. (Illustration by Tim Miller.)

6-3). For example, we can slow down the speed of the tree's fall by making more draw-
ings of the movement, or by holding a drawing on the screen for more frames. In general,
try to control timing through the drawings themselves, using changes in frame rates as a
way to fine tune your timing.

the importance of animation techniques

Materials are expressive. Just as some painters love watercolors and others love oils, some
animators love animating drawings and others love animating clay. Anything can be
animated: drawings, puppets, cutouts, objects, and clay are only a few examples. The
choice of a technique is a personal one, based on an affinity for materials. For example,
Alexandre Alexieff worked as an engraver of book illustrations. When he came to anima-
tion, he invented the pinscreen, which simulated the look of his engravings. The following
discussion presents some broad categories of animation techniques. These categories are

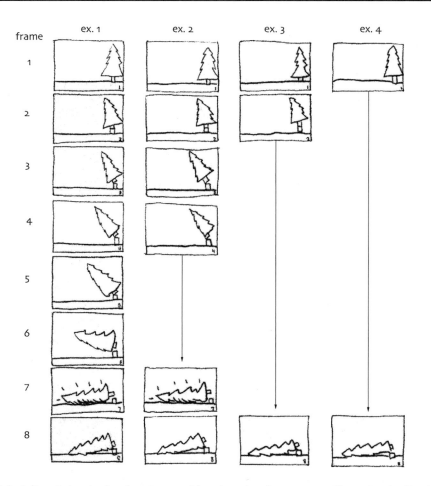

Figure 6-3 Adjust timing in the drawings and by changing frame rates. (Illustration by Tim Miller.)

not a definitive list; they are meant to start your thinking about materials. Play with materials. Explore the potential inherent in them to find techniques that excite you and spark your imagination.

objects

Objects can be animated by replacing one for another, or by moving them frame-by-frame across the screen. Replacement animation requires finding a group of objects that have some feature in common. For example, a group of seashells can be animated according to size or shape. Replacing a small seashell with progressively larger shells of the same shape will create the illusion that the shell is growing. Alternatively, you could take a single seashell and animate it by moving it incrementally across the bed of a scanner or under a DV camera. In this case, the animation creates the illusion that the shell is moving across the screen. Any objects can be used with this technique—beads, stones, trash, cloth, or just

Figure 6-4 Three examples of cutouts: a solid shape, loose parts, and hinged. (Illustration by Tim Miller.)

about anything else. Because of their physical presence, objects retain their identity as objects, and the animator may choose objects that suggest the idea of the animation. For example, in his film *Dimensions of Dialog*, Jan Svankmajer used fruits, vegetables, and other foods to create a surrealistic animation of two characters alternately eating and regurgitating each other. In this case, the presentation of a conversation as a form of cannibalism was reinforced by actually creating the characters out of food.

cutouts

Cutouts are a subset of object animation that use pieces of flat material to create animation. The simplest cutout is a single shape without any moving parts. An example of this might be a collaged character cut out and glued together from newspapers or magazines. You could move this type of cutout across the screen as a solid shape. An alternative that allows for more complex movement is made from separate shapes. For example, you can create a character out of various body parts (arms, legs, head) and then move these individually on a scanner bed one frame at a time. These body parts could be separate, loose pieces, or they could be connected to each other with thread, wire, or some other method to create a hinged cutout (Figure 6-4). The cutouts could be created from almost any flat material, including paper, cardboard, plastic, cloth, wood, metal, and they can be painted, collaged, glued, or sewed together. In Yuri Norstein's films, characters are made from pieces of clear acetate cel (an example is *Hedgehog in the Fog*). The pieces of cel are treated in various ways—painted, for example, or scratched to create a texture. The semitransparent cutout pieces create a sense of depth when they are layered on top of each other. Cutouts can also be used without creating characters. In *Frank Film*, Frank Mouris animated thousands of images of objects (food, appliances, cars, furniture, etc.) that he cut out of magazines.

puppets

Puppets are moveable objects that can stand up on their own. They may be molded from clay, or they may be constructed from materials such as wire and wood (Figure 6-5). A

Figure 6-5 Three examples of puppet construction: clay, wire, and armature. (Illustration by Tim Miller.)

popular example of clay puppets is the Wallace and Gromit characters in films by Nick Park and Aardman Animation Studio. Another choice is to make a puppet from aluminum wire. This wire (called armature wire) comes in a variety of thicknesses, and the wire skeleton can be covered in cloth, foam, paper, or clay to "dress" the puppet. The most durable type of puppet construction uses jointed armatures. These are hinged skeletons that can be used over and over again.

However you make your puppet, you will need some way to make the puppet stand up. You can depend on gravity, using the weight and balance of the puppet to keep it upright. Other options depend on fixing the puppet's feet to the floor. One of the simplest methods is to attach pins to the bottom of the puppet's feet and stick them into a foam core or Styrofoam floor (see Chapter 7 for an example). Other methods include screwing bolts into the puppet's feet from below a wooden floor, or fixing magnets to a puppet's feet and using a metal floor.

pixillation

In pixillation the animator uses live actors as if they were puppets. Instead of moving a clay or wire puppet frame by frame, the animator asks a live actor to break down a movement into a series of still positions and hold each position while the camera takes a frame. This technique can be used to reconstitute a natural movement, such as a person walking across a room, or it can be used to create impossible movement, such as a person slithering like a snake over furniture. An example of pixillation is Norman MacLaren's film *Neighbors*, in which he tells a story about two men fighting over a flower. In this film pixillation is used to create stylized and speeded up action. MacLaren even paints expressions on the actors' faces, emphasizing their role as "puppets."

rotoscoping

Rotoscoping involves tracing over live-action film frame by frame. In this technique, the animator begins by shooting live-action video. That sequence then is brought into a program

like Flash, where the animator can draw on top of the live-action frames to copy natural movement (see Chapter 7 for an example). In Walt Disney's *Snow White*, for example, the characters of Snow White and the Prince are both traced from live-action footage of real actors. As a result, Snow White and the Prince move naturalistically (like real people) while all the other characters move in a stylized, cartoony way.

time lapse

Time-lapse animation is normally used to record and speed up natural phenomena. The camera is mounted on a tripod to prevent movement, and pointed at some natural subject (for example, clouds in the sky, a plant in a pot, or a pumpkin sitting on a table). Then a single frame is taken at regular intervals (for example, one frame every minute, every hour, or every day). The result will be a recording of compressed time. Clouds skitter across the sky, a flower blooms, or a pumpkin decomposes in a few seconds. Time lapse can tie up a camera and computer for a long time, but software such as Premiere can be set to take frames at regular intervals so that the animator does not have to manually take each frame.

drawing

Drawing is the most common method of animating. By drawing, I simply mean making marks of some sort. This definition is a very broad one and can include a wide variety of techniques. For example, you could draw on paper with pencil, ballpoint pen, marker, crayon, charcoal, brush, rollers, or twigs. You could make marks with stamps, mono-printing, or frottage (for example, rubbing a crayon over paper against a textured surface such as tree bark). You could use ink, watercolor, acrylic paint, smeared clay, or coffee grounds. You could collage by incorporating torn paper, stickers, tape, thread, and pieces of packaging in your drawings. You could include mechanical processes such as typing on an old typewriter or enlarging images on a copy machine. Drawing can include inscribing lines in clay, wood, metal, or plastic (in his films, Piotr Dumala creates animation by scratching into prepared blocks of plaster).

Just as you have many choices with mark-making tools and materials, you also have many choices in surfaces on which to make marks. You can draw on 8 1/2" × 11" sheets of white office paper, you can draw on 4" × 5" index cards, or you can draw on large sheets of archival printing paper. You can draw on clear acetate cels, you can draw on photographs, or you can draw on sheets of metal. You can also draw on furniture, walls, or people.

registering drawings

You will need some way to keep your drawings registered during the drawing and scanning processes. The simplest system is corner registration, which consists of a 90-degree angle made from a piece of cardboard taped down to your drawing surface. Put the corner in the lower left if you are right-handed, or in the lower right if you are left-handed. During the drawing process, register each piece of paper by putting the lower left (or lower right) corner of the paper in the cardboard corner. During the scanning process, line up the draw-

Figure 6-6 Two ways to register drawings: corner and peg bar. (Illustration by Tim Miller.)

ings in a corner of the scanner bed, face down. Precise registration can be achieved by taping an animation peg bar down to your drawing surface. A peg bar is a metal or plastic bar with three pegs on it; the middle peg is round, and the two outer pegs are rectangular. The peg bar will hold paper punched with corresponding peg holes during drawing and scanning. Paper can be purchased prepunched from an animation supply company, or you can make holes in your own paper with an animation punch (see Chapter 3). During the scanning process, you would tape the peg bar to the side of the scanner bed and place your drawings face down (Figure 6-6).

You will often want to refer to the last few drawings you made so that you can draw smoother changes in your animation. To do this, you can either flip your drawings, or you can use a light under the drawings so that you can see through the top couple of sheets of paper. The simplest underlight design is a sheet of glass or Plexiglas propped up on some books with a desk lamp shining down onto a sheet of white paper to reflect light back up through your drawings. Fancier setups might use a fluorescent kitchen counter tube instead of a desk lamp. Still fancier setups can include pre-made lightboxes for viewing slides, or specialized animation desks with built-in lights and rotating drawing discs.

Alternatively, you can draw directly into the computer using a mouse or a drawing tablet. The advantage of this method is that you don't have to go through the process of registering and scanning your artwork. The disadvantage is that drawing tools and software are only a distant approximation of drawing with physical media. Drawing with a mouse can work for some people, but most will want a drawing tablet (see Chapter 3).

define your goals

What is your main purpose? Is it to tell a story or make people laugh? Is it to bring a character to life or make a painting move? Perhaps you want to visualize a piece of music or experiment with a particular technique. What do you want to learn from making this project? Do you want to develop your ability to tell stories or animate characters? Do you want to learn more about matching sound and image? Perhaps you want to experiment with lip sync or cutout animation techniques. Often the initial impulse to animate comes from playing

with specific materials such as clay, paper, or paint. Make a list of your goals and put them in order of their priority to you. Doing so will help you stay focused on what's most important to you as you make your project.

consider length and final format

Having length in mind is important for two reasons. First, the length of the project will determine how you approach the project. What you can do in 30 seconds is different from what you can do in 3 minutes. Shorter screen time demands that your animation get to the point quickly; longer screen time requires that your animation develop the idea more fully. Second, screen time will make a difference in how long it will take you to finish the project. How long can you spend working on this animation? Is this a project you want to finish in a week, a month, or a year? How much time do you have to work on this animation? Plan for a length you can realistically complete in the time you have.

format choices

There are several options for showing work, and each option has different advantages and technical requirements. The five basic screening options are on computer disc (hard drive, CD-R, or DVD-R), on DVD-V, on videotape, on the Web, and on motion picture film. Whenever possible, plan a project for the final format you choose.

1. **Showing animation on a computer disc (the hard drive, a DVD-R, or a CD-R):**
 Playing the animation right off the hard drive is the simplest and most direct way to play back animation. This method is fine if you want to show your animation to just a few people at a time. You can expect your animation to run at somewhere between fifteen and thirty frames per second and at a frame size of about 320 × 240 pixels. Playing the animation back on your own computer or similar systems will generally guarantee good results, but computers with different specifications may not play the animation back as well. If you want to make copies for others to play on their own computers, you will need to copy your animation onto CD-Rs or DVD-Rs, singly or in bulk. This requires a drive and software capable of recording (or burning) CD-Rs or DVD-Rs.

2. **Showing animation on a DVD-V:**
 Animation on a DVD-V will play at thirty frames per second at full screen size. The experience is similar to watching videotape. Standards are still evolving, but DVD-Vs will play on most dedicated DVD-V players (what people use to watch movies), and on most computers equipped with a DVD drive. In addition to a drive capable of burning a DVD, you will need special software that can convert (encode) your animation and soundtrack into the proper format for playback as a DVD-V disc (see Chapter 7).

3. **Showing animation on videotape:**
 Animation recorded on videotape will play back at thirty frames per second at full screen size. You will need video equipment to record your animation to tape (for example, a mini DV camcorder). The only equipment needed to play the animation is a tape deck in the same format as the tape (most likely, VHS or DV). In the United States, Canada, and Japan, the video standard is NTSC; in the United Kingdom and Europe,

the video standard is PAL. The two formats have different specifications and are not compatible.

4. Showing animation on the Web:

Putting your work on a web site will make the animation accessible to anyone with an Internet connection. You can either submit your animation to a web showcase in the hope that they will put your work on their site, or you can learn the process of maintaining your own site to show your work. Most people have slow Internet connections, so animation designed for the Web must be small, short, and run at a slow frame rate. The Web is best for animation designed for these limitations, or as a place to advertise your work.

5. Showing animation on motion picture film:

Motion picture film is still the most common medium for projecting animation in a theater. Theatrical projection can reach potentially thousands of people at once, and can be an exciting special event that elevates the viewing experience. Transferring digital files to film requires an outside service and is quite expensive. Theatrical screenings are usually in the context of an animation festival, a school, a library, a gallery, or a film archive.

By making a decision about screening format early in the process, you can design your animation to match the technical requirements from the beginning. This kind of planning will save you the headache of reformatting the animation later on. The main considerations when designing for different screening formats are aspect ratio, scanning resolution, project length, frame rate, and screen size.

aspect ratio

Aspect ratio refers to the shape of the projected image, and is arrived at by dividing the longer, horizontal measurement by the shorter, vertical measurement of the screen. Motion picture film uses several aspect ratios, but the two most common today are Academy (1.33:1) and widescreen (1.85:1). TV has traditionally used the Academy ratio of 1.33:1, although a widescreen format is now emerging for TV as well (1.77:1). When video is digitized into the computer, it is reproduced as a series of square pixels arranged in a grid. The most common video screen size is reproduced at 640 pixels across by 480 pixels high (a ratio of 1.33:1). Digital video and DVD-V also use the Academy ratio of 1.33:1. However, the shape of the pixels in digital video and DVD-V is rectangular instead of square; they are slightly taller than they are wide. So, when digital video or DVD-V is displayed on a computer monitor, an aspect ratio of 1.33:1 turns out to be 720 × 480 pixels (Figure 6-7).

scanning resolution

Scanning resolution is measured in dots per inch (dpi) for printed images and pixels per inch (ppi) for images displayed on a video monitor, but because scanning software almost always measures in dpi, the term ppi is rarely used. When scanning for eventual output to film, you must first decide between 1K (low), 2K (medium), and 4K (high) as the target resolution for your film image. If you choose 2K (a common choice), you can calculate your scanning resolution by dividing 2K (2000) by the horizontal measurement of your artwork.

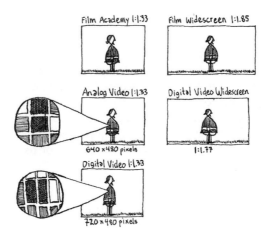

Figure 6-7 Common aspect ratios for film and video. (Illustration by Tim Miller.)

For example, if your artwork measures 10 inches across, you would scan it at a resolution of 200 dpi. When scanning for video, choose a resolution that will match the screen size for which you are planning. One of the most common screen sizes for analog NTSC video measures 640 pixels horizontally by 480 pixels vertically. If you were to scan your 10-inch drawing at 64 dpi, the resulting image would measure 640 pixels by 480. Scanning the same artwork for a monitor measuring 800 by 600 pixels would require a resolution of 80 dpi. To keep things simple, I use 72 dpi as a standard for most computer screens and video monitors.

project length

Normally, a short animation will range from a few seconds to a few minutes long. Motion picture and video allow for the longest projects. Files playing off of hard drives can reach several minutes, but Web animations must be very short (a few minutes at most), unless they are set up for streaming.

frame rate

Frame rate determines how fine the movement will be. This is measured in frames per second (fps): the more frames per second, the smoother the movement can be. Video and DVD-V run at 29.97 (commonly referred to as 30) fps, and motion picture film runs at 24 fps. Most animation playing off of a hard drive can reach 30 frames per second, but the playback speed will vary from computer to computer and even on the same computer depending on processing speed. Animation on the Web will usually run somewhere between 6 and 15 fps.

screen size

Screen size is how big the projected image will be. This can range from a few inches to many feet across. Motion picture and video projection are the largest projections, next are video monitors, and the smallest are windows of animation playing from hard drives or over the Web.

format suggestions

In this section, I provide some suggested settings for formatting your animation for the various distribution choices. Use these as starting points; you may need to test and adjust them to meet the needs of your specific project and screening situation.

If you are planning to play your animation on a computer monitor from a disc (the hard drive, a DVD-R, or a CD-R), use the following specifications as a benchmark for your project:

- Scanning resolution—72 dpi
- Project length—up to 3 minutes
- Frame rate—30 fps
- Screen size—320 pixels wide by 240 pixels high
- Aspect ratio—1.33 : 1 is a standard choice, but on the computer it can be whatever you want

If you are planning to show your animation on DVD-V:

- Scanning resolution—72 dpi
- Project length—an hour or longer
- Frame rate—30 frames per second
- Screen size—full screen
- Aspect ratio—1.33 : 1

If you are planning to show your animation on videotape:

- Scanning resolution—72 dpi
- Project length—an hour or longer
- Frame rate—30 frames per second
- Screen size—full screen
- Aspect ratio—1.33 : 1

If you plan to project your animation from motion picture film:

- Scanning resolution—2000 divided by the horizontal measurement of the artwork
- Project length—limited only by budget
- Frame rate—24 fps
- Screen size—theatrical projection
- Aspect ratio—1 : 1.33 or 1 : 1.85 (widescreen)

The following specifications are for delivering over the Web as a progressive download:

- Scanning resolution—72 dpi
- Project length—up to about 1 minute
- Frame rate—8 fps
- Screen size—160 pixels wide by 120 pixels high
- Aspect ratio—1.33 : 1 is a standard choice, but it can be whatever you want

progressive download or real-time streaming?

The two methods of showing work on the Web are progressive download (sometimes called "progressive streaming") and real-time streaming. With progressive download, the animation is copied from the web site to the local computer in chunks and then played from the viewer's computer's memory. The longer the animation, the longer the viewer must wait for the first chunk to download, so this is a good option for animations of up to 1 minute long. Real-time streaming plays the animation directly from the web site. As a result, there is almost no wait time. But depending on the viewer's type of Internet connection, the playback may drop, or skip, frames, and real-time streaming requires a special web server capable of delivering this type of file over the Web. Streaming is the best option for animations longer than 3 minutes. Animations between 1 and 3 minutes in length fall into a gray zone and must be evaluated on a case-by-case basis.

file formats and compression utilities

At some point in your project you will have to make decisions about file formats and compression utilities (or codec, short for compression/decompression). A file format is a language that describes how the data in a file are saved. You must choose a format every time you save a file. There are many file formats available, each one designed for a particular type of data. For example, the TIFF (.tif) format is designed for bitmap images, whereas the AIFF (.aif) format is designed for digital sound recordings. Some formats are software specific; that is, they work only with the software that created them. Some, such as QuickTime, are not actually file formats; QuickTime is an example of a multimedia "architecture," so-called because it offers more options than just data storage. For example, QuickTime includes compression, various file formats, server software, and browser plug-ins. Other multimedia architectures include RealVideo and Windows Media.

Some examples of common file formats and architectures include:

TIFF: A file format that saves a still image without compression
JPEG: A file format that saves a still image with compression; the amount of compression can be adjusted with a slider
AIFF: A file format that saves a digitized sound waveform (originally developed for the Mac)
WAV: A file format that saves a digitized sound waveform (originally developed for Windows)
MIDI: A file format that saves a sound file as a series of sound event parameters; note that these parameters are not an actual sound, but rather are instructions for synthesizing audio
GIF: A file format that saves an animation as a silent animation (originally designed for the Web)
SWF: A file format that saves Flash animations and sound for playback on the Web
QuickTime: An example of a multimedia architecture that saves video or animation with soundtracks for playback in a variety of situations

A compression/decompression utility (called a codec for short) looks for ways to eliminate unnecessary data in a file. But every time you compress a file, you also degrade its quality, so while you are making your animation you should try to use as little compression as pos-

sible (none would be best). The time to compress a file is at the very end of the project when you are ready to distribute your animation. At that stage, compression is very important because the size of the file usually makes it too large to play back well. The QuickTime format offers a number of codec choices, and new QuickTime codecs are constantly being developed. There is no one best QuickTime codec for all files; experiment until you find the one that works best with your particular situation.

Some common QuickTime codecs include:

Animation: Very little compression; retains much of the original data
Video: Designed for compressing video
Cinepak: General-purpose codec
Sorenson: General purpose codec which offers a high degree of compression
MPEG: Compresses video or animation in the format used on DVD-Vs

improvising and planning

The two basic ways of working are by improvising or by planning. At one end of the spectrum, improvised animation starts with a seed idea, image, movement, or sound, and proceeds through a series of experiments that evolve into a finished piece. At the other end of the spectrum, planned animation starts with a vision of what the finished piece should look like, and the animator proceeds through sketches and boards, to key-framing and in-betweening, until the final product approximates the initial vision as closely as possible.

A musical analogy compares the performances of a classical pianist and a jazz pianist. The classical pianist starts with a finished score and knows ahead of time where the music is going. In this case, the pianist's musical score is equivalent to the animator's storyboard, which guides the animator to a planned result. On the other hand, a jazz pianist does not know exactly how a piece of music will turn out. Instead, he or she starts with a musical theme and improvises on it, creating a dialog between the performer and the musical theme. In animation, a theme can be many things—an image, a movement, a character, or a sound. An animator starts with a theme and then improvises, using exploration and accidents to create a dialog with the initial theme. In this case, the project is finished when the improvisation has reached a point of conclusion.

Of course, every improvised project involves some planning, and every planned project involves some improvisation; the difference between the two is one of emphasis. Your particular approach will vary depending on each project's needs and your personal preferences.

improvised animation

To improvise is to create without preparation—that is, to create sequences of images with a minimum of advance planning. The animator starts with an idea (developing ideas is discussed in Chapter 5), and then explores the idea through the process of animating. The pleasure of improvisational animation is in the joy of discovery that comes from sponta-

neous decisions and accidental surprises. There is no predetermined way to create this type of animation because improvisational techniques grow out of an individual's interests and materials. However, some examples of improvisational approaches include the general category of under-the-camera techniques, as well as two specific examples of improvisational drawing: straight-ahead and evolving cycles.

under-the-camera techniques

"Under-the-camera" is a general category to describe materials that are animated during the recording process. In the case of film animation, recording animation means shooting frames with a film camera (which is where the term "under-the-camera" originated). With digital techniques, the animator will either animate under a DV camera or use a scanner (in which case I suppose it could be called "on top of the scanner" animation). As a distinction, this term usually refers to flat artwork rather than three-dimensional artwork (stop-motion animation). Some examples of under-the-camera techniques include cutouts, sand, and painting on glass.

- To animate cutouts on top of a scanner, place the pieces of artwork face down on the scanner bed and then scan them each time you move them. A detailed example of this process is described in Chapter 7 in the second technical example, "Crab."
- To animate sand on top of a scanner, first protect the scanner by placing a sheet of clear or translucent glass or Plexiglas over the scanner bed. Spread a layer of sand on top of the protective glass so that no light reaches the scanner interior. Shine lights down onto the scanner bed to back light the sand. Then carve an image out of the darkness by using your fingers or other tools to draw in the sand. Where the sand is thinner, more light will come through; where the sand is thickest, no light will come through. If the lights produce hot spots in the scans, try bouncing the lights off of the ceiling or placing a sheet of translucent material (such as milky Plexiglas) between the lights and the scanner. Scan an image you have created, alter the image by carving new marks and filling in old marks, and scan again.
- To animate a painting, place a clear piece of glass on top of the scanner bed with lights above the scanner (as in the sand example). Then paint an image on top of the glass and scan it (you will be scanning the underside of your painting). Alter the painted image with your fingers, a paintbrush, or whatever tools you are using, and scan it again. To keep the paint from drying out, mix colored inks or acrylic paints with a medium that will keep them moist, such as acrylic paint extender.

straight-ahead animation

Animating straight-ahead is an improvisational drawing technique. It is like taking your drawings for a stroll without a specific destination in mind. Your first drawing is your point of departure, and each subsequent drawing becomes the next step in your journey. When you stop drawing, your animated journey is done.

1. Start a sequence of straight-ahead animation by drawing an image. It might be a drawing of a character, an object, a line, a word, or a gestural mark.
2. On a new piece of paper (or on a new frame in your animation software), make a second drawing similar to the first image, but make some sort of change to the image.

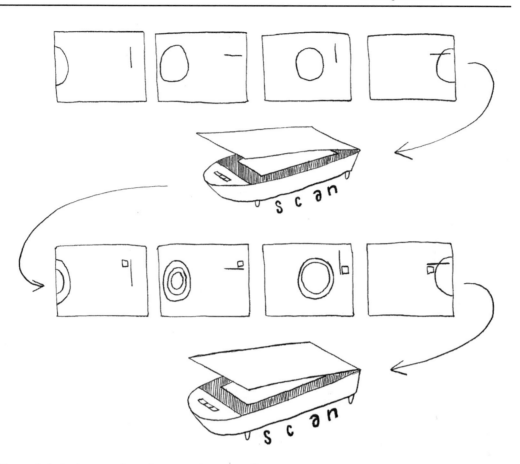

Figure 6-8 Evolving cycles. (Illustration by Tim Miller.)

For example, if it is a character, you might begin moving the character across the page, or you might begin changing the character's shape.

3. Repeat this process as many times as you want.

evolving cycles

Another improvisational technique is animating evolving cycles. The basic idea is to start with a sequence of animation, record it, then add to the original sequence, record it again, and so on until you feel the sequence is fully developed. This approach works well on the computer because of the ease with which you can duplicate files. Finally, you can string all the sequences together in the order you made them and see your animation evolve from a simple beginning to a complex ending (Figure 6-8).

1. Start by making a sequence of animation in Flash or another software application and save it with a name like "Anim01." This first sequence could be as simple as a line animating across the screen in twenty frames.

2. Duplicate the animation file and rename it "Anim02."

3. Open the duplicated file and add a new element of animation to the sequence. For instance, you could add three small shapes dropping into the frame from the top of the screen.
4. Duplicate the altered file and name it "Anim03." Open it and add new animation.
5. Continue until your sequence feels finished to you.

planned animation

Planned animation requires a goal, a preconceived vision of the finished animation. The emphasis here is on the final result rather than on the process of discovery. Just as with improvised animation, planned animation starts with an idea. Once the idea has been clarified (for example, through the processes described in Chapter 5), the animator develops a plan to realize his or her vision. Most commonly, animators plan projects with the help of storyboards and animatics. Backgrounds or sets are usually designed next—before the animation is begun—because they will determine the direction of the action. Then the process of keyframing and in-betweening can be used to create the animation in a controllable and predictable way.

storyboarding

The most common way to plan an animation is to make a storyboard. A storyboard is a series of drawings or other images that previsualize your animation. Actually, the term is a bit of a misnomer because not all animations tell a story. Perhaps a more neutral word, such as "continuity board," would be better, but "storyboard" is commonly used, so that is the term I will use here. Working out a storyboard involves sketching out all the important action, making sure the images flow in a logical way, and making sure the action is shown from the desired point of view. Developing a good storyboard can save time and effort, avoid mistakes, and improve the overall quality of the finished work.

Storyboarding is not about making good drawings; it is about thinking through a sequence of images. Each of these images will show a significant moment in the animation. A "significant moment" is an important action or event. An "action" is something that a character does: opening a door, kicking a ball, or moving across the screen. An "event" is any other type of change—lightning striking, the sun setting, or a change of location. You will want to be able to change your mind frequently and easily, so start with loose, quick thumbnail sketches. Sketch on sheets of paper, on index cards, or on whatever else is handy. The sketches don't have to look anything like your final artwork; they can be illegible to anyone but you. And don't worry about starting at the beginning of the animation; you may want to begin by simply sketching images that you feel clear about, regardless of where they end up in the final sequence. You can always rearrange them later on.

Storyboarding is an iterative process; you will make a number of versions as you work out the details of the sequence (you might make anywhere from two to a dozen drafts of the board). With each draft, you will solve problems and generate new questions. Along the way, the structure of the project will begin to take on its final form. Eventually, you will reach a point of clarity and satisfaction. At that point, you are ready to animate. As an

Figure 6-9 First storyboard. (Illustration by Tim Miller.)

example, let's say that we are storyboarding the nursery rhyme, "The Grand Old Duke of York":

> Oh, the grand old Duke of York,
> He had ten thousand men,
> He marched them up to the top of the hill,
> Then he marched them down again.

Reading this rhyme out loud takes about 10 seconds, so that is the length of screen time I expected to use for this project. Figure 6-9 shows an initial board for this rhyme. It contains ten drawings, or panels, one panel for each second of screen time. One panel per second is not a rule, but it is a good way to begin. Starting in the upper left corner, it shows a close-up of the Duke, followed by a pan down to a close-up of his hand, which holds a group of men. Then there is a change of scene. The fourth panel begins a sequence showing the men marching up a hill, directed by a sign pointing uphill. At the top of the hill is another sign with a hand pointing downhill. The board ends with a long shot of the men turning around to march back down the hill.

Figure 6-10 Second storyboard. (Illustration by Tim Miller.)

Although this is a good board and could certainly be the basis for an interesting animation, the narrative is not as clear as it could be. With the goal of narrative clarity in mind, I would say that this initial version suffers from two common (and related) problems that people run into when storyboarding. First, it contains too many ideas for the length of time we have to work with; and second, it does not develop the ideas it contains. The board presents two locations for the marching men: in the Duke's hand and on the hill. The space is not well defined; where is the Duke in relation to the hill? Time is not well defined: there is a jump in the action between the drawing of the men in the Duke's hand and the drawing of the men marching up the hill—when and how did they get from the hand to the hill? And the ending is not well resolved; does the last image put enough closure on the action?

Figure 6-10 presents a second version of the board. It still consists of ten panels, but the narrative in this version is clearer. In the interest of clarity, alternative ideas like the men in the palm of the Duke's hand and the signs on the hill have been dropped, while the main idea of the men marching up the hill has been more fully developed. Panel one introduces

the Duke, and panel two shows him in front of his men, already facing the direction in which they will march. In the next panel is a wider view, which shows his "ten thousand men" as they start marching. In panel four we see a frontal view of the action, which provides an opportunity for a close-up of the Duke as well as a different point of view of the action. Panels six, seven, and eight are now clearer than in the first storyboard in their depiction of the Duke reaching the top, turning around, and then marching back down with his men following him. The close-up of the feet in panel nine again provides a new point of view of the action, and emphasizes the thousands of marching feet. The last panel now shows the Duke and his men reaching the bottom of the hill. This is a more final destination than in the first version, which ended with the men turning around at the top of the hill.

making an animatic

An animatic is a series of images recorded onto film or video, or scanned into a computer so that they can be played back in a specific time frame. Usually, these images are taken directly from the storyboard. Each image is held on the screen for the duration of the animation it represents. By playing the images in time, an animatic brings a storyboard a step closer to finished animation and reveals strengths or weaknesses in the board that are not always apparent from looking at a static board. It used to be that animatics were recorded on either slide film or movie film and then projected onto a screen. Later, videotape was used. Now, it is quite easy to make an animatic on the computer. If you already have a soundtrack, you can load the track into the software you are using and then match the storyboard images to the track. This will result in an animatic with images that last for different lengths of time, according to how much of the soundtrack each image represents. If you do not have a soundtrack, start by making each image last for one second; then adjust the length of time each image is on the screen from that default.

To make an animatic, you must get your storyboard images into the computer. This can be done in three ways. The first is simply to draw the storyboard in the computer using a program such as Flash. This is a good choice if you are going to draw your animation directly in the computer. The second way is to scan images into Photoshop and then import them into a program such as Premiere. This is a good choice if you are going to create flat animation outside the computer (drawings, paintings, cutouts, etc.). The third way is to capture images with a DV camcorder directly into Premiere. This is a good choice if you are going to create dimensional animation outside the computer (puppets, pixillation, etc.). For the purposes of demonstration, here is an explanation of making and evaluating a scanned animatic in Premiere 6.

1. First, scan your storyboard images into PhotoShop. Either scan each image as a separate image file by selecting only one image at a time with your scanning software, or scan the entire storyboard in as one single-image file and then cut it apart into individual files in PhotoShop. In either case, you will end up with individual TIFF or JPEG files for each storyboard image. Each file should have the same image size and resolution, and each image should be named sequentially (SB001.tif, SB002.tif, etc.).
2. Before you bring the images into Premiere, you should set the default clip length for imported files to thirty frames. This is done by choosing Edit > Preferences > General &

Still Image. This will open a window; look in that window for the "Still Image - Default Duration # frames" choice. Change the number to thirty so that each storyboard image will come in as a 1-second clip. One second is a good starting point, but can be adjusted later to change the timing of the images.

3. To import the files into Premiere, choose File > Import > File. This will open a window in which you can select the file or files you want to import. Click on "Open" when you are done. This will bring the selected files into Premiere's Project window (also called the Bin). If you named your images sequentially, as noted above, the images will appear in the bin in order from the top down.

4. Next, put your images in the Timeline by clicking in the Bin to make it active, and then choosing Edit > Select All to select all the images in the Bin. With all the images selected, drag any one of them onto the Timeline window. When you release the mouse button, all the images will appear in the Timeline in the same order, from left to right, for one second each.

5. To play the animatic, click on the Timeline window to make it active and press the space bar. Press the space bar again to stop playing the animatic. Look at the animatic and decide whether or not any of the images need to be held for a shorter or longer period of time. You can shorten the duration of an image clip by moving the arrow cursor over the end of the clip until the arrow changes into a red bracket. Then click and drag the end of the image clip with the red bracket. You can lengthen an image's duration by dragging another copy of the image from the Bin and inserting it into the Timeline next to the previous clip. If you need to move adjacent clips to accommodate the new length of the clip, do so by clicking and dragging them with the arrow cursor.

How do you know if the length of an image needs adjustment?

- **Music:** If your project is based on a piece of music, your pacing is governed by the recording. In this case, you need to import the music into Premiere (more about this in Chapter 7) and place it in the audio track of the Timeline. Then you can adjust the placement and lengths of the images to match the pacing of the music.
- **Narration:** If your project is based on dialog or narration, your pacing is also based on that narration. You need to import the dialog or narration track into Premiere's Timeline and then match the images to the voice track.
- **Description:** If your project has neither music nor a voice track, try describing out loud what is happening in the animatic while it's playing. If you have to talk very quickly in order to keep up with an image, then that image is not on the screen long enough. If you finish your description long before the image changes, then that image is on the screen too long.
- **Acting:** Try physically acting out a movement or an action represented by an image or a sequence of images. With a stopwatch or a second hand, time how long it takes you to act out the movement, which is approximately how long your images should be on the screen.

Viewing your animatic might reveal unexpected strengths or weaknesses. Sequences that seemed mundane on the board may come to life when they are timed correctly; other sequences that seemed clear in the storyboard may not make sense when they are played in time. The animatic is a chance for you to check that you have included all the important

action, that you have laid it out in the correct order, that you are showing it in the best way, and that the length of your project is what you expected.

With your storyboard and animatic in hand, pre-production is over. Now you are ready to begin production: making the artwork and animation.

backgrounds and sets

A background is a two-dimensional image on which the animation happens. A set is a three-dimensional place in which the animation happens. Designs for backgrounds and sets can range from a flat color to a few simple shapes to a highly detailed scene. And they can range from naturalistic to stylized to completely abstract interpretations. Backgrounds and sets are important for two reasons. First, separating the moving elements (such as characters) in a scene from the static elements (such as a house or a playground) will save work because you won't have to recreate the background for each frame. Second, backgrounds and sets determine the direction of the action in a scene. In a background or set designed to look like a limitless plain, for example, a character would have the potential for an unlimited range of movement. On the other hand, in a background designed to look like a room crowded with furniture, a character's range of motion would be restricted and directed by the objects in the room. In the case of "The Grand Old Duke of York," our background directs the action up and down the hill (Figure 6-11).

Background and set design will affect the expressiveness of a scene. For example, a background or set with areas of deep shadow may be more mysterious than one in which all the elements are evenly lit. When you are designing backgrounds and sets, look through

Figure 6-11 A background directs the flow of action. (Illustration by Tim Miller.)

reference material for ideas—paintings, drawings, prints, photographs, live-action films, other animated films, or your own observations of the world around you. Some design elements to consider are composition, focal points, balance, depth, and lighting.

- *Composition* is the arrangement of the various elements in the set or background. Elements include actual objects such as buildings, mountains, and furniture as well as shapes and areas of color, light, and darkness. These elements can be arranged on both horizontal and vertical planes as well as backward and forward in space.
- *Focal points* are where you want the viewer to look. Different compositions will direct the viewer's attention to different places on the screen. An extreme example of this is a spotlight, but similar effects can be achieved with more subtle methods. For example, an arrangement of buildings in the scene can direct the viewer's attention to a particular street corner.
- *Balance* is the degree of symmetry or asymmetry in the composition. Symmetrical compositions convey a sense of order and stasis; asymmetrical compositions convey a sense of imbalance and change.
- *Depth* is the sense of space receding into the distance. It can be achieved through a number of visual cues. One way is to overlap elements in the background to show that one is behind the other. Another way is to present the scene from an angle so that more than one side of an object is visible. Shadows will indicate that objects have form and a particular location in the set. In a landscape, colors might become less saturated and shift toward blue as they recede into the distance. Finally, putting foreground objects in sharper focus than background objects (or vice versa) is using depth of focus as a spatial cue.
- *Lighting* is the relationship of areas of light and shadow in the background or set. Lighting can be even, with as few shadows as possible, it can be a balanced mixture of areas of light and shadow, or it can be almost entirely in shadow with one or two spots of light. Lighting can be used to create a mood or to focus attention on a particular part of the scene. In two-dimensional background, light and shadow are created with art materials—in paint or in charcoal, for instance. In a three-dimensional set, light and shadow can be created with the placement of actual lights.

keyframing

Keyframing means drawing all the most important animation frames first. Keyframing allows the animator to lay out the flow of animation quickly and flexibly before committing to making all the intermediate, or in-between, drawings. It also gives the animator more control over the timing of the animation, and keyframes can be used to compose action against a specific background. Figure 6-12 shows an example of keyframing based on panels six, seven, and eight from the storyboard for "The Grand Old Duke of York." Each keyframe drawing shows a stage in the progress of the action. Number one is an empty background; number two shows the Duke entering at the bottom; number three shows his men in the frame; and number four shows everyone at rest with the Duke at the top of the hill. The keyframes are numbered according to their place in the total finished sequence. For this example, let's say that we will be animating at 24 frames per second. Because each panel represents 1 second of screen time, the whole sequence will take 3 seconds. Holding each drawing for two frames means that there will be a total of 36 animation drawings. If we divide this evenly by the four panels, we get a keyframe every twelve drawings, so the first

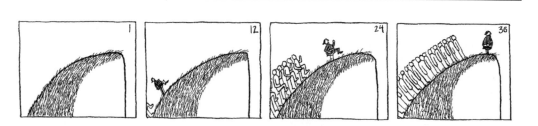

Figure 6-12 Keyframing storyboard panels six, seven, and eight. (Illustration by Tim Miller.)

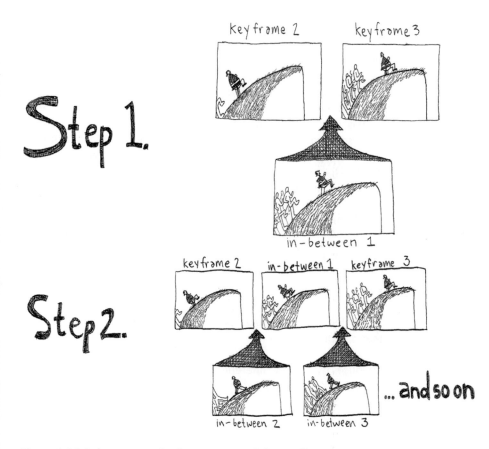

Figure 6-13 In-betweening keyframes two and three. (Illustration by Tim Miller.)

keyframe will be number one; the second keyframe will be number 12; the third keyframe will be number 24; and the fourth keyframe will be number 36.

in-betweening

In-betweening means making all the intermediate images that connect two consecutive keyframes. Figure 6-13 shows in-betweening keyframes number two and three. There

will be 12 in-between drawings between these two frames (12 drawings on two's equals 1 second in film). The first in-between shows the action halfway between the two keyframes; this will eventually be drawing number 18 in the final sequence. In-between number two shows the action halfway between the first keyframe and the first in-between; this will be drawing number fifteen in the final sequence. In-between number three shows the action halfway between in-between number one and keyframe number two; this will be drawing number 22 in the final sequence. To finish the sequence, we would continue making new drawings between each of the existing drawings until all 12 were complete.

the production process

Making animation can involve many tasks. Sometimes it is difficult to know where to start and how to organize the work. You may find it helpful to divide the work into three stages: pre-production, production, and post-production. Pre-production is what you do before you begin animating, production is the actual process of making the animation in whatever technique you are working, and post-production is what you do after you have finished animating. Here I give a list of some of the common tasks in each stage of production. It is unlikely that one project will involve all these tasks, but use these lists as a guide to help you organize your own projects. Discussions of some of these stages are spread across a number of chapters. For example, Chapter 5 is entirely devoted to developing ideas, and Chapter 8 is entirely devoted to distributing your animation. This chapter (6) includes discussions of tasks that fall into all three stages.

Pre-production may include some or all of the following activities:

- develop ideas and goals
- write scripts
- get permission to use copyrighted materials such as stories and music
- make a storyboard or other structuring plan
- make an animatic
- design the look of the animation by testing different techniques
- record sound
- get frame counts for sync animation

Production may include some or all of the following:

- make artwork
- animate under-the-camera
- design characters
- make backgrounds
- block out the action in a background with keyframes
- in-between the drawn animation or animate straight-ahead
- build puppets
- build sets and set up lights

Post-production may include some or all of the following:

- edit picture
- record sound effects, music, and voice
- edit and mix sound in sync with the picture
- compress animation files for playback from hard drive, CD, DVD-V, or the Web
- record the animation to DV or VHS tape
- send files to a transfer house for recording onto 35 mm film
- distribute your animation

summary

- The three basic principles of animation are image change, registration, and timing.
- Materials and techniques are personal and expressive choices.
- Clarify your goals to keep your project focused, and decide ahead of time how you will show your animation (film, video, computer, the Web).
- Improvisational animation develops seed ideas or themes with no final result in mind, and planned animation uses storyboards and keyframing to produce a predictable result.
- Storyboards and animatics are important tools for planning animation.
- Sets and backgrounds will determine the direction of the action.
- Keyframing and in-betweening are tools to control the flow and timing of animation.
- Making animation can be divided into pre-production, production, and post-production tasks.

> *Fire, waves, falling snow, and animation are four things that I really like to watch.*
>
> Tim Miller

chapter 7

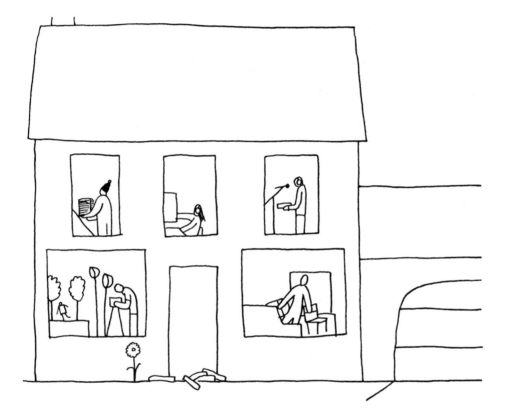

technical examples

> *What I like most about animation is that it is filmmaking in its most pure and elemental form.*
>
> Bryan Papciak

This chapter presents descriptions of how I made the example projects on the accompanying CD. With each description, I intend to demonstrate a particular technical aspect of making animation. I provide these projects because an example of a specific situation can be helpful in making the details of animation production clear. But these are examples, not prototypes; don't let these limit your thinking. Choices in subject matter, technique, and design are highly personal, so use this chapter as a reference to understand the process of production and then make your animation in your own way.

This chapter is divided into four parts. The first part consists of three projects that demonstrate scanning (drawings, cutouts, and objects). The second part consists of six projects that demonstrate ways of working in Flash. The third part consists of two projects that demonstrate stop-motion animation. And the fourth part contains four projects that demonstrate different ways to make soundtracks for animations. In each of the first five projects, I also discuss the specifics of outputting the project for different playback scenarios (hard drive, CD, DVD, the Web, and videotape). I do not repeat the discussion of output options for the remaining ten examples.

	Project Name	Example of	Primary Software	Output to
1.	Hairy Birds	scanning artwork	PhotoShop, Premiere	hard drive
2.	Crab	scanning cutouts	PhotoShop, Premiere	CD-R
3.	Seashells	scanning objects	PhotoShop, Premiere	DVD-V
4.	Frog	metamorphosis	Flash	Web
5.	Walk	walk cycle	Flash	videotape
6.	Crow	working with layers	Flash	n/a
7.	Naomi's Birds	working with loops	Flash	n/a
8.	Waving	acting	Flash	n/a
9.	Dizzy	rotoscoping	Flash	n/a
10.	Fruit Salad	stop-motion objects	Premiere	n/a
11.	Boy and Dog	stop-motion puppets	Premiere	n/a
12.	Dance	animating to music	Making Music, Flash	n/a
13.	Forecast	animating lip sync	Premiere, Flash	n/a
14.	Sneeze	recording Foley sound	Premiere, Flash	n/a
15.	Hannah's Peacocks	sound mix	ProTools, Flash	n/a

scanning examples

The first three exercises are examples of scanning animation into the computer. The first, "Hairy Birds," demonstrates how to scan animation drawings. The second, "Crab," demonstrates how to scan animation of a hinged cutout. The third, "Seashells," demonstrates how to scan replacement objects.

"Hairy Birds"

"Hairy Birds" is an example of scanning drawn animation, including a description of output for playback from a computer hard drive.

tools and materials used

- Paper, pencils, crayons
- Lightbox, peg bar, ruler, tape
- Computer, scanner
- Adobe PhotoShop, Adobe Premiere

the process

step 1: animate on paper. I created the animation on paper. First, I punched about a hundred sheets of 8.5" × 11" white office paper with a special animation punch (see Chapter 3). Next, I drew a rectangle 6" across by 4.5" high on a piece of punched paper. This rectangle served as my guide for the limits of my drawing area. It also represented the area I would later scan. The size was arbitrary (based on what was comfortable), but the ratio of width to height was based on an aspect ratio of 1:1.33 (see Chapter 6). Then I drew the animation on the punched paper using a peg bar to keep the drawings registered. I numbered the drawings as I drew them so that I would not confuse their order later.

step 2: scan the artwork. There are three things to consider when scanning in animation drawings: registration, scanning area, and resolution. Before I began scanning, I taped the peg bar to the side of the scanner so that all my drawings would go into the computer already registered. I set the scanning area by scanning the 6" × 4.5" rectangle first, matching the scanning software's selection box to the drawn rectangle. I set the resolution to 72 dpi, which is an appropriate number for both computer and most video output (see Chapters 6 and 8 for discussions of resolution issues). After I scanned the rectangle, I left the scanning settings the same and scanned in each of my drawings in order, placing each one on the peg bars face down on the scanner bed (Figure 7-1). When I finished scanning in the drawings, I saved the scans in their own folder named "HBScans."

Note: Naming files is an important detail. For best results, use a descriptive name no more than eight characters long, including a three-digit number, with no spaces in the name, and followed by a file extension ("hbird001.tif," for example). This naming convention is called "8.3," and will work on both Macs and PCs.

step 3: clean up the scans. After I saved all my scans, I opened them all in PhotoShop in order to rotate them and clean them up. I adjusted the images in four ways: rotated each

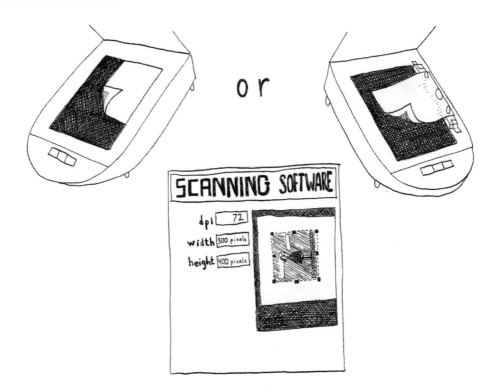

Figure 7-1 Two ways to register drawings during scanning: corner and peg bar. (Illustration by Tim Miller.)

drawing 90 degrees counter-clockwise, set the Image Size to a standard number in case the scanning had resulted in slightly different image sizes, slightly increased brightness and contrast, and slightly sharpened the focus. I recorded an Action (see the PhotoShop manual) to perform all these steps with one keystroke.

- Rotate (angle: −90 degrees)
- Image Size (width: 6 inches, height: 4.5 inches, resolution: 72 dpi, interpolation: bicubic)
- Levels (Input: 0, 255; Gamma: 0.75)
- Unsharp Mask (Radius: 34, Amount: 39, Threshold: 15)

I then saved the adjusted scans as copies rather than overwriting the original scans. That way, in case I made a mistake or changed my mind, I would be able to return to the original images without having to scan the drawings all over again. I saved the copies into their own folder named "HBcleans" in the TIFF format.

step 4: load the images into Premiere. To begin, I started a new Premiere file, choosing a video project preset (NTSC, 640 × 480 pixels, 29.97 frames per second). Next, I set the default length of imported images to two frames by choosing Edit > Preferences > General & Still Images, and typing "2" for Still Image Default Duration. Then I imported all my adjusted drawings at once by choosing File > Import > Folder, and choosing the folder

named "HBcleans." The folder (and all its contents) appeared in the Project window. I dragged the folder from the Project window onto the Video 1A track in the Timeline window, and all my drawings appeared in the Timeline for a duration of two frames each. To see the animation, I pressed the Play button in the Monitor window.

step 5: output the animation for playback from my computer's hard drive. I decided to output this particular animation for playback from a computer hard drive. I wanted to be able to play the animation on any computer similar to my own, regardless of whether or not Premiere was installed, so I exported the animation as a QuickTime file by choosing File > Export Timeline > Movie. I chose QuickTime because it is as near to a universal media player format as we currently have on the computer. When the Export Movie dialog box came up, I clicked on the Settings button to specify how I wanted to export the file:

- File type—QuickTime
- Video compression—Sorenson Video (this reduced the size of my file from 35 MB to 7 MB)
- Frame size—320 × 240 pixels
- Frame rate—30 fps

After designating these settings, I named the file "Hbird.mov" (".mov" is the file extension for QuickTime) and clicked on the "Save" button. This generated a file that I could play on any computer that has QuickTime installed.

"Crab"

"Crab" is an example of how to scan cutout animation, including a description of output to CD-R (or DVD-R).

tools and materials used

- Thick paper, watercolors, brushes
- Thread, tape, push pin, scissors
- Computer, scanner
- Adobe PhotoShop, Adobe Premiere
- Roxio's Toast Titanium

the process

step 1: make the cutout. I began this project by making a cutout crab. First, I chose a size for the crab based on the size of my scanner. Because the scanner bed was 8.5" × 11", I decided to make the crab about five inches across; this would leave enough space for me

to move the cutout without bumping into the scanner's edges. I lightly sketched the pieces of the crab cutout onto stiff paper in pencil and painted the pieces in watercolors. Next, I cut the pieces of the crab drawing out of the paper and used a black marker to darken their edges (so that the white of the paper would not be visible). I then laid the pieces of the cutout together, overlapping them slightly. I poked holes in the bottom cutout pieces with a pushpin; the hole is hidden by the cutout piece on top. Next I pushed a piece of thread through each hole and taped the thread to the back of both the bottom and top cutout pieces. After taping, I trimmed the excess thread. The length of thread will determine how loosely or tightly a cutout is jointed; ideally, it is just tight enough that all the pieces follow in a natural way when the body is moved (Figure 7-2).

step 2: scan the cutout. To animate the crab cutout, I placed it face down on the scanner bed, leaving the cover up. I started scanning by setting the scanner to capture the entire surface of the scanner bed (8.5" × 11") at 72 dpi. After the first scan, I moved the cutout slightly, starting with the body and then working out to the limbs. I scanned again, repeating this process until I was finished with the animation (I scanned the cutout thirty times). I saved the individual scans as "Crabscan001.tif," and so on.

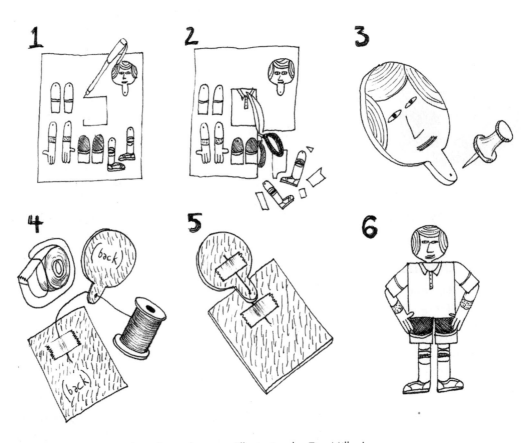

Figure 7-2 How to make a hinged cutout. (Illustration by Tim Miller.)

Note: I left the cover up during the process of scanning because I didn't want to disturb the placement of the cutout by lowering and lifting the scanner cover. Leaving the cover up during a scan will result in a black background. To scan an image behind your cutout, tape the artwork to the inside of the scanner cover. If you use a heavy paper to make the cutout and slowly raise and lower the cover, you won't disturb your cutout's position.

step 3: clean up the scans. I opened all the scanned images in PhotoShop and cleaned them up. The crab didn't move much from the center of the screen, so I included a Canvas Size command in my Action list to crop the images. I liked the colors, brightness, and contrast just as they were, so I didn't change any Levels.

- Rotate (angle: –90 degrees)
- Canvas Size (width: 640 pixels, height: 480 pixels)
- Unsharp Mask (Radius: 34, Amount: 39, Threshold: 15)

I saved copies of the scans in their own folder in the TIFF format.

step 4: load the images into Premiere. I opened Premiere and chose the standard NTSC video preset (640 × 480 pixels, 29.97 frames per second), and set the default clip length to two frames. Then I imported the folder containing the cleaned-up crab images and dragged the folder from the Project window to the Video 1A track in the Timeline window. I played the animation to check it, then saved the project.

step 5: output the animation to cd-r (or dvd-r). In this case, I decided to output the animation for playback on a CD-R—that is, store the animation on a CD-ROM so that I could play it on any computer equipped with a CD or DVD drive. I would save to a disc that could only be saved to once (CD-R).

In Premiere, I generated a QuickTime file by choosing File > Export Timeline > Movie. Once the Export Movie dialog box came up, I specified the settings:

- File type—QuickTime
- Video compression—Sorenson Video
- Frame size—320 × 240 pixels
- Frame rate—15 fps (this lower frame rate allows for playback on older CD drives)

Once the QuickTime file was made, I burned (saved) it onto a CD. I wanted both PC and Mac users to be able to read my CD, so I made sure to burn a hybrid (cross-platform) CD. On my Mac, I used Toast Titanium (on a PC, I could have used Easy CD Creator). I opened Toast and clicked on the icon labeled "Data." Then in the pop-up menu below this icon, I dragged to "Mac OS and PC (Hybrid) CD." Next, I chose Disc > Add, and selected my QuickTime movie. Last, I chose Recorder > Record, and clicked on the Write Session button to burn the CD. With the proper software, a similar procedure could be used to burn a DVD-R with a DVD-RW drive. A DVD-R offers two advantages over a CD-R: DVDs have more storage space and they are automatically saved in a cross-platform format.

"Seashells"

"Seashells" is an example of how to scan objects, including a description of output to DVD-V.

tools and materials used

- A collection of objects (seashells)
- Computer, scanner
- Adobe PhotoShop, Adobe Premiere
- Apple's QuickTime Pro Player
- Apple's DVD Studio Pro

the process

step 1: find objects that animate. Collections of objects and images can be grouped according to similarities in shape, size, and color, and then sorted according to progressive differences in these attributes. When these objects or images are played in sequence, they will animate. For this project, I organized seashells from my children's beach collections according to shape and size. I put all the clam shells facing left in one pile, all the clam shells facing right in another pile, and all the symmetrical seashells in a third pile. Then I sorted each pile according to size, from smallest to largest. Each of these piles would become a sequence of animation.

step 2: scan the objects. I placed the largest seashell face down in the middle of the scanning bed and set the scanning area accordingly; about 8 inches wide by 6 inches high in this case. I scanned the seashells at 72 dpi, leaving the scanner cover up. To register the seashells, I held the next seashell in the sequence directly above the seashell on the scanner bed. Then as I lifted the first seashell up, I put the next seashell down on the scanner bed in exactly the same place and in the same orientation. After scanning in all the seashells, I saved them with names that described their sequence as well as their order—for example, "LS001.tif," "RS001.tif," and "SS001.tif."

step 3: clean up the scans. I opened the seashell images in PhotoShop and cleaned them up. In this case, the only adjustment I made was to make sure that each file had the same image size of 640 pixels by 480 pixels by choosing Image > Image Size, and then setting the Pixel Dimensions to 640 for Width and 480 for Height. I saved each sequence of images in its own folder ("LeftShell," "RightShell," and "SymShell").

step 4: load the images into Premiere. I opened a new Premiere project with the NTSC, 720 × 480 digital video preset, and made sure that the default clip length was set to two

frames in Edit > Preferences. Then I imported the folders containing the seashell sequences. Next I planned the structure of the animation. I felt that a pattern of sequences facing right, left, right, right, and then left would work, with each sequence separated by a short burst of symmetrical seashells. I dragged each folder to the Video 1A track in the Timeline in the order I wanted them to play (right, symmetrical, left, symmetrical, right, symmetrical, right, symmetrical, left). After I loaded the sequences in the order I wanted them to play, I adjusted their timings. To create some variation in the animation, I changed the animation rate of all the symmetrical seashells as well as the first and last sequences of right- and left-facing seashells from two frames each to one frame each. Changing the rate to one's (one frame for each image) doubled the speed of these sequences. Last, I decided to start the entire animation with a fade in and end the entire animation with a fade out.

To create the fade in, I first put the still image of the first seashell in the Video 1A track at the beginning of the animation. I moved the entire animation to the right in the Timeline by about 100 frames with the Multitrack Select Tool, and then extended the still image to fill in the empty space in the Timeline by dragging the right end of the clip with the Selection Tool. Next I created a clip of black video by choosing File > New > Black Video and dragged it into the Video 1B track under the clip of the still seashell image. I dragged the right end of the Black Video clip length to be about half the length (50 frames) of the seashell clip. I opened the Transitions window by choosing Window > Show Transitions, and opened the folder labeled "Dissolve." From this folder, I dragged the icon named "Cross Dissolve" to the "Transition" track between the Black Video clip and the Seashell clip. The cross dissolve transition clip shows an arrow pointing either up or down. In order to fade from black to an image, this arrow should be pointing up—away from the Black Video clip and toward the Seashell clip. To see the transition, I needed to render the Timeline (this creates a preview file of the project). I rendered the Timeline by choosing Timeline > Render Work Area (Figure 7-3).

step 5: output the animation to dvd-v. In this case, I decided to output the animation for playback on a DVD-V. My first step was to make a QuickTime movie; in Premiere, I chose File > Export Timeline > Movie. I checked my settings, and named the movie "Seashell.mov."

- Compressor: DV NTSC
- Frame Size: 720 × 480
- Pixel Aspect Ratio: D1/DV NTSC (0.9)
- Frame Rate: 29.97
- Depth: Millions; Quality: 100%
- Audio Settings: Turned off because this project had no sound. If I were exporting sound, I would have saved the audio separately as an AIFF (or WAV) file by choosing File > Export Timeline > Audio, and choosing settings (for example, format AIFF, 48000 Hz, 16-bit, stereo, uncompressed).

My next step was to convert the QuickTime movie into a format for DVD-V. To do this, I opened my movie in QuickTime Pro Player and chose File > Export. In the dialog box, I clicked on the Export pop-up menu and dragged down to Movie to MPEG 2 (this option appears when you install your copy of DVD Studio Pro). This export command saves a copy of the QuickTime movie with the file extension .m2v (the proper format for DVD Studio Pro).

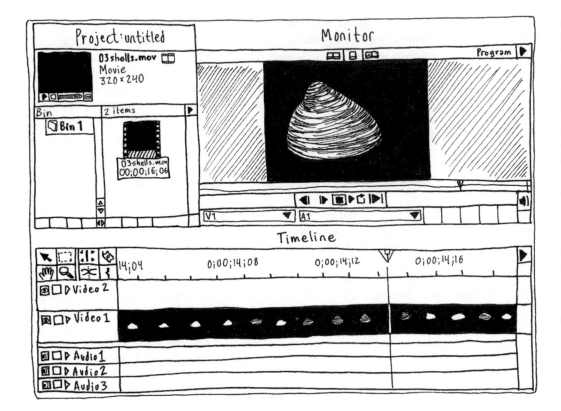

Figure 7-3 Premiere's Timeline. (Illustration by Tim Miller.)

Then I quit QuickTime Pro Player and opened DVD Studio Pro. DVD Studio Pro presented a new, empty DVD-V disc project named "untitled." I added my asset (my movie) to the project by choosing File > Import, navigating to "Seashells.m2v," and clicked on Add and Import to load it into the Assets Container in Studio Pro. In order to create a track in which the animation would play, I clicked on the New Track button at the bottom of the Graphical View window. An icon of a folder (with several buttons on it) appeared in the Graphical View. I renamed it "Seashells," then I dragged "Seashells.m2v" from the asset container to the icon of the track folder in the Graphical View window.

In the Property Inspector (if you don't see it, choose Windows > Property Inspector), I clicked on the pop-up menu for Start-up Properties under the General category, and dragged down to "Seashells." This told DVD Studio Pro to play my animation when it starts a disc preview. To preview the disc, I clicked on the Preview button at the bottom of the Graphical View window. To get ready to burn the DVD, I chose File > Build & Format Disc. Studio Pro asked me to select a folder in which to build the necessary files; I created a new folder called "Seashell DVD." Then a dialog box appeared in which I made sure that Record To Device was selected (the name of my DVD burner appeared in a list in the dialog box). I clicked on OK and the computer opened the DVD tray and asked me to insert a blank DVD. After I inserted the disc and closed the tray, Studio Pro began burning the DVD-V.

Note: The seashell exercise was inspired by my wife and colleague, Amy Kravitz. One of Amy's exercises for her animation students at Rhode Island School of Design is to find animation in the world around them rather than to create it. She asks her students to bring in collections of objects whose similarities and differences will create animation. There must be enough similarity in the objects for registration and enough difference for change in the image. Amy calls this assignment, "Multiples, Succeeders, and Discontinuities." Some of the solutions to this assignment have included collections of peanuts, leaves, nails and screws, cigarette butts, computer keyboards, and socks.

Flash examples

The next six exercises use Flash. Working directly in the computer saves time and materials, and Flash is a good substitute for many drawn animation techniques. The first exercise, "Frog," demonstrates animating a metamorphosis. The second, "Walk," shows one way to animate a human walk cycle. The third exercise, "Crow," is an example of separating animation onto different layers in order to save time and gain more control over the animation. "Naomi's Birds" shows how to work with a series of animating loops. The fifth exercise, "Waving," demonstrates exaggeration as a method of animation acting. The last exercise, "Dizzy," is an example of rotoscoping, or tracing, live-action video.

"Frog"

"Frog" is an example of animating metamorphosis, including a description of output for playback over the Web.

tools and materials used
- Computer
- Drawing tablet
- Macromedia Flash

Before going any further, I'd like to present the basic Flash work environment and important terms used in Flash. Starting at the top is the Timeline, which shows each frame of your animation arranged horizontally, starting with frame 1 at the extreme left and moving forward in time to the right (Figure 7-4). At the very top of the Timeline is the Playhead. You can move the Playhead back and forth ("scrub") through any frames you have created by dragging the Playhead across the Timeline. Below the Playhead is the first layer, by default called "Layer 1." A layer is like a sheet of transparent acetate (called a "cel" in traditional animation terminology) on which you can draw and paint an image in an animated sequence. Flash allows you to add additional layers in the Timeline. The advantage of

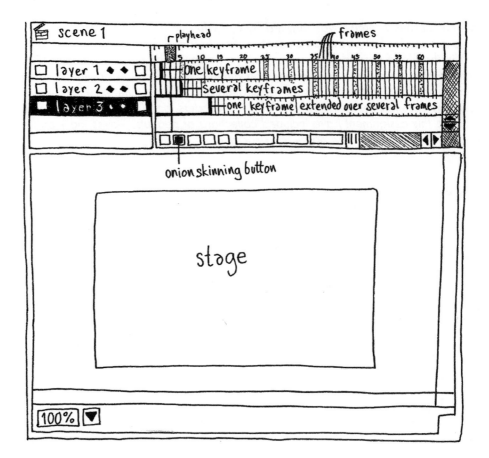

Figure 7-4 The Flash screen. (Illustration by Tim Miller.)

working in layers is that you can put different parts of your image (a background image, for example) onto separate layers so that you won't have to redraw all parts of the image in every frame. A layer consists of a row of rectangles that represent individual frames.

When you open a new Flash document, the first frame in Layer 1 looks different from the other frames; it is drawn in black but all the subsequent frames are drawn in gray. The gray frames are actually empty frames; as such, they cannot be drawn in yet. The black frame is a keyframe (Flash makes this first one for you automatically), and it is open to be drawn in. In order to draw in frame two, you must first convert it into a keyframe (to create animation, you will be drawing in a sequence of keyframes). Select frame two of Layer 1, then choose Insert > Keyframe. To change frame rates, each keyframe can be extended so that it plays for more than one frame. To do this, select the keyframe you want to extend and choose Insert > Frame; this extends the keyframe so that it covers two frames in the Timeline; this would change your animation rate from one's to two's. The inserted Frame is simply a copy of the Keyframe. To recap, the Timeline in Flash consists of layers, empty frames, keyframes, and frames.

At the bottom of the Timeline is a series of buttons with different icons in them. For this project, we are concerned with the second box, which shows a small gray box behind a blue box. Clicking on this button turns on Onion Skinning, which simulates drawing on a lightbox. This feature allows you to see frames before and after the frame you are drawing as semi-transparent images. When Onion Skinning is selected, you can adjust which frames are included in the view by dragging sliders in the Playhead over frames to the left and right of the current frame. The Tools window is displayed vertically to the left of the Timeline. Selecting any of the tools brings up options for that particular tool at the bottom of the Tools window. For example, the Brush tool (which I used to draw this project) includes options for brush size, shape, and color.

The Stage is the large white area below the Timeline. This is where your animation will play; it is also where you draw and compose the contents of any particular keyframe. The size of the Stage can be changed by choosing Modify > Movie, entering the pixel dimensions you prefer, clicking on the Save Default button, and then clicking on the OK button. It is a good idea to set the Stage size before you begin animating.

the process

step 1: start a new Flash project. I opened a new Flash project by choosing File > New. I planned to play this animation on the Web, so I opened Movie Properties by choosing Modify > Movie, and in the dialog box that appeared, I typed "Frame Rate 15 fps" and "Dimensions 160 Width by 120 Height." At 160 by 120 pixels, the Stage is quite small. To make animating easier, I wanted to see a larger view of the Stage, so I clicked on the pop-up menu next to "100%" in the lower left of the project window and dragged down to Show Frame. This view automatically zoomed the Stage to fill the window. I selected the Brush tool in the Tools window and set the brush size by clicking on the brush size pop-up menu under Options (at the bottom of the Tools window). I changed the color of the Brush to black by clicking on the Fill color palette (next to the picture of a Paint Bucket) and dragging to a black swatch in the color palette.

step 2: animate straight-ahead. My plan was to animate a frog growing from an egg to an adult. I would do this by starting with a drawing of a small circle (the egg), and then gradually changing the circle's shape over a number of frames until it looked like a tadpole and, eventually, a fully grown frog. I wasn't sure how many frames this would take; I would just keep animating until the changes were complete. To begin, I clicked in the first keyframe (in the Timeline) and then drew a small circle on the Stage. Next, I added a new empty keyframe by choosing Insert > Blank Keyframe. This automatically advanced the Stage to frame two, which was blank. I turned on Onion Skinning so that I could see the previous drawing, and traced the egg, making the new drawing slightly longer to start changing its shape into a tadpole. Then I inserted another blank keyframe and traced frame two, again making the new drawing even longer, getting closer to a tadpole shape. I continued this process of inserting blank keyframes and tracing new shapes until I reached the end of my animation.

Note: This exercise is an example of metamorphosis, or shape changing. One fundamental way to animate an image is to change its position in space; for example, an animation

Figure 7-5 Metamorphosis. (Illustration by Tim Miller.)

of a ball flying through the air consists of a circle drawn in different positions in the frame. Another fundamental way to animate an image is to change its shape. The metamorphosis can be naturalistic, as in the case of an egg changing into a frog, or it can be metaphorical, as in the case of a coffee bean gradually changing into a cup of coffee (see Figure 7-5).

step 3: output the animation for playback over the Web. There are two ways to output an animation in Flash. The first is to choose File > Export Movie; this command will save the Flash animation in the file format chosen (for example, QuickTime, GIF, Shockwave, etc.). The second way is to choose File > Publish. This will automatically create one or more files in different formats based on what you select ahead of time by choosing File > Publish Settings. In addition, Publishing can create an HTML file to make your animation ready to play on the Web.

I wanted to play this animation from my Web site as a Shockwave file. Shockwave files (SWF) are among the best formats in which to create animation for the Web because the files are relatively small and play back quickly. Viewers with the Shockwave Plug-In in their browser will be able to see a Shockwave animation over the Web (the free Shockwave Plug-In can be downloaded from www.macromedia.com). First, I previewed what my animation would look like on the Web by choosing File > Publish Preview > HTML. This command opened my default browser and played the animation in a new window. Once I was satisfied with how it looked, I closed my browser, returned to my Flash file, and chose File > Publish Settings. This command opened a dialog box in which I could select which file formats I wanted output to go to. I selected the boxes next to "Flash (.swf)" and "HTML (.html)" and clicked on the OK button. Last, I chose File > Publish to output the animation to the selected formats. This made a Shockwave file and an HTML document that I could use to distribute the animation on the Web (see Chapter 8 for more information about Web distribution).

"Walk"

"Walk" is an example of animating a human walk cycle, including a description of output to videotape.

tools and materials used

- Computer
- Drawing tablet
- Macromedia Flash, Adobe Premiere
- Mini DV camcorder, Mini DV tape, FireWire cable

This project is an example of a stationary walk cycle. The walk cycle is a sequence of eight drawings. Each drawing shows a different position of a human figure taking two strides—the first stride leading with the left foot, and the second stride leading with the right foot. In a walk cycle, the arms and legs move in opposite directions; for example, as the right foot comes forward, the left arm swings forward and the right arm swings backward (Figure 7-6).

Note: In this exercise, it is as if we are traveling with the character through a landscape. This requires that the character's body stay in one place and that its feet step forward and then slide back so that the character never actually advances across the screen. However, if our viewpoint were stationary and the character were to move across the screen, then the character's feet would not slide backward. In that case, it would be important to keep the feet still when they step onto the ground, and instead, move the body forward through space.

the process

step 1: animate the walk cycle. Before I began animating, I drew a ground line so that I would know where the feet should fall. Without this line, I might have drawn my character's feet higher or lower in each frame, destroying the illusion that it was walking on a flat surface. To animate the walk cycle, I first drew the two extreme positions, then the middle position, and last the two intermediate positions. In the first keyframe, I drew the figure with its right foot and left arm all the way forward and its left foot and right arm all the way back; this was my first extreme position. Then, I inserted a second keyframe, turned on Onion Skinning, and traced the first drawing. But this time I changed the feet and arms; now its left foot and right arm were all the way forward and its right foot and left arm were all the way back. This was my second extreme position. Next, I inserted a new keyframe between the two existing ones, and with Onion Skinning still on, drew the torso and head

e x p a n d e d view

Figure 7-6 A walk cycle. (Illustration by Tim Miller.)

slightly higher than it was in the two extreme drawings. Then I added the arms and legs as they would be in mid-stride. The right leg was straight and directly under the torso, the left leg was bent and directly under the torso, and the arms were both close to the center of the torso. This drawing was my middle position. Next, I inserted two more keyframes; one between the first extreme and middle positions, and the second between the middle and second extreme positions. In these intermediate positions, I drew the arms, legs, and torso in positions halfway between those of the adjacent keyframes.

At this point, I had five drawings: 1) the first extreme position with the right foot all the way forward; 2) the first intermediate position with the right leg halfway between all the way forward and the middle; 3) the middle position with the right leg directly under the torso; 4) the second intermediate position with the right leg halfway between the middle and all the way back; and 5) the second extreme position with the right leg all the way back. This completed the first stride showing the left foot coming forward. Next I needed to animate the second stride showing the right foot coming forward. To do this, I inserted three more keyframes after the existing ones. In the first of these new keyframes, I traced the first intermediate position with arms and legs reversed. In the second of these new keyframes, I traced the middle position with arms and legs reversed. In the third of these new keyframes,

I traced the second intermediate position with arms and legs reversed. This completed all the drawings for the walk cycle. When I played it, the walk was too fast, so I slowed it down by extending each keyframe for two frames (select a keyframe and then insert a frame by choosing Insert > Frame).

step 2: output the animation to videotape. I wanted to output this animation to videotape. This was a two-part process; the first part was to export the Flash animation as a Quick-Time file, and the second part was to record the QuickTime file to videotape in Premiere. In Flash, I chose File > Export Movie. In the dialog box that appeared, I clicked on the file format pop-up menu and dragged down to QuickTime. I checked to make sure that the pixel dimensions were 720 by 480 (the 1.33 aspect ratio for digital video). I typed in a name for the movie, "Walk.mov," and clicked on OK.

After quitting Flash, I attached a mini DV camcorder to the computer with a FireWire cable. I turned on the camcorder, put in a blank mini DV tape, put the camcorder in VTR mode, and rewound the tape to the beginning. Once the camcorder was attached and ready to record, I opened a new Premiere document with the NTSC 720 × 480 digital video presets. The camcorder must be attached and turned on when Premiere starts up in order for the program to recognize it. To make sure that Premiere recognized the camcorder, I chose Edit > Preferences > Scratch Disks & Device Control. Next to DV Device Control you should see "DV Device Control." If you don't see these words, try selecting them from the pop-up menu. If this doesn't work, it is possible that you do not have a supported DV camcorder, or that you do not have the DV Device Control Plug-In installed. Next, I chose File > Import > File and imported my QuickTime movie. After dragging the movie to the Timeline and render-ing it, I chose File > Export Timeline > Export to Tape. In the dialog box that appeared, I selected the box next to Activate Recording Deck and entered 100 frames next to Preroll (this gives the camcorder time to come up to full speed). To begin recording, I clicked on OK. When the animation finished playing, Premiere automatically stopped the camcorder's recording.

I wanted to copy my animation from mini DV tape to half-inch VHS tape to make it easier to look at in a home viewing situation. To do this, I connected the camcorder's video-out port to my VHS deck's video-in port with a regular RCA cable. Then I rewound the cam-corder, put the VHS deck in record, and pressed Play on the camcorder.

"Crow"

"Crow" is an example of animating in layers.

tools and materials used

- Computer
- Drawing tablet
- Macromedia Flash

For this project, I wanted to animate a cycle of a crow flying through a landscape—the flying crow would stay in the center of the screen while the landscape passed by. To help create an illusion of depth, closer objects in the landscape would move more quickly than more distant objects; trees close to our view would pass by quickly, trees farther away would pass by more slowly, and mountains in the distance would seem to stand still. To achieve this with the least amount of drawing, I decided to separate the different elements (the crow, the near trees, the distant trees, and the mountains) onto different layers. This would give me a double benefit: first, I would not have to draw the crow, trees, and mountains many times; and second, I would be able to adjust the speeds at which the different layers pass by independently of each other (Figure 7-7).

the process

step 1: animate a flying crow as a Flash library symbol. Flash organizes a project into Scenes, Symbols, and Instances. A Scene is the entire project as it will appear when you output your finished animation, including whatever images, sounds, and animations you have put together (Flash allows you to create more than one Scene for complex projects). A Symbol is an image, a sound file, or a sequence of animation that you create independently of the Scene. These Symbols can then be used in the Scene one or more times. An Instance is a specific use of a Symbol in the Scene; you can have many Instances of a single Symbol in the same Scene. The Library is a storage bin that contains all the Symbols in your project. You can see a list of the Library contents by choosing Window > Library.

You can create a new Symbol in the Library by choosing Insert > New Symbol. This command will open a dialog box asking you to name the Symbol and choose the Symbol's behavior. The behavior choices are Movie Clip, Button, and Graphic. Always choose

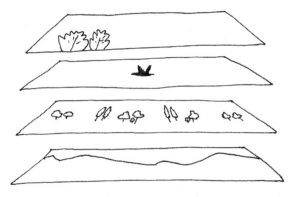

Figure 7-7 Separating artwork into different layers. (Illustration by Tim Miller.)

Graphic when creating a Symbol containing animation; otherwise you will not see the Symbol animate until you output, or Publish, the file.

When you create a new Symbol, Flash automatically opens a new Timeline and Stage in which you can create and edit your Symbol. You can check whether you are looking at the Timeline and Stage of a Symbol or the Scene by looking in the upper-left corner of the project window. If you are looking at the entire Scene, the word "Scene" is all you will see. If you are looking at the contents of a Symbol, then you will see the word "Scene" as well "(Symbol Name)" next to it. To return to the Scene, click on "Scene." To edit an existing Symbol, double-click on the Symbol's name in the Library list.

To animate the crow as a Symbol, I chose Insert > New Symbol, named it "Crow," selected Graphic as its behavior, and clicked on OK. When the new Symbol's Timeline appeared, I drew the animation of the crow in ten drawings, each in its own keyframe. I animated on one's (one frame for each drawing).

step 2: create the background layers. Traditionally, animators used cels (sheets of transparent acetate) to separate the moving parts of their scenes from the static parts. For example, a stationary background would be painted on paper and an animated character would be painted on a series of cels laid on top of the background. This technique saved the labor of repainting the entire background for each frame of animation. Flash recreates cels through the use of layers; each layer is like a sheet of transparent acetate. When you start a new Flash project, you are given one layer by default, called "Layer 1." You can add more layers to the Scene by choosing Insert > Layer, and you can rename layers by double-clicking on the layer name (naming the layers is a good idea so that you don't forget which layer is which).

For this project, I needed a total of four layers: one for the crow, one for near trees, one for distant trees, and one for the mountains. I inserted three new layers and renamed all four layers, starting with "mountains" at the bottom, "distant trees" above that, "crow" above that, and "near trees" at the top. The order in which the layers are stacked is important because those underneath will be behind those on top. However, if you make a mistake, it is easy to change the order of a layer by dragging it up or down in the list of layer names next to the Timeline.

Before I began drawing, I changed my view by choosing View > Magnification > 50%. This allowed me to see beyond the edges of the Stage area so that I would be able to draw images that extended off-screen. This was important because later on I would be panning (sliding) my images across the screen.

I clicked in the keyframe in the "mountains" layer so that whatever I drew would be in that layer. I drew an image of distant mountains the same size as the Stage. Because it was so far away, the image in this layer would not move. In the "distant trees" layer, I drew some small trees. I drew this image beyond the right edge of the Stage (about 25% longer than the width of the Stage). In the "near trees" layer, I drew larger trees. I drew this image even farther to the right of the edge of the Stage (about 50% longer than the Stage)—the longer the image, the farther (and faster) it would travel in the same number of frames. *Panning*

is an animator's term that means sliding an image across the screen. In this case, my crow was flying toward screen right, so I wanted my background images to pan from right to left.

step 3: pan the background layers. Flash pans an image by changing its position over a number of frames; this is an example of "Motion Tweening." The animator sets a starting position for the pan in one keyframe and an end position in another keyframe. The first keyframe will be extended until it reaches the second keyframe. The length of time the first keyframe lasts is how long the Motion Tween will last. Motion Tweening only works if the image has first been converted into an object. Grouping an image combines all the separate lines in a drawing into a single object. This makes it possible for Flash to calculate all the different tweening positions easily. The image looks the same, but it cannot be edited unless it is first "UnGrouped." To group the "distant trees" drawing, I selected the keyframe containing the image and then chose Modify > Group. This put a blue rectangle around the image to show that it was selected. Then I grouped the "near trees" drawing.

I extended all my layers for a total of 200 frames (the exact length was not important). To do this, I scrolled through the Timeline until I reached frame 200. Then I selected frame 200 in all four layers and chose Insert > Frame. This automatically extended the keyframe in frame one of each layer by 199 frames.

To pan the "distant trees" layer, I first selected frame 200 in the "distant trees" layer and chose Insert > Keyframe. This created a new keyframe with a copy of the image of the distant trees in it. Next, I held down the Shift key while I dragged the "distant trees" image in the second keyframe (in frame 200) to the left. Holding down the Shift key constrained the image from moving up or down; it would only slide back and forth horizontally. I moved the image only a short distance, until the right edge of the image was just outside the right edge of the Stage. This new position for the second keyframe would be the ending position for the pan. Last, I selected the first keyframe and chose Insert > Motion Tween. This command put an arrow in the first keyframe, extending the length of the keyframe and pointing toward the second keyframe. Now the "distant trees" layer would pan from right to left. I repeated this procedure with the "near trees" layer. Because this image was longer, I moved the second keyframe farther, resulting in a faster pan.

Note: There are two ways to pan a background across the screen. The first way is to make a very long piece of artwork and move it incrementally across the screen once. In this case, the background would have to be long enough to last for the duration of the scene. The second way is to make a shorter piece of artwork that can be panned as a cycle several times. In this case, the two ends of the artwork must match if you want the transition from the end of the cycle to the beginning of the cycle to be seamless.

step 4: add the crow symbol. I clicked in frame 1 of the "crow" layer and dragged the crow Symbol from the Library to the Stage (an Instance is automatically converted into an object in the Scene). I positioned the crow in the middle of the Scene. The Instance of the crow automatically extended to the end of the animation (frame 200). To check the Scene, I could scrub through the animation by dragging the cursor across the

Timeline's frame numbers, or I could see a preview of the animation by choosing File > Publish Preview > Flash.

"Naomi's Birds"

"Naomi's Birds" is an example of animating with loops.

tools and materials used

- My daughter's drawings
- Computer, scanner, drawing tablet
- Adobe PhotoShop, Macromedia Flash

Because this project includes converting bitmap images into vector images, it is helpful to understand the difference between the two. Software applications like PhotoShop and Premiere work with bitmap graphics; software applications like Flash work primarily with vector graphics. A *bitmap graphic* is an image that the computer describes as a series of dots. The dots are arranged in a grid, like rectangles on a piece of graph paper. When you draw, paint, or erase a bitmap image, you are changing the colors of these individual dots. Bitmap graphics are especially good at reproducing shading and tonal variation, but they can be memory intensive: the higher the resolution, the larger the file size. A *vector graphic* is an image that the computer describes as a series of mathematically defined points, lines, and area fills. For example, a blue rectangle could be described by four points, four lines, and an area of blue. When you edit a vector image, you are changing the mathematical description of these parameters. For example, you could drag the points of the blue rectangle farther apart or closer together, and the software would automatically make the lines and blue area fill larger or smaller to match the positions of the points. Vector graphics are best for generating images with flat colors and sharp outlines, and are especially good for the Web because they generate smaller file sizes than most comparable bitmap animations (Figure 7-8).

Over the course of several months, my daughter made a number of drawings of birds with markers, pencils, and crayons on white paper. As I looked at the drawings, I noticed that most of them were drawn in profile with the wings either up or down. By organizing the drawings into groups of two (one with wings up and one with wings down), I could create cycles of birds flying and then animate these cycles around the screen in Flash.

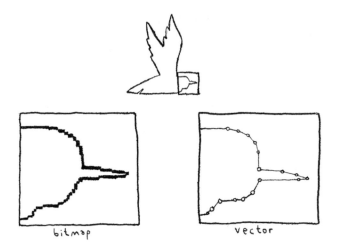

Figure 7-8 The difference between bitmap and vector images. (Illustration by Tim Miller.)

the process

step 1: organize the drawings. I sorted my daughter's drawings of birds into pairs according to similarities in size, color, and the direction they were facing. I made sure that one drawing had the wings up and the other drawing had the wings down. In the end, I found five pairs of birds that I felt would work.

step 2: scan the drawings. I scanned the drawings at 72 dpi in a scanning area of 640 pixels high by 480 pixels wide. In PhotoShop, I made an Action to rotate the images 90 degrees and to increase the contrast so that the white paper would be as evenly white as possible. This would be important later on in Flash so that I could easily delete the white area around each bird.

- Rotate (angle: −90 degrees)
- Image Size (width: 640 pixels, height: 480 pixels, resolution: 72 dpi; interpolation: bicubic)
- Levels With Auto
- Unsharp Mask (Radius: 34, Amount: 39, Threshold: 15)

Last, I saved each pair of drawings in its own folder with its own name, "Bbird001.jpg," "Bbird002.jpg," and so on. I changed the file format to JPEG because that is the preferred format in Flash.

step 3: import the scans into Flash symbols. After opening a new Flash project, I created a new Graphic Symbol by choosing Insert > New Symbol. To import the scanned bird drawings into the Symbol, I chose File > Import and navigated to the folder containing the JPEG files. I selected only the first image in the folder and clicked on Add, then clicked on Import. A dialog box appeared saying, "This file appears to be part of a sequence of images. Do

you want to import all of the images in the sequence?" I clicked on Yes, and Flash automatically placed both images with the same name in two consecutive keyframes. If I had added both images to the Import list and then clicked on Add, Flash would have placed them on top of each other in the same keyframe and I would have had to go through the trouble of cutting and pasting one of them into a second keyframe. I created new Symbols for each of the five pairs of drawings and imported the rest of the images in the same way.

step 4: vectorize the bitmap images. The imported images came into Flash as bitmaps. I wanted to convert these bitmaps to vector images to reduce the file size and also to make them easier to modify (scale, rotate, etc.). I opened the first Symbol and selected the first keyframe in it. Then I chose Modify > Trace Bitmap. I accepted the default settings and clicked on OK, and Flash took a few moments to make the conversion. When the process was finished, the image looked like a posterized version of the original scan because much of the tonal variation was eliminated. Next, I deselected the image by choosing Edit > Deselect All. Then I selected the white area around the bird by clicking on it, and pressed the Delete key to erase it. I deleted the white background because I wanted to include many birds in the final animation, and the white would have covered up other birds in the other layers. Last, I selected the bird by choosing Edit > Select All and then chose Modify > Group to group the various parts of the vectorized image into one object. I repeated this process with the rest of the imported bitmaps. In the end, I had five Library Symbols named, "Bird1," "Bird2," "Bird3," "Bird4," and "Bird5." Each one of these Symbols contained two frames of animation showing a bird flapping its wings up and down.

step 5: tween instances of the symbols in the scene. My next task was to animate the bird Symbols across the screen. To do this, I first dragged Instances of the Symbols into the Scene, and then created Motion Tweens to move the animated Instances across the screen. I clicked on "Scene 1" at the top of the Timeline to return to the Scene. Then I dragged the Symbol "Bird1" from the Library to the Scene's Stage and positioned it just beyond the right side of the Stage. Then I scrolled the Timeline to frame 300 and inserted a frame (Insert > Frame) to extend the length of the animation. Next, I inserted a new keyframe in frame 300 (Insert > Key Frame). I dragged the Instance of "Bird1" in frame 300 just beyond the left side of the Stage. At this point, inserting a Motion Tween would make the bird fly across the screen from right to left. But before I inserted the Motion Tween, I decided to change the size of the Instance in frame 300; doing so would also make the bird grow larger as it flew across the screen. In frame 300, I selected the Instance of "Bird1" and then chose Modify > Transform > Scale. This command added handles to the corners of the Instance; I dragged the handles to increase the size of the Instance. Then I selected the first keyframe in the Timeline and chose Insert > Motion Tween. Now when I played the animation, "Bird1" grew larger as it flew across the screen (as if it were flying toward us).

Before adding any more Instances, I organized my Layers in the Timeline. I renamed Layer 1 "Bird1." Then I inserted four more layers (Insert > Layer) and renamed them "Bird2," "Bird3," "Bird4," "Bird5." To stay organized, I placed all the Instances of "Bird1" in the "Bird1" Layer, all the Instances of "Bird2" in the "Bird2" Layer, and so on. Next, I added more Instances to the Scene from the Library. Each time I added an Instance of a Symbol

I changed something about the way the animation played. Changes to an Instance do not affect the original Symbol. Some of the modifications to Instances included:

- Scaling the size of the Instance
- Starting Instances at different frames in the Timeline
- Extending the Instances for different numbers of frames to make them fly faster or slower
- Changing the direction of the Instance's flight (right to left, left to right, top to bottom, etc.)
- Flipping the orientation of the Instance by choosing Modify > Transform > Flip Horizontal

Finally, to create a sky background, I changed the movie color to light blue by choosing Modify > Movie, and clicking on the white box labeled "Background Color."

"Waving"

"Waving" is an example of exaggeration as an aid to acting in animation.

tools and materials used

- Computer
- Drawing tablet
- Macromedia Flash

Animated characters often rely on physical acting to convey information, and animators often exaggerate their drawings to make the action clearer. My "actor" was a simple character, consisting of a rectangle for a torso, a circle for a head, and lines for arms and legs.

the process

step 1: animate the restrained wave. I began by creating a new Graphic Symbol called "Restrained." In the Symbol, I drew my character standing in the first keyframe with one arm down and the other arm up and bent (the first position of the wave). Then I added another keyframe, turned on Onion Skinning, and traced the first drawing, except that I slightly moved the position of the waving arm. I added a third keyframe and again traced the character, again slightly moving the position of the waving arm. I continued this process until the character's arm was almost back to its starting position (completing the wave to a point just before the starting position would allow me to cycle the animation smoothly). I ended up with six keyframes. The character was waving too quickly, however, so I slowed down the animation by selecting each keyframe in the Timeline and choosing

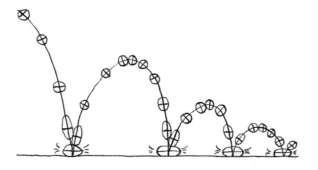

Figure 7-9 A bouncing ball demonstrates squash and stretch. (Illustration by Tim Miller.)

Insert > Frame. This resulted in a twelve-frame animation cycle consisting of six drawings on two's.

step 2: animate the exaggerated wave. I created another Graphic Symbol called "Exaggerated." In this animation my character would be jumping up and down, so I drew a ground line as a reference for where the character would land. To create the animation, I animated the torso first, then the head, then the legs, and finally the arms. The torso is the central body part, so it is the main action; the head and limbs are appendages attached to the torso, so their movements are secondary, dependent on the position of the torso.

In the first keyframe, I drew my character standing on the ground line. In the second keyframe I drew the rectangular torso slightly lower than in the first frame, and slightly squashed the torso to suggest compression in the character's body. I continued lowering and squashing the torso in the next keyframe. Then I raised and stretched the torso in each of the following five keyframes until the character reached its highest point in the jump. The next three keyframes held the apex position of the torso to create the illusion that the energy of the jump kept the character up in the air for a beat. Then the final keyframe showed the torso halfway down to the starting position to indicate a fast fall back to the ground.

Next I added the secondary elements. The head followed the movement of the torso. The legs bent as the character squashed, and straightened as the character stretched. The arms followed the torso by about one drawing; for example, when the torso was at its lowest point, the arms were still descending. Also, I added a quick wave at the top of the jump. The animation worked well on one's, so in the end I had a twelve-frame cycle of animation consisting of twelve drawings each held for one frame.

Note: Animators often distort their drawings to emphasize the action. For example, when an object (or character) hits something hard (like a wall or the ground), the shape of the object flattens, and when the object is moving through space, its shape elongates. This technique of exaggeration is called "squash and stretch," and is used to make the action clearer. A classic exercise that teaches this principle is animating a bouncing ball (see Figure 7-9). As the ball falls and rises, its shape elongates; when the ball hits the ground, its shape flattens.

"Dizzy"

"Dizzy" is an example of rotoscoping.

tools and materials used

- Computer, scanner, mini DV camcorder
- Mini DV tape, FireWire cable
- Adobe Premiere, Macromedia Flash

the process

step 1: shoot the live action. First, shoot the live action you want to rotoscope. It can be shot in real time, as pixillation, or as time lapse. Once you have recorded the live action onto tape, you are ready for the next step.

step 2: capture the live action in Premiere. After connecting the camcorder to the computer with a FireWire cable and making sure the camcorder had a tape in it and was in VTR mode, I opened a new Premiere project with the NTSC digital video presets (720 × 480, 29.97 fps). Then I chose File > Capture > Movie Capture. This command opened the Movie Capture dialog box, displaying the image from the DV tape in the window. I used the controllers at the bottom of the Movie Capture window to play and rewind the tape in the camcorder to the section I wanted to capture. (If you cannot control the DV camcorder from Premiere, you can use the controls on the camcorder itself to cue the tape to the correct spot.) I rewound the tape to slightly before the section I wanted to capture, pressed Play to roll the tape, and then pressed the Record button in the Movie Capture window. Premiere captured the video in real time. When I had captured enough footage, I pressed the Stop button. Premiere opened a Save dialog box in which I typed a filename and saved the captured video as a QuickTime file.

step 3: import the quicktime file into Flash. I quit Premiere and opened Flash. In Flash, I chose File > Import and navigated to the QuickTime file I had just saved in Premiere. I selected this file, clicked on Add, and then clicked on Import. The QuickTime movie automatically appeared in frame 1 of Layer 1 in my Flash document. To see the movie, I needed to extend the number of frames it occupied in the Timeline. I selected the first frame and chose Insert > Frame to make it last two frames long. Then I dragged the second frame to the right until it lasted long enough to display the entire clip.

step 4: trace over the live action. Next, I created a new layer by choosing Insert > Layer. The new layer must be above the layer containing the live action in order to be able to see

what you are drawing. In frame 1 of Layer 2, I used the brush to trace over the live-action image. Then I chose Insert > Blank Keyframe, which created a new empty frame for the next live-action frame. I traced over this second frame, chose Insert > Blank Keyframe again, and continued the process until I had finished rotoscoping the live-action sequence.

step 5: delete the live-action layer and output the animation. My last step was to delete the live-action layer containing the QuickTime file. This way I could play the animation by itself without seeing the live action. To output the animation, I chose File > Export Movie and saved the animation as a QuickTime file (the choice depends on your needs).

stop-motion examples

The next two exercises are examples of animating stop-motion. In "Fruit Salad" I demonstrate animating objects on a tabletop. In "Boy and Dog" I demonstrate the process of building and animating puppets.

"Fruit Salad"

"Fruit Salad" shows an example of animating stop-motion objects.

tools and materials used

- Objects (fruits, knife, cutting board, bowl, etc.)
- Set materials (table, tablecloth, desk lamp)
- Mini DV camcorder, mini DV tape, tripod
- FireWire cable, computer
- Adobe Premiere

In this project, I animated fruit, a bowl, and a knife to create an animation of a fruit salad preparing itself. I captured the animation using a mini DV camcorder and Premiere. This method of capturing animation—using a camera to record three-dimensional objects or puppets frame by frame—is called stop-motion animation.

the process

step 1: set up. First, I gathered the objects I would animate: various fruits (an orange, a banana, a pear, and an apple), a bowl, and a knife. I moved a table near the computer and prepared the set by laying a tablecloth over a table and putting a cutting board on

the tablecloth. To light the set, I first closed the shades in the room to avoid fluctuations in sunlight. I then turned on the ceiling light and set up one desk lamp to the side of the cutting board. The overhead light provided an even "fill" light, and the desk lamp provided a more focused "spot" light. I put the camcorder on a tripod and positioned it next to the table. I adjusted the height and view of the camcorder so that I was capturing the animation from an imaginary cook's point-of-view. I put the camcorder in Camera mode with a DV tape in it, and connected the camcorder to the computer with a FireWire cable.

step 2: capture the animation. Before animating, I planned the action. I decided to start with an empty cutting board, have the knife enter, then have the fruits enter one at a time. The knife would chop up the fruits. Then a bowl would enter. All the pieces of fruit except one would climb into the bowl. The reluctant fruit would exit the scene with the knife chasing it.

I opened a new Premiere project with the NTSC digital video presets (720 × 480, 29.97 fps). Then I opened the Stop Motion window by choosing File > Capture > Stop Motion. I adjusted the camcorder's framing and focus while looking at the Stop Motion window in Premiere. When it looked right, I clicked on "Start" to capture the first frame of the empty cutting board (after starting the animation, I pressed the Space Bar to take frames). Then I moved the knife into the scene in small increments, one frame at a time. After the knife entered, I animated the fruits onto the cutting board. I chopped the fruits in stages, taking frames as I went. To keep registration, I tried to move the fruits as little as possible while cutting them. If I did have to pick up a fruit to cut it, I tried to put it back in exactly the same place it had been before. As I animated, I was careful not to leave other objects (a dish-towel, for example) in the camcorder's view. I also tried not to block the light with my body while taking frames. When I was done, I took a frame of the empty cutting board again and then clicked on "Stop" to finish capturing. This opened the animation in a new clip window. After playing it, I saved it as "FruitCap," and then dragged the clip directly into Premiere's Timeline. I saved the Premiere project as "FruitPro."

step 3: change the animation rate. After looking at the animation, I decided it was too fast. To convert the animation rate from one's to two's, I needed to export the animation as a sequence of individual frames and then import them back into Premiere at two frames each. I chose File > Export Timeline > Movie, clicked on Settings in the Export Movie dialog box, changed File Type to TIFF Sequence, and clicked on OK. I clicked on the New Folder button and named it "FruitTif." I named the sequence "Fruit" and clicked on Save. This command automatically saved each frame in my animation as a separate TIFF file, naming them sequentially, "Fruit001," "Fruit002," and so on.

I deleted the animation clip in my Premiere project (the original was still saved as a separate file), and then chose File > Import > Folder. I checked to make sure that the default clip length was set to two frames by choosing Edit > Preferences > General & Still Image. Then I selected the folder named "FruitTif" and clicked on Choose. This command brought all my frames of animation back into the Premiere project at two frames each. I dragged the folder containing the animation from the Project window to the Timeline and played the animation.

"Boy and Dog"

"Boy and Dog" is an example of animating stop-motion puppets.

tools and materials used

- Puppet materials (aluminum wire, clay, tape, etc.)
- Set materials (table, foamcore, desk lamp, etc.)
- Mini DV camcorder, mini DV tape, tripod
- FireWire cable, computer
- Adobe Premiere

This project is an example of animating wire and clay puppets. Wire is a good material for animating a puppet that changes position, and clay is a good material for a puppet that changes shape.

the process

step 1: make the puppets. The wire puppet used in this project was about 8 inches high. The construction of this puppet is adapted from the designs of Yvonne Andersen (see her book, *Make Your Own Animated Movies and Videotapes*, listed in Chapter 9). To make the wire puppet, I first assembled the necessary tools and materials:

- Approximately 3' of aluminum armature wire ($^1/_{16}$" thick) for arms, legs, and neck
- An electric drill (adjustable speed drills are safest)
- A pair of pliers
- A wire cutter
- A piece of stiff cardboard for the torso ($^1/_8$" thick)
- Heavy duty stapler to fasten the wire to the cardboard
- Dense foam for the head (I carved this from packing material)
- Scissors to cut the cardboard and packing foam
- Two long-shank pushpins for the feet (to stick the feet into the surface of the set)
- Black tape to wrap the feet and hide the pushpins
- Paper and crayon for the face
- Glue to affix the face to the head

As the aluminum wire is bent into different positions, it gradually grows weaker and eventually breaks. To make a more durable armature, I used a drill to twist the wire into a double thickness. I took the 3' piece of aluminum wire and folded it in half, clamped the two ends

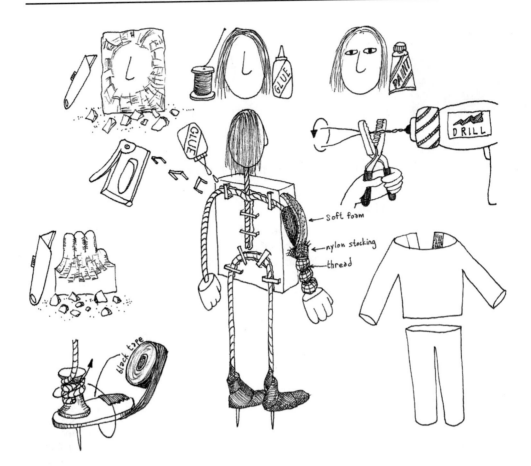

Figure 7-10 How to make a wire puppet. (Illustration by Tim Miller.)

of the folded wire in the chuck of the electric drill, held the other end of the wire with the pliers, and turned the drill on (slowly). The drill quickly twisted the two strands of wire together, producing a more durable armature that would not break as quickly as a single wire. Then I cut an 8-inch piece of the twisted aluminum wire for the legs, a 6-inch piece for the arms, and a 2-inch piece for the neck. I cut a 1½-inch by 2-inch piece of cardboard for the torso and two ½-inch by ¼-inch pieces of cardboard for the feet. Next, I trimmed a bit of the twisted ends of the 8-inch wire back so that I could wrap a ½-inch single strand of wire around the handles of the two pushpins. To create the feet, I stuck the pushpins through the two small pieces of cardboard and wrapped them in black tape (the sharp ends of the pushpins still extended beyond the cardboard and tape). Then I stapled the three pieces of wire to the cardboard and pressed the staples securely into place to make sure the wires wouldn't come loose. With the scissors, I carved a small piece of packing foam into the shape of a head and stuck that on the neck wire. Finally, I tore a small piece of paper slightly larger than the foam head and drew a face on it, and glued this face to the foam head (Figure 7-10).

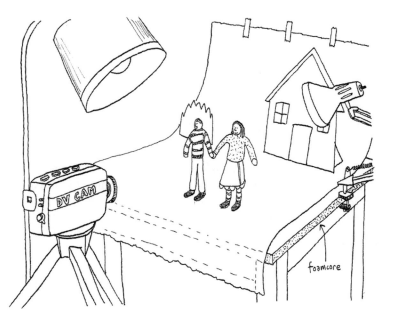

Figure 7-11 A stop-motion puppet set. (Illustration by Tim Miller.)

Making the clay puppet was a much simpler process. The only material I needed was an oil-based modeling clay (oil-based so that the clay doesn't dry out during the animation). These clays come in a variety of colors. You can mix different colors in the same puppet or you can use one color throughout. It is important to keep your hands clean when animating clay because the clay can get dirty as you handle it. I used Van Aken modeling clay, but there are other brands available. I softened the clay by kneading it for a few minutes, and then I molded it into the shape of a dog.

step 2: build the set. I built the set on a tabletop with a 3-foot by 3-foot piece of ¼-inch foam core, a 6-foot by 3-foot piece of brown paper, and tape (Figure 7-11). First, I taped the foam core to the tabletop so it wouldn't move during the animation (the puppet would stand up when I stuck the pushpins in the puppet's feet into the foam core, which would be hidden under the paper). I taped one end of the paper to the wall behind the table, about 4 feet up from the surface of the table, and then taped the other end of the paper to the tabletop. The paper formed a smooth curve covering the back edge of the table, thus creating an illusion of depth.

To light the set, I first closed the shades in the room to avoid fluctuating sunlight. I then turned on the ceiling light and set up one desk lamp to the side of the paper. The overhead light provided an even "fill" light, and the desk lamp provided a more focused "spot" light. I put the camcorder on a tripod and positioned it directly in front of the set. I adjusted the height and view of the camcorder so that I was capturing the animation at the puppet's eye level and so that I was not seeing beyond the edges of the set.

step 3: capture the stop-motion animation. After connecting the camcorder to the computer with a FireWire cable and making sure the camcorder had a tape in it and was in camera mode, I opened a new Premiere project with the NTSC digital video presets (720 × 480, 29.97 fps). Then I opened the Stop Motion window by choosing File > Capture > Stop Motion. I adjusted the camcorder's framing and focus while looking at the Stop Motion window in Premiere. I clicked on Start to capture the first frame of the empty set. Then I positioned the wire puppet just outside the left edge of the frame and bent the legs into a walking position. The rear leg was firmly pressed into the foam core to secure the puppet. I took a second frame and then repositioned the puppet in the next walking position and took another frame, and so on. With the clay puppet, I used balance to stand the dog up rather than a pushpin. When it came time to animate the dog's metamorphosis, I reshaped the dog a little bit in each frame. At the very end, I took a frame of the empty set and then clicked on Stop to finish capturing. This opened the animation in a new clip window. After playing it, I saved it as "PuppetCap" and then dragged the clip directly into Premiere's Timeline. This put the animation in the Project window as well. I saved the Premiere project as "PuppetPro."

step 4: change the animation rate. To convert the animation rate from one's to two's, I needed to export the animation as a sequence of individual frames and then import them all for two frames each. I chose File > Export Timeline > Movie, clicked on Settings in the Export Movie dialog box, changed File Type to TIFF Sequence, and clicked on OK. I clicked on the New Folder button and named it "PuppetTif." Then I named the sequence "Puppet" and clicked on Save. This command automatically saved each frame in my animation as a separate TIFF file, naming them sequentially as "Puppet001," "Puppet002," and so on.

I deleted the animation clip in my Premiere project (the original was still saved as a separate file), and then chose File > Import > Folder. I checked to make sure that the default clip length was set to two frames by choosing Edit > Preferences > General & Still Image. Then I selected the folder named "PuppetTif" and clicked on Choose. This command brought all my frames of animation back into the Premiere project at two frames each. I dragged the folder containing the animation from the Project window to the Timeline and played the animation.

sound examples

The last four exercises are examples of different ways to work with sound. The first, "Dance," shows how to import a MIDI soundtrack into Flash and animate to it. The second, "Forecast," shows the process of creating lip sync animation to a voice track. The third, "Sneeze," demonstrates recording a live soundtrack to an existing animation. The fourth, "Hannah's Peacocks," demonstrates mixing a soundtrack to an existing animation.

Note: Copyright laws protect artistic and intellectual works, including almost all recorded music. If you use any pre-recorded sound or music, be aware that it is probably under copyright with an individual, a business, or an organization. You are not allowed to use copyrighted materials in your projects without the written consent of the copyright holder. This is not an issue if you are making an animation for your personal use or to share with a few friends, but it does matter if you will be showing your work at festivals, on Web showcases, or through other forms of distribution to the public. In fact, most of these places will require

that you sign a release stating that you own the copyright to all the elements that appear in your work. If you feel you must use pre-recorded materials, be sure to write to the copyright holder (listed on the recording) to ask for written permission. Sometimes you can get permission, usually for a fee, but it is much easier to avoid the copyright issue by creating original music and sound for your projects.

"Dance"

"Dance" is an example of animating to a music track.

tools and materials used

- Making More Music, QuickTime Pro Player,
- Computer, drawing tablet
- Macromedia Flash

the process

step 1: create the music track. In this project, I started with a music track and created animation according to the timings of the music. I created the music in Making More Music, by Morton Subotnick (my father). Making More Music is one in a series of applications designed by Subotnick to allow children and adults to create their own musical compositions.

Note: This program (and others like it) generates music as MIDI files. MIDI stands for Musical Instrument Digital Interface; it is a language that describes various parameters of musical events, such as pitch, duration, and loudness. However, these MIDI descriptions are not actual sounds; in order to hear a MIDI note, MIDI software must control a MIDI-compatible sound synthesizer. Think of a MIDI file as being like a player piano roll; the roll is punched with holes, and as the roll advances inside the player piano, it triggers specific keys to strike piano strings. In this analogy, the roll is the MIDI file and the player piano is the synthesizer. Contrast this to sound file formats like AIFF or WAV. These are actual digital sound recordings in which a specific sonic waveform is digitally reproduced. All of this is important because Flash and Premiere cannot play MIDI files; they will only play actual digital sound recordings saved in the AIFF or WAV formats.

In Making More Music, I created a musical composition and then saved it as "music.mid." Then I used QuickTime Pro Player to convert the MIDI file to an AIFF file (the free Quick-Time Player and the inexpensive QuickTime Pro upgrade can both be downloaded from www.apple.com). I opened QuickTime Pro, chose File > Import, and selected the MIDI file. After it loaded into QuickTime Pro, I chose File > Export, changed the Export pop-up menu to "Music to AIFF," and named the file "music.aif."

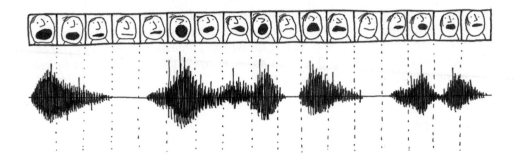

Figure 7-12 An audio waveform is a visual representation of a sound. (Illustration by Tim Miller.)

step 2: import the music track into Flash. After I had converted the MIDI file to an AIFF file, I opened a new Flash project. To bring the music track into my project, I chose File > Import, and selected the AIFF file, "music.aif." I clicked on Import, and the file automatically loaded as a Symbol in the Library. Then I dragged the Symbol of the music file onto the Stage. This created an Instance of the audio Symbol in Layer 1, keyframe 1. I extended the duration of keyframe 1 by selecting it and then choosing Insert > Frame. Once I had two frames of the keyframe, I dragged the right end of the keyframe to the right in the Timeline until it was long enough to show the entire sound's waveform.

In order to hear the sound while scrubbing the Playhead, I changed the behavior of the sound's Instance from Event to Stream. I first selected the keyframe containing the sound in the Timeline and chose Windows > Panels > Instance. In the panel that opened, I clicked on the Sound tab, and then clicked on the Sync pop-up menu and dragged to Stream.

Note: Flash can play a sound file in two basic ways: as an Event Sound or as a Stream Sound. When the behavior of a sound is set to Event, the sound is played when Flash reaches the first frame of the sound. An Event behavior is like a trigger; the sound continues until it is finished, regardless of what is happening in the animation. This behavior is best for sounds that don't have to be in sync with the picture. The other option, which is better for animation, is to set the behavior of the sound's Instance to Stream. In this case, Flash forces the animation and sound to play together; the sound does not continue to play after the animation stops.

step 3: animate to the music track. First I listened to the music track. I played the track a few times to get a sense of what parts of the music I was interested in animating to. To get a more precise sense of these timings, I scrubbed through the track by dragging the Playback Head. Scrubbing allowed me to listen to the track at a slow speed while looking at the waveform in the Timeline. The visual representation of an audio waveform gets bigger when the sound is loud and gets smaller when the sound is quiet (Figure 7-12). This way I was able to identify on exactly which frames sounds occurred. Next, I began drawing specific frames, making images that changed on beats.

"Forecast"

"Forecast" is an example of animating lip sync.

tools and materials used

- Desktop microphone
- Paper, paint, paintbrushes, gluestick
- Computer, scanner
- Adobe Premiere, Adobe PhotoShop, Macromedia Flash

Lip sync requires matching the shapes and action of a character's mouth to the sounds of speech. The goal is to make it look as though the animated character is really speaking the words in the soundtrack. For example, a small, round mouth shape would match the sound, "oo"; lips pressed together would match a number of sounds, including, "m," "p," and "b" (Figure 7-13).

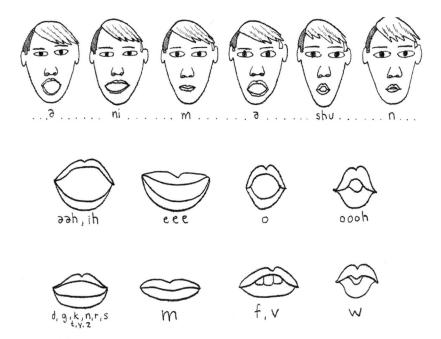

Figure 7-13 Examples of mouth positions for animating lip sync. (Illustration by Tim Miller.)

the process

step 1: record the audio track. To record the soundtrack in Premiere, I chose File > Capture > Audio Capture. This opened a small dialog box that showed the audio input levels coming through the microphone. As the audio got louder, the yellow bar moved from left to right. The sound is too loud if the bar reaches the right edge and turns red; this would mean that the sound was distorting. To avoid distortion, I practiced saying my lines a few times while watching the yellow bar to determine how far away from my mouth the microphone should be. Then I clicked on the Record button. To stop recording, I clicked on the Stop button in the Audio Capture dialog box. After clicking Stop, a new window opened up showing a soundwave form of my recording. I played this by clicking on the window's Play button, and then saved it as "forecast.aif."

Note: There are two common audio file formats: AIFF and WAV. AIFF is common in the Macintosh operating system; WAV is the file format developed for Windows operating systems. Both formats can be used on either type of computer, depending on the software application in use. You can convert an audio file from one format to the other in a software application like ProTools Free, which will read and save both types of files.

step 2: make the artwork. Before I made the artwork, I spoke the lines in my recording while watching my face in a mirror. I noted the basic shapes my mouth made during the speech, and I made five different collages of a character's face, each version with one of these different mouth shapes. I scanned the collages into PhotoShop, cleaned them up, and saved them as JPEG files with names that described their mouth positions. For example, I named the image of the face with a small, round mouth "oo.jpg."

step 3: import sound and images into Flash. In a new Flash project, I created five new Symbols named according to their mouth positions: for example, "oo," "m," and "ah." Then I opened the "oo" Symbol and imported the file, "oo.jpg" into it. Next, I chose Modify > Trace Bitmap to convert the scan into a vector image. After importing and converting the remaining faces into their respective Symbols, I imported the file "forecast.aif"; this came in automatically as an audio Library Symbol.

step 4: sync up the sound and images. I returned to the Scene and dragged the audio Symbol onto the Stage into Layer 1. I renamed this layer "soundtrack," and extended the keyframe to last the length of the recording. Next, I changed the behavior of the sound-track to Stream in the Instance panel (Window > Panel > Instance). Then I inserted a new layer and named it "animation." Before I dragged any images into the animation layer, I first inserted blank keyframes at all the major sync points. For example, the first word in the recording was "Today." At the frame under the sound "d," I inserted a blank keyframe. At the end of the word, after the sound "y," I inserted another blank keyframe. This gave me two blank keyframes for the word "Today"—one that lasted the length of the sound "To . . . ," and one that lasted the length of the sound ". . . day." I continued through the entire track, inserting blank keyframes at each major change in vowels or consonants. Then I dragged the corresponding image for "To . . ." (the Symbol named "oo") into the first keyframe. Because that keyframe already lasted the same number of frames as the sound "To . . . ," the image and the sound matched. I continued dragging Symbols from the Library

into keyframes, matching the sounds and the images as I went. When I was done, I played the animation to check sync and made any necessary adjustments.

Note: Sometimes an audio track in Flash will begin with an ugly distortion if the keyframe containing the audio starts on frame number 1. If this happens, slide the keyframe one frame later in the Timeline so that the audio keyframe starts on frame 2.

"Sneeze"

"Sneeze" is an example of recording a Foley soundtrack.

tools and materials used

- Animation previously made in Flash
- Computer, desktop microphone
- Adobe Premiere, Macromedia Flash

This project is an example of recording a sound track while watching the animation play. This way of recording sound has been widely practiced ever since the advent of film sound, and it became forever associated with a Hollywood inventor and master of the technique, Jack Foley. Foley recording is usually used for sound effects needed in an animation, but it can also include voice and music recording. I started this project with an animation of a man sneezing created in Flash.

the process

step 1: set up the computer to record. I first made sure my computer was ready to record through a microphone. First, I connected my microphone to the computer: on my Macintosh computer, I used a simple and inexpensive Multimedia Microphone from Apple Computer. I connected the microphone's mini RCA plug to the mic input jack on the back of the computer. Then I chose Apple Menu > Control Panels > Sound. In the Sound dialog box, I selected "Input," then selected "Built In," then dragged the pop-up menu to "External Mic," and closed the dialog box.

step 2: bring the animation into Premiere. Because I made this animation in Flash, I first needed to output it as a QuickTime movie so that I could import it into Premiere. To do this in Flash, I chose File > Export Movie, and set the format to "QuickTime." I named the file "Sneeze.mov." Then I opened a new Premiere project with the standard NTSC settings and imported the QuickTime file by choosing File > Import > File. It didn't matter which project settings I selected because I was using Premiere only to record sound. Once the animation

was imported into the Project window, I dragged the animation into the Timeline so that I could see the animation play.

step 3: record the sound. To record the soundtrack, I chose File > Capture > Audio Capture. To avoid distortion, I practiced sneezing a few times while watching the yellow bar to determine how far away from my mouth the microphone should be. I began recording by clicking on the Record button. Then I played the animation in Premiere and recorded myself sneezing as my character sneezed on the screen. I tried to sneeze in time with the animation so that the sound would be in sync with the picture. To stop recording, I clicked on the Stop button in the Audio Capture dialog box. After clicking Stop, a new window opened up showing a soundwave form of my recording. I saved it as "Sneeze1.aif." I repeated this process several more times until I felt sure I had at least one good recording.

step 4: check sync. To check which audio clip worked best with my animation, I dragged each clip's soundwave from the clip window into Premiere's Project window. Then I dragged the sound clips one at a time to the Timeline, playing each one separately with the animation. By sliding the audio clip back and forth in the Timeline, I could find the alignment that most closely matched the action. After listening to all the clips, I picked the best one and noted its name. If my goal had been to output a QuickTime movie or record to videotape, I would have finished up the project here in Premiere. But I wanted to play this animation on the Web, and for this I preferred to have a Shockwave file. So my next step was to import the audio file into Flash.

step 5: import the audio into Flash. After quitting Premiere (I didn't bother saving the Premiere project), I opened the Flash animation of my character sneezing. To bring the audio file into Flash, I chose File > Import, selected the audio clip "Sneeze1.aif," clicked on Add, and then Import. This automatically brought the audio clip in as a Symbol and added it to the Library. To get the sound into the Timeline, I first inserted a new layer (Insert > Layer), and named it "soundtrack." Then I dragged the audio clip Symbol from the Library window to the Stage. The Instance of the audio clip appeared as a waveform in a keyframe that lasted as long as my animation. (If the keyframe hadn't been long enough to accommodate the entire length of the audio clip, I could have extended the keyframe by choosing Insert > Frame, or by dragging the end of the keyframe to the right.)

"Hannah's Peacocks"

"Hannah's Peacocks" is an example of mixing a soundtrack.

tools and materials used

- Animation made from my daughter's drawings (saved as a QuickTime movie)
- Computer, desktop microphone
- Adobe Premiere, DigiDesign ProTools Free

This project is an example of mixing a combination of sound effects to an existing animation. The animation was created by scanning in drawings of peacocks made by my daughter. I imported these scans into Flash and converted them into vector images. Then I broke them apart into pieces so that I could animate them as if they were paper cutouts. I exported a copy of the Flash animation as a QuickTime movie so that I would be able to import it into ProTools Free. The process of sound mixing involves placing individual sounds in different tracks so that they can be individually edited, and then creating a new sound file that combines all the tracks into one new file. ProTools Free allows up to eight tracks (one of which will be taken up by the QuickTime movie).

the process

step 1: record sound effects. Because I was using my computer as a recording deck, I had to either bring sound sources to the computer or move the computer to the source of the sounds. This meant that I could not go out and record sounds outside of my home. If I had wanted to record away from home, I would have needed a portable recording device (cassette tape, DAT recorder, or a digital recorder), and a way to get the recordings into my computer. Short of buying a specialized sound card, there are three ways to get sounds into the computer:

- Through the sound port (requires an RCA mini plug; see your computer's specifications)
- Through a USB or Flash Memory Card port (from a digital recorder)
- From a disc (a sound file already on a CD, DVD, or Zip disc)

Before I started recording sound effects, I first looked at the animation and made a list of the effects I thought I would need. These included footsteps, rustling feathers, cuckoo clock chimes, and an ambient environmental sound. I gathered together various materials that I thought might help me make the sound effects. For example, I tried tapping pencils on plastic food containers for the footsteps, and I tried crumpling plastic bags for the sound of rustling feathers. For the ambient sound, I simply opened my window and listened to the sounds of my neighborhood.

To record, I first made sure my computer was set up to receive audio through an external microphone (on the Mac, Apple Menu > Control Panels > Sound > Input > External Mic). Then I opened Premiere and opened the Audio Capture window (File > Capture > Audio Capture). I practiced the sound effects while watching the levels (the yellow/red bar) to make sure that I would not distort the sound. Then I recorded each sound effect a number of times. I saved each sound effect with a descriptive name such as "steps1" or "steps2." After saving the clips, I chose File > Export Clip > Audio, and clicked on the Settings button. In Audio Settings, I changed the Format to "16-bit Mono."

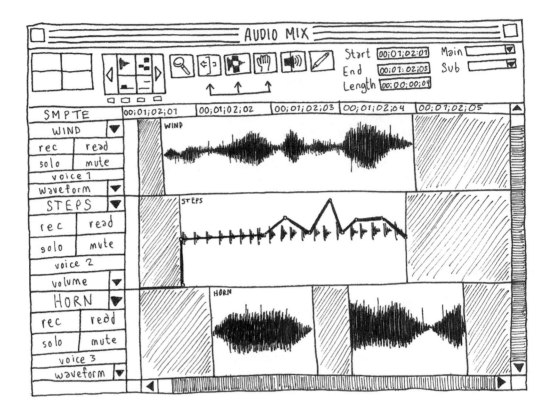

Figure 7-14 The ProTools Screen. (Illustration by Tim Miller.)

step 2: import sound and image into ProTools Free. After all the individual sounds were recorded, I quit Premiere and opened ProTools Free (Figure 7-14). To open a new project, I chose File > New Session. ProTools then prompted me to name the Session. I named it, and ProTools then prompted me to choose between 16- and 24-bit depth. Audio bit depth is a measurement of the digital sound file's resolution; the higher the number, the finer the sound (and the larger the file). Because Premiere recorded the audio at a resolution of 16 bits, I chose a bit depth of 16 for this Session (you cannot mix different audio resolutions in the same Session).

Next, I brought my QuickTime movie into ProTools by choosing Movie > Import Movie. In the dialog box, I selected the QuickTime animation and clicked on Open. This command placed the QuickTime movie in a Track in the Edit window, and opened a new window displaying the animation. ProTools automatically named this first track after the name of the QuickTime movie (the name is at the far left of the track). ProTools displayed the Edit window contents in blocks of 30 seconds. Because my animation was short, I wanted to look at the tracks in smaller blocks of time. To do this, I clicked on the Scale button facing right; this expanded the track so that I could see more detail. As I expanded my view of the track, I could see individual frames of the QuickTime movie in track number 1.

To import the sound files, I chose File > Import Audio/Track. In the dialog box that opened, I selected up to seven sound files, clicked on the Add button, and then clicked on the Done button to import them. Each of the seven sound files came into ProTools in its own track, creating the maximum number of eight tracks ProTools Free will allow. I needed to free up tracks for more importing, so I selected the tracks containing the sounds by clicking on their names at the far left of each track and then deleted them by choosing File > Delete Selected Tracks. (When a track is selected, its name is white; when it is deselected, its name is gray.) If you delete the track containing the sound's waveform, your sounds are still available in your ProTools session. You can see a list of the imported sounds by clicking on the double-arrow button in the lower-right corner of the Edit window (this is called the Audio list). To work with these sounds again, drag them from the list into any track.

step 3: edit and mix. After I had finished importing all my sound files, I was ready to edit them. I dragged my first sound file from the Audio list onto a track and listened to it by clicking on the Play button in the Transport window. ProTools played the QuickTime movie and the sound files simultaneously; however, the sound wasn't in sync with the picture. To sync the sound to the picture, I chose the Hand tool from the top of the Edit window and dragged the sound file in its track until it was lined up with the proper frame of animation. I used the sound's waveform to help me see which part of the sound file should be lined up with a particular frame of animation. If the sound file was too long, I trimmed it by choosing the Trim tool at the top of the Edit window and dragging the end of the waveform (if I changed my mind, dragging the waveform out again would reveal the trimmed portion again). When I dragged the next sound from the Audio list to a track, I made sure that I did not place it over the existing waveform; this would have automatically trimmed the first waveform. I continued dragging sound files from the Audio list into tracks and lining them up with frames of animation until I had all the sounds I needed in sync with the picture.

Next, I wanted to adjust the volume of individual sounds. To do this, I clicked on the pop-up menu labeled "Waveform" (found under each track's name) and dragged down to "Volume." This command grayed out the waveforms and added a horizontal line to that track. The horizontal line is the volume control for the track; dragging the line up or down with the Trim tool will raise or lower the volume of the track. To change just a portion of the track, you can click and drag a point on the line with the Hand tool. In these ways, I adjusted the volume of each track (and individual sounds within each track) until the relative loudness of the different tracks sounded right. I also added a short fade in and fade out to the beginning and end of sounds that started or stopped too abruptly.

step 4: bounce to disk. The last step was to create a new sound file that combined all the sound edits made in ProTools. ProTools calls this process "Bounce to Disk." I chose File > Bounce to Disk, and in the dialog box that opened, I chose to make the new file as a single stereo file, and to have ProTools convert the file after bouncing. I clicked on the Settings button and clicked on the File Format pop-up menu to select the format for my final mix. I named the new file "PCmix.aif."

step 5: import the sound and movie files into Premiere. After quitting ProTools, I opened a new Premiere project with the DV NTSC presets and imported my QuickTime file

("peacocks.mov") and sound mix ("PCmix.aif"). Then I dragged the QuickTime file into the Video 1a track and the AIFF file into the Audio 1 track in the Timeline.

summary

In summary, I want to emphasize that the examples in this chapter are designed to give you some basic techniques and concepts to work with. There are many ways to make animation other than those demonstrated here, using different approaches, different techniques, and different software and hardware choices. Your interests may lead you in very different directions in style and subject matter. Remember that the medium of animation is constantly being reinvented by animators (that is, you).

Consider challenging the received conventions of smooth, nice, slick, fluid action or design by:

Setting impossible goals.
Drawing with your "other" hand.
Using an unfamiliar stylus, like one of those extra long brushes used by Matisse.
Drawing upside-down.
Using "inappropriate" media like trash, left-overs, hand-me-downs.
Messing a sequence of pencil lines by vigorous finger rubbing.
Crumpling or ripping your cleaned-up paper drawings, before capture.
Restoring some angles and weird, jerky pauses to those perfect keyframed arcs.
George Griffin

chapter 8

showing your work

My personal work is inspired by true events. I interview people and animate to their soundtracks. This gives me a structure to work from, and I am inspired by their stories.

Sheila Sofian

distribution options

Motion picture film remains an option for theatrical shows, and videotape is still a common format for both public and private screenings. But many people now distribute their work informally on CD-R and DVD-R, and DVD-V is emerging as an alternative to videotape (DVD-R is a particular format of DVD used for storing computer files, and DVD-V is a format of DVD used as an alternative to videotape). Perhaps the biggest frontier is the Web. As data transfer speed increases and personal computers become more powerful, the quality, size, and length of Web-delivered video and animation will improve. These improvements will multiply the ways in which the Web can be used as a distribution medium.

In general, there are four basic ways to show your work. First, you can enter your animation in festivals and other competitions; if you are accepted, your work will be seen by festival audiences and you will gain recognition as an animation artist. Second, you can submit your animations to a distribution service such as Microcinema International. This distribution service shows work in alternative screening venues like film cooperatives, special programs in festivals, and museums. Third, you can submit your work to Web showcases. These sites function as online galleries featuring the work of various video and animation artists. Fourth, you can distribute your work yourself to others on tape, disc, or the Web.

film and video festivals

Showing your work in festivals can be gratifying, exciting, and educational. Inclusion in a festival can stimulate and encourage your practice of animation, and it can bring your work to the attention of a wider audience. A festival is presented to the public in the spirit of a celebration of animation. If your work is selected, it means that others in the field consider your animation to be a valuable contribution to the art form. Your animation will be shown with other works, competing for the further recognition of an award. Last, but not least, is the value and pleasure of attending an animation festival. Seeing the many works and meeting other animators and those who appreciate animation in the concentrated experience of a festival will teach you a tremendous amount about the art form.

There are many kinds of festivals and competitions. Some, which I call traditional festivals, take place in a specific location in a specific period of time, but others are virtual festivals that take place on the Web. Web festivals don't usually offer the intimacy of a traditional film festival, although some of them may also organize a theatrical screening as part of their celebration. Traditional festivals are best for seeing work in good screening conditions, and because people come together for a period of time, these events generate excitement and facilitate the exchange of ideas. Certain festivals show only animation, and other festivals show a mixture of animation and live-action work. In general, festivals that show only animation are better for the animator because they have a more concentrated focus.

Figure 8-1 The Hiroshima International Animation Festival. (Courtesy of Sayoko Kinoshita.)

Most of these festivals can show work on either film or video, a few festivals can show only video, and in rare cases, you will find a festival that shows only work on film. The standard video format for theatrical screening has been Beta, but it will probably become increasingly common to screen on DV and DVD-V. The United States and Japan use the NTSC video standard, and Europe uses the PAL video standard; some festivals can show both NTSC and PAL video, but other festivals can show only one or the other. Film formats are universal: the first choice is 35 mm, but 16 mm is also quite common. The bottom line is that you will have to check with a particular festival to see which video and film formats they are able to screen. If your work is accepted, some of the larger, international festivals will offer to pay for your accommodations and meals. Remember that festivals are highly competitive. Many people submit work, but because of limited screening time, only a small percentage of the submissions can be accepted. Try not to be discouraged if your animation is rejected by a festival. The works are usually reviewed by committees, and there are times when excellent work does not get into one festival, but does get into another.

To enter your animation in a festival (traditional or Web), you will need to output your work to an appropriate format (read the festival regulations on the festival's web site), fill out an entry form (these often can be completed on the festival web site), pay an entry fee (if

required), and send a copy of your animation, a publicity photo of yourself, and an image from your animation to the festival by the entry deadline. To begin researching festivals, see Chapter 9.

When picking which festivals to enter, consider the cost of entering, the reputation of the festival, and what type of work that festival favors. For example, many European festivals don't charge entry fees, but most festivals in the United States do. The fees range from $25 to $50 for each entry. Occasionally a festival that looks legitimate may be a scam; fees should only cover the cost of processing the entry, so high entry fees are suspect. One way to judge the reputation of a festival is to ask other animators for their opinions; another is to visit reputable web sites such as awn.com, and view their listings. Judge whether or not a festival is right for you by visiting the festival's web site (if they have one). Their site may give you a sense of the type of work they favor by featuring what kind of work they have shown in the past.

Microcinema International

Microcinema is a company name and a term that refers to a variety of alternative screening venues for independent and experimental work. These venues include art galleries, museums, schools, and filmmaker collectives, as well as special screenings in film and video festivals. Finding such venues can be difficult for the individual animator, so Microcinema International (see Chapter 9 for contact information) has been established to coordinate distribution of independent work to these screening situations. Microcinema International will take submissions from animators on videotape, and then distribute accepted work to various screening locations with which they have established alliances.

Figure 8-2 Microcinema International. (Courtesy of Joel Bachar.)

Web showcases

Web showcases are sites that show video and animations made by several people (see Chapter 9 for a partial listing of Web showcase sites). A showcase works like a gallery. All the works available for viewing are listed on the site, and by clicking on an image or text link, the viewer can either download the file or view it over the Web as a streaming file. There are many sorts of showcase sites on the Web; some of these sites will show just about any work sent to them, and others are highly selective about the work they will exhibit. All of them will put accepted work up on their sites for a certain period of time, and during this time, your animation can be viewed by the public.

If you choose to pursue this method of distribution, your first step will be to visit various showcase sites to see which ones seem right for your work. Then you should look at their policies (these should be available on the site) to check that you are comfortable with their requirements for content, technical specifications, distribution rights, and payment (if any). After you have done this, then you will send your work to them according to their instructions (on tape, on disc, or over the Web). The showcase site will take it from there, putting your animation up in their gallery for a given period of time. In general, these sites offer exposure but no money. Most of them do not charge application fees for looking at your work. If they do offer payment, they are likely to require the right to show your work exclusively for the period of time specified in their contract. Whatever the arrangement you make with the site owners, be sure to read their policies carefully. There are a number of issues to consider:

- **Content of the site:** Does the site show primarily animation, live-action, shorts, or features? Are the works primarily humorous, experimental, narrative, or documentary? Do you like the work?
- **Method of acquiring works:** Is this site open to submissions, or do they select work by invitation only?
- **Delivery method:** How do they want the animation delivered? Some options for sending your animation include VHS, DV, QuickTime on CD or DVD, or files transferred directly from your web site.
- **Technical specifications:** Does the site require specific frame sizes, frame rates, file formats, or codecs?
- **Distribution rights:** Most sites will accept your animation nonexclusively, but some sites will want exclusive rights to your work, meaning that they don't want anyone else to exhibit your work while they have it. If you decide to sign an exclusive deal, ask how long the contract will last, and ask yourself what you are getting in exchange for their exclusive screening rights. For example, will they pay you?
- **Period of time:** How long will they show your animation on the site? In the case of an exclusive deal, you might want the contract to expire when they stop showing your work.
- **Application or hosting fees:** Most sites do not charge fees, but some charge an application fee and some charge a hosting fee (usually calculated as a certain amount of money per minute of screen time). If the site does charge, ask yourself if it's worth it, and check around on the Web and through word of mouth to make sure the site is reputable.

Figure 8-3 A Web showcase: IWantMyFlashTV. (Courtesy of Nicholas Da Silva.)

- **Payment:** Most sites will not pay you. The idea is that you are getting exposure while they are getting good work to show on their site. If the site will pay you, ask how they calculate payment: is it a one-time fee, or is it a percentage of their revenue?

direct distribution

You can also advertise and distribute your work directly to the public on videotape, on disc, or most commonly, over the Web. There are two requirements for distributing your work. The first is that you have a method for delivering your animation; the second is that you create awareness of your work.

Most people who distribute their animation directly use their personal web sites to deliver their work, but other methods can include videotape (VHS is still the most common video format), DVD-V (which is gradually replacing VHS), and CD-R or DVD-R. If you distribute your animation on tape or disc, you will be delivering your work by hand or through the mail. If you distribute your animation over the Web, your viewers will either download and play back your files on their hard drives, or they will watch your animation play in real time over the Web as a streaming file (streaming requires a special streaming Web server). Creating awareness of your work is the harder part of this process. There are a number of strategies you can use to make your site more visible on the Web (for example, meta tags, discussed later in this chapter), but the main ingredients for success are quality and consistency. If you establish a web site and continuously show good work on it, people will

Figure 8-4 An animator's personal web site: MikeOverbeck.com. (Courtesy of Mike Overbeck.)

return to your site and create awareness of it through word of mouth (the best advertising of all).

If you are distributing your animation through a computer medium (CD, DVD, or the Web), you will need to export a copy of the animation to a format designed for viewing media. There are three popular formats in use right now: QuickTime, RealMedia, and Windows Media Player. These formats are called *media players*, and they each function a bit like a projector. For example, if you save your animation as a QuickTime file, it can be played on any computer that has QuickTime Player software installed. These players are usually free; they often come pre-installed on computers, or they can be downloaded from the manufacturers' web sites. You can also include the appropriate media player on your disc with your animation, such as the QuickTime Basic Installer (read about using the Installer at www.apple.com).

- In general, design your animation so that your files will work on the least sophisticated systems (within reason) you expect your audience to use, and test your files on a number of different systems to make sure they actually work. Friends and family can help with this. Here are some questions to ask yourself:
- Do you expect your viewers to have a DVD drive?
- If you are making CDs, is your CD readable by both Macs and PCs (called a hybrid, or cross-platform, CD)?
- What is the slowest CD drive you expect your viewers to have (for example, 4x)?

- What is the slowest system you expect your viewers to use? This is a measure of CPU speed: for example, an iMac with a CPU speed of 500MHz.
- What is the slowest Web connection you expect your viewers to use? Generally, the slowest connection will be a 56K modem.
- What media player do you expect your viewers to use? QuickTime is currently the closest thing to a universal format for distributing media on computers, but other choices are Windows Media Player and RealMedia Player.

I have always distributed my work first to film and video festivals, and this is usually my first recommendation to my students. Festivals are major events and offer the greatest rewards: large audiences, critical attention, a chance to travel to an international gathering of colleagues, and inspiring screenings. Another reason I send my work first to festivals is that most festivals will only accept work made within the two years prior to the competition. Therefore, I make sure to start distributing my animations as soon as they are finished.

Once I have exhausted the festival circuit, I begin looking for alternative methods of distribution. Some opportunities arise as a result of festival screenings, such as inclusion in various curated screening programs. I have also shown my animations in small screenings at galleries, schools, and libraries, and have participated in Microcinema distribution as well. I keep copies of my films on hand so that I can give them to people who show an interest, or people who I think should be aware of my work. My screening copies are currently all on VHS, but I imagine that within a few years I will be distributing my work on DVD-Vs as well. At this point, I am not showing animation over the Web, but I do maintain a site to provide information about my work and as a point of contact.

output examples

The six formats in which you can show your animation are computer hard drive, CD-R (or DVD-R), DVD-V, videotape, film, and the Web. In general, playing animation from a hard drive, CD-R, or DVD-R is appropriate for a single viewer sitting at a computer. DVD-Vs can be played on a personal computer, a home DVD set-top box, or in a screening hall. Animation on videotape can be viewed either in the home or in a theater. Transferring animation to motion picture film is practical only if you are planning to release your animation theatrically or sending it to film festivals.

Showing your animation on the Web offers both advantages and disadvantages. Internet connections are increasingly common, so the Web is a good way to reach a potentially large audience. But most people use dial-up modems, meaning that data rates are very slow, requiring that animations be low resolution and short. If possible, decide how you want to show your animation *before* starting a new project (see Chapter 6); it will help you decide how to make the animation. For example, designing an animation to play over the Web will require low resolution and small screen size, whereas designing an animation for transfer to 35mm motion picture film will mean very high resolution, lots of image detail, and a huge screen size. Following are tips for outputting your animation to the six formats.

I used Premiere 6 and the Cleaner EZ plug-in to output the example projects for this book. Premiere is a good general-purpose editor, and Cleaner is one of the best tools I know for preparing media for output. The settings in Cleaner determine things such as file format, compression, and data rate. Cleaner will automatically format your project for the medium you select, or you can customize the settings.

- **File format:** This is the basic way that your file is stored. Since QuickTime is the most common media player file format, that is the format I use in this book. Actually, QuickTime is more than just a file format; it is referred to as an architecture (see Chapter 6).
- **Codec (compression/decompression):** This is software that reduces the size of your file for efficient storage and faster playback. Different codecs use different strategies to reduce file size; some are more efficient than others, and each codec will affect the look of your animation in a slightly different way. You won't know which is best for your particular file until you test your animation in each (see Chapter 6).
- **Frame rate:** This is a measure of how quickly your animation will play back. Ideally, you will want to choose the same rate at which you made the animation. If you must lower the frame rate in order to achieve smooth playback, choose an even division of that number (for example, try fifteen frames per second if you animated at thirty frames per second). That way the reduced frame rate will be less noticeable.
- **Frame size:** This is a measure of how many pixels tall and wide your animation will be when it plays back. Common choices are 160 pixels wide by 120 pixels tall for playback over the Web, 320 by 240 for playback on CD-R or DVD-R, and 720 by 480 for DV and DVD-V.
- **Bit depth:** There are two types of bit depth, one for image and one for sound. Also called "color depth" when it refers to image, this is a measure of how many colors can be displayed in your project (24-bit depth can display millions of colors). For sound, bit depth is a measure of audio quality (16-bit audio will produce good results).
- **Audio channels:** This refers to either stereo or mono sound. Use stereo when it is important for the quality of your audio; otherwise, mono is fine. In fact, you should plan to use mono sound when playing animation over the Web to keep the file as small as possible.
- **Data rate:** This is determined by the speed of the computer's CPU. It is a measure of how much information can be processed by the computer at any one moment. For Web playback, data rate is primarily a measure of how much information can pass through the type of Internet connection (modem, cable, DSL) at any one moment. Cleaner will help determine optimal data rates for different situations.
- **Delivery style:** This refers to the method of transmitting animation from a Web server to the viewer. The two basic choices are Progressive Download and Realtime Streaming.

playback on a computer's hard drive

The hard drive is the disc installed inside the computer. You can simply play back the animation on your own computer, or you can put your animation on another computer's hard drive. Here is a list of the settings you might want to use when outputting an animation in a format to play back from a hard disc:

- File format = QuickTime
- Video codec = Sorenson Video
- Color bit depth = 24-bit (millions of colors)
- Frame rate = 30 frames per second
- Frame size = 320 pixels × 240 pixels
- Audio codec = IMA 4:1
- Audio sample rate = 44.100 kHz
- Audio channels = stereo
- Audio bit depth = 16-bit
- Data rate = roughly 250 kilobytes per second

To output your animation from Premiere using the Cleaner plug-in:

1. Open your project and render the Timeline.
2. Choose File>Export Timeline>Save for Web.
3. Click on the Settings pop-up menu and drag down to Settings Wizard; click on the Start button. This will open Cleaner's helper application, Settings Wizard.
4. Select the following choices as you move through the "Settings Wizard" screens:
 - Delivery Medium = Kiosk, Presentation from Hard Drive, etc.
 - Target Machines = High-end & Midrange
 - File Format = QuickTime
 - Preferences = Audio & Video Equally Important; Balanced Motion & Quality; Higher Quality
 - Options = none
5. Click on the Finish button to output your animation. This will save a copy of your animation with the above settings. This file can then be played back on any computer with QuickTime Player installed (QuickTime Player is a free download from www.apple.com).

After you have saved your compressed animation file to the hard disc, you can play it back on your computer for yourself and others, or you can copy your file (along with the Quick-Time Player) to another computer's hard disc for other people to view on a computer installed in a school, museum, or gallery.

playback on a cd-r or a dvd-r

CD-R stands for "compact disc-recordable," and DVD-R stands for "digital versatile disc-recordable." "Recordable" means that once you save your files to the disc, they cannot be changed or erased. CDs and DVDs are optical storage devices; the data are stored and read by beams of laser light reflecting off the disc. These discs are an inexpensive and durable medium, and most people have CD/DVD drives on their computers, so it is easy to distribute work on this medium. CDs can only store about 650 MB of information, which may not be enough for longer animations. DVDs can store almost 5 GB. Because the discs must be played on a computer, the quality of the viewing experience will depend on the speed of the computer. Older, slower machines may cause the animation to skip frames or pause during playback. To ensure that your animation will play on most computers, consider using the following settings for your file:

- File format = QuickTime
- Video codec = Cinepak
- Color bit depth = 24-bit (millions of colors)
- Frame rate = 15 frames per second
- Frame size = 320 pixels × 240 pixels
- Audio codec = IMA 4:1
- Audio sample rate = 22.05 kHz
- Audio channels = mono
- Audio bit depth = 16-bit
- Data rate = between 150 and 200 kilobytes per second

Here is a simple way to output your animation to CD-R or DVD-R from Premiere 6.0:

1. If your animation is not already in Premiere, import it, drag it to the Timeline, and render it.
2. Choose File>Export Timeline>Save For Web. This will open the Cleaner plug-in.
3. Click on the Settings button and drag down to QuickTime CD-ROM > 2X CD-ROM, Cinepak.
4. Click on the Start button. Cleaner will prompt you to name the file, and it will save the file with the extension ".mov."
5. Write your new file to a CD blank using software like Toast or Easy CD Creator. CD-R and DVD-R blanks are available through mail-order catalogs; they are cheaper in bulk.
6. Make a label for the CD. This can be as simple as writing on the back of the CD with an indelible marker, or sticking on an adhesive label, which can be printed on an inkjet or laser printer.
7. Put your CD in a case to protect it. The case can be a paper sleeve, a plastic sleeve, or a hard plastic case.

Make copies of the CD or DVD to distribute your animation. If you are planning on ten or fewer copies, it will be simple enough to make them yourself. However, if you need to make fifty, one hundred, or more copies, contact a CD replication service to have the copies made for you.

playback on a dvd-v

DVD-V is a disc-based alternative to videotape. It is a special format of DVD that allows animation or video to play back at full screen and at full frame rate on a dedicated player, called a set-top player, or on a computer with a DVD drive and DVD player software. There are a number of advantages to DVD-V compared to videotape. One advantage is that DVD-V resolution is higher than VHS tape resolution. Also, DVD-Vs can include a menu that will take you to a specific clip with the click of a button, instead of fast-forwarding or rewinding back and forth through a VHS tape. Another advantage is that various formatting options can be selected at the time the DVD-V is made, including the option of NTSC (for the United States and Japan) or PAL (for Europe).

DVD-Vs will eventually replace videotape for most viewing situations, but DVD-V technology is still evolving and there may be some incompatibilities between formats. For example, as

of this writing, most, but not all, set-top players will play a DVD-V burned with Apple's DVD Studio Pro. However, these incompatibilities will probably diminish over time as standards emerge and become widely implemented.

To make a DVD-V, you will need to import your animations into a DVD-V authoring application (like DVD Studio Pro on the Mac, or DVDit! on the PC). These applications will encode the visual part of your project in an MPEG format, and the audio part of your project in one of several acceptable formats.

Following is an example of making a basic DVD-V with DVD Studio Pro on the Macintosh. First, save your animation with these settings:

- File format = QuickTime, Shockwave, or AVI
- Video codec = choose a codec that maintains highest quality
- Image size = 720 × 480 pixels (NTSC)
- Frame rate = 29.97 frames per second
- Aspect ratio = 1.33 : 1 (4 : 3)
- Audio format = AIFF or WAV
- Audio sample rate = 48 or 96 kHz
- Audio bit depth = 16- or 24-bit
- Audio channels = mono or stereo
- Data rate = DVD-V data rates are high, so this is not a concern in most cases

Next, save your audio and video as separate files with the aid of QuickTime Pro Player (you can upgrade from the free QuickTime Player to QuickTime Pro Player by paying a small fee online and registering at www.apple.com.

1. Import your animation file into QuickTime Pro Player to export separate audio and video files. The easiest way to import is to drag the animation file's icon onto the icon of Quick-Time Pro Player and choose File>Export.
2. When you installed DVD Studio Pro, a new export option became available in Quick-Time Pro Player. This new export option is called Movie to MPEG 2; choosing this and clicking on OK will save the visual part of your animation with the file extension required for Studio Pro, ".m2v."
3. Go back to the QuickTime Pro Player and choose File>Export again. This time, select Sound to AIFF from the pop-up menu, click on the Options button, and change the sample rate to 48 kHz and 16-bit. Click on OK and save the sound portion of your animation.

To create a DVD-V disc in DVD Studio Pro:

1. When you open DVD Studio Pro, you will see a new empty DVD-V disc project named "untitled." Your first task will be to add assets (video and audio files) to the project by choosing File>Import, and then navigating to the ".m2v" and ".aif" files you exported from QuickTime Player. Click on Add to select these files and then click on Import to load them into the Assets Container in Studio Pro.
2. Your next step will be to create a track in which the audio and video files will play. Click on the New Track button at the bottom of the Graphical View window, and you will

see an icon of a folder (with several buttons on it) appear in the Graphical View. This folder is named "untitled track" by default. You can rename it the same name as your animation.

3. Once your track is made, you will need to add your assets (audio and video files) to the track by dragging the files from the asset container to the icon of the track folder in the Graphical View window, one at a time.

4. To preview your disc, you must first choose the method by which the DVD-V will start up. This is called the "start-up property," and can be set in the Property Inspector (if you don't see it, choose Windows>Property Inspector). Find the pop-up menu for start-up properties under the General category, and drag down to your track's name. This setting tells DVD Studio Pro to play your animation when it starts the disc preview. To preview the disc, click on the Preview button at the bottom of the Graphical View window. Your disc will play on your computer as it would from a DVD-V; click on the Stop button to return to the editing mode.

5. If you are happy with the preview, you can go ahead and burn the DVD-V. First, you must have a blank DVD-R. DVD-Rs are write-once discs—that is, once they have been burned, they cannot be changed or erased. You can order these discs in bulk from computer supply catalogs or directly from manufacturers such as Apple Computer.

6. With your DVD-R ready, choose File>Build & Format Disc. Studio Pro will ask you to select a folder in which to build the necessary files. After you select a folder, a dialog box will appear in which you must select Record To Device. The device should appear in a list in the dialog box (for example, "Pioneer DVD-RW"). Click on OK and the computer will open the DVD tray and ask you to insert the DVD you are going to write to. Insert the disc, close the tray, and Studio Pro will begin burning the DVD-V. This process takes a while; on my G4, it takes about one minute per second of animation. If you are going to burn many DVDs and don't want to make them one at a time, you can contact a duplication house to make the copies for you (see Chapter 9 for suggestions on finding a duplication house).

playback on videotape

The two videotape formats you are most likely to use are VHS and DV. VHS is the familiar half-inch cassette found in most home video equipment. DV stands for digital video, and there are two varieties of digital videotape cassettes: a larger cassette usually found in professional equipment is commonly called DV Cam, and a smaller cassette usually found in home consumer equipment is called mini DV. Mini DV camcorders with a FireWire port can be connected directly to the FireWire port on your computer; this is an easy way to record your animation from computer to video. In this book, whenever I refer to DV tape, I mean mini DV tape, not DV Cam.

The great advantage of looking at animation on videotape is that, unlike computer discs, videotape always plays back at a constant rate; there is never a danger of dropping frames or irregular playback speed. The disadvantage of DV tape is that few people have DV tape decks in their homes, so most people would have to use their DV camcorder as the tape deck, and hook up the DV camcorder to a video monitor in order to see the animation. However, if your DV camcorder has a regular analog video-out port, you can copy your DV tape recording to a VHS tape and then distribute the VHS tapes.

If you already have a DV camcorder, choose a preset in Premiere that matches the settings of your camera (for example, "DV-NTSC > Standard 48 kHz"). The DV camcorder records your animation as it plays in real time on the computer, so it is important that the animation play back smoothly on the computer during the recording. If your animation is not playing back smoothly, make sure you have rendered the Timeline, quit any other programs, and if necessary, rebooted the computer to clear its memory. Choosing a DV-NTSC preset will generate something similar to the following settings for your project:

- File format = QuickTime
- Video codec = DV-NTSC
- Color bit depth = 24-bit (millions of colors)
- Frame rate = 30 frames per second
- Frame size = 720 pixels × 480 pixels
- Audio sample rate = 44.100 kHz
- Audio channels = stereo
- Audio bit depth = 16-bit

In Premiere, the easiest way to record to tape is by using the Export to Tape command.

1. Set up your DV camcorder. Make sure your camcorder is plugged into the wall (not running on batteries); turn the DV camcorder on and put it in VTR mode (as opposed to camera mode), and put a blank DV tape in the camcorder and cue it to where you want to begin recording. Connect the camcorder's video and audio outputs to the inputs on your video monitor so that you can see and hear what the camcorder is recording. If you don't have a monitor, then you can look at the camcorder's display to monitor the recording. Connect the DV camcorder to your computer through the FireWire ports. Do not open Premiere until after you have connected the camera to the computer. Connecting the equipment first will allow Premiere to recognize the camera when it starts up.
2. Open your project and render the Timeline. As you do this, you should see the animation play on your DV camcorder; if you don't, review Premiere's documentation on preparing a DV device for recording. Choose File>Export Timeline>Export to Tape. In the window, click on the box next to "Activate recording deck." Movie Start Delay should be set to 4, and Preroll to 100 frames.
3. Click on the Record button to begin recording. Premiere will automatically start and stop the DV camcorder when it plays the animation.

After you have recorded your animation to DV tape you have the option of showing it on a DV tape deck or transferring it to another video format. Although DV decks are not yet common in homes, they are increasingly used in screening rooms and theaters, so if you are planning on showing your tape in a festival, for example, you can ask if they can show work on DV tape. Otherwise, you can transfer your DV tape to another video format at a business called a transfer house. For home viewing, transfer to VHS. For public screenings, if DV projection is not available you may need to transfer to Beta.

Here is the general procedure for recording to VHS from a mini DV camcorder in your home:

1. Record to DV tape as described in the previous section; rewind the tape.
2. Connect the audio and video outs from the DV camcorder to the audio and video ins on the VHS deck.
3. Put a blank tape in the VHS deck, and press Record. Then play the DV tape recording of your animation.

playback on motion picture film

Output to motion picture film is practical only if you plan to show your work in film festivals or if you have the option of theatrical distribution. 35 mm film will provide the highest-quality viewing experience, but it is expensive. To transfer a 3-minute film can cost anywhere from $1,000 to $10,000, depending on the transfer house and the type of equipment they use. Here are a few tips if you are considering working this way.

- Find a transfer house before you begin production. Each business will have its own equipment and its own way of doing things, so it is important to talk with the people who will do the transfer before you begin working.
- Decide on an aspect ratio. The aspect ratio is the ratio of the horizontal to vertical measurement of the cinema screen. The usual choices are 1.33:1 (called Academy aperture) and 1.85:1 (a widescreen format). The transfer house you work with may limit your choice of aspect ratios based on the equipment they use.
- Ask the transfer house how they want you to send your files. This includes asking what file formats they will accept as well as what media they can accept. File formats might include QuickTime movies or a sequence of JPEG images, and media might include CDs or digital storage tapes.
- If you are scanning your artwork, scan at film resolution. The choices for film resolution are 1K, 2K, and 4K. 1K is low film resolution; it looks similar to video transferred to film. 2K is the minimum full film resolution; this is the most common choice for an independent filmmaker. 4K is a high resolution used primarily in Hollywood features or for creating special effects. To calculate 2K film resolution, divide 2000 by your artwork's field size. *Field size* is your artwork's horizontal measurement in inches. For example, if your images are 10 inches across, scan them at 200 dpi. You might want to scan at a slightly higher resolution (5–10%) in case you need to crop your images later on.
- Make low-resolution copies of your scans for editing. High-resolution scans can be huge, and will not play in real time. You can make copies of your original scans in PhotoShop at a low resolution (72 dpi or lower) so that you can see the motion play in real time during editing. Later, you can re-edit your high-resolution images according to the edit you made with the low-resolution images.
 Note: Adobe AfterEffects can help automate the process of editing high-resolution images according to the changes made to low-resolution copies. Read about Proxies in the AfterEffects manual.
- Plan to visit the transfer house to oversee color correction. Make sure the transfer house is close enough that you will be able to visit at the end of the process. You will want to be able to correct things such as color balances during the transfer.

output for playback on the Web

The most significant factor affecting Web playback is the viewer's connection speed. The main choices of connections are through a modem, a DSL, or a cable connection. To give you an idea of the range of viewing experiences this can encompass, consider that a basic modem connection means viewing short video or animation clips that are small, fuzzy, and show choppy movement, whereas a fast cable or DSL connection can mean viewing feature-length, full-screen video and animation at full frame rates. As time goes on, more and more people will use fast Internet connections, but for now, you must expect that the average viewer will be using a basic modem. The following settings are an estimate for a progressive download animation assuming the viewer is using a 56K modem:

- File format = QuickTime
- Video codec = Sorenson Video
- Color bit depth = 24-bit
- Frame rate = 15 frames per second
- Frame size = 160 pixels × 120 pixels
- Audio codec = Qdesign Music 2
- Audio sample rate = 22.05 kHz
- Audio channels = mono
- Audio bit depth = 16-bits
- Data rate = roughly 12 kilobytes per second

Another consideration is whether or not to stream your animation. In most cases, short animations will not benefit much from streaming. The progressive download method can usually handle the data flow of a short animation and progressive downloads can be delivered without the need for a special streaming web server. However, to give you an idea of the differences in preparing your file for streaming, the following settings are an estimate for a streaming animation assuming the viewer is using a 56K modem:

- File format = QuickTime
- Video codec = Sorenson Video
- Color bit depth = 24-bit
- Frame rate = 8 frames per second
- Frame size = 160 pixels × 120 pixels
- Audio codec = Qdesign Music 2
- Audio sample rate = 11.025 kHz
- Audio channels = mono
- Audio bit depth = 16-bits
- Data rate = roughly 6 kilobytes per second

downloading versus streaming

There are two ways of delivering animation over the Web. The first is called *downloading*, and the second is called *streaming*. There are two basic versions of downloading: basic downloading and progressive downloading (sometimes called progressive streaming, but this is a misleading term because it is not true streaming). Basic downloading simply copies the entire animation file as one download to the viewer's computer and then plays it back

from the hard drive. In this case, the viewer waits until the entire file is copied before it starts playing, which can take a while. Progressive downloading is an improvement. This method also copies the animation file to the viewer's computer, but it plays the animation as it is being downloaded. The viewer must wait for the first chunk of data only, because that first chunk plays while the second chunk is being downloaded. However, if the data are not transferred quickly enough, there will be pauses in the animation between the downloaded chunks of data.

The second basic option for delivering media over the Web is streaming. Streaming is designed to play an animation file without any pauses at all. In this case, the animation plays directly from a server's hard drive in a continuous stream. The advantages of streaming are that the animation plays immediately, with no wait time, and there are no pauses while waiting for downloads. But if the Web connection cannot transmit data quickly enough, frames will be skipped and the motion may look jerky. Also, you must put your animation on a special server capable of delivering streaming media in order to do this. Downloadable files can be delivered from a personal site without special software, and once the files are downloaded, the viewers can play the animation again at any time, whether or not they are connected to the Web. But the viewers must wait for the download before they can begin watching, and the downloaded files can clog up their computer's hard drive. Also, the downloaded file can be edited, copied, and reused by the viewer, which may be objectionable to some creators. Streamed files require much shorter wait times, they do not clog up the viewer's hard drive, and the animation is better protected from unauthorized use by the viewer. However, streaming requires putting your animation on a separate server with special streaming software, and the playback can become slow or interrupted if the viewer uses a slow modem connection or if there is heavy use of the server delivering the stream. Also, the viewers will be able to view the animation only when they are connected to the server.

For most short animations, progressive downloading is a good option for delivering your work. If your animation is longer than a few minutes, you may want to consider streaming your file over the Web. The easiest way to do this is to upload your animation to a dedicated streaming media server. There are also a number of sites that will stream your animation for you. These may be Web showcases or sites maintained by hardware and software manufacturers. In either case, these sites will stream your animation for a given period of time, and then they will remove your files to make room for other projects. Another option is to pay a service to stream your animations from their web server. Because you are paying them a monthly fee, they will keep your animations on their server indefinitely. In this case, you would create a link to their server in your personal site so viewers could access your streaming animations from your web site.

building a personal web site

A personal site can be used both to advertise and to distribute your work. Animation can be shown directly on a site, the site can be used to direct people to a Web showcase exhibiting your animation, or the site can be used as a point of contact for ordering a disc or videotape containing the animation. To view animation on a site, the file will either be

downloaded and then played back from the viewer's hard drive, or streamed in real time over the Web. The choice depends primarily on the length of the animation. The design of a personal site can be as simple as a single page (screen) with some images, text, and an email link, or a site can consist of many pages linked to each other, each page containing its own information and graphics. However you use your site, you will need a company to host your site. The fee for hosting a site starts at about $30 per month and goes up based on how much storage space you need. If you have only minimal web site plans, you can find a company to host your site for free.

free web sites

The two basic options for a free web site are: 1) companies that will offer you a free site in exchange for the right to advertise on your site, such as Tripod and Yahoo!; and 2) an ISP that provides free sites (usually without advertising) to its members, such as AOL or Earthlink. Note that companies like Tripod and Yahoo! do not offer Internet access; you would still need an ISP like Earthlink or AOL to provide you with access to the Web. The advantage of these free sites is that—first and foremost—they are free. Because it will cost you nothing but a little time to get up and running, these sites are an excellent way to begin working on the Web. If you decide the Web isn't right for you, your investment will have been minimal and, if you like showing your animation on the Web, a free site may be all you ever need. If you decide you want more space and flexibility than the free sites offer, your experience building a free site will help prepare you for buying your own Web space.

The disadvantages of these free sites are that they limit the size of your site, they limit the types of files you can put on your site, and (if it bothers you) some of them put advertisements on your site. As of this writing, most free sites are limited to somewhere between 5 MB and 15 MB, depending on the company, but the size of free sites will probably increase as computers get faster. A more serious limitation is that these sites often are designed primarily for showing JPEG and GIF image files. The JPEG format is for viewing still images, and the GIF format is for showing short, silent animations. But if you want to show longer animations or animations with soundtracks, you will need the ability to include other formats as well, such as QuickTime, Shockwave, or streaming media.

All these companies (Tripod, Yahoo!, Earthlink, and AOL) will also provide web site tools that take you through the process of building your site quickly and easily. Although each company's tools will work slightly differently, they all follow the same basic steps. The process starts with filling out a registration questionnaire, then by agreeing to abide by the terms of their contracts (no objectionable material, for example), and then by answering a series of questions about how you want your web page to look and which JPEG or GIF files you want to include in it. At the end of the process, you will be able to put your page up on the Web with the click of a button. As an example, here is a description of building a web site with Earthlink's "Click-N-Build" guide.

1. Go to the Web address for Earthlink's "Click-N-Build" page. At this writing, the address is: http://hometools.earthlink.net/clicknbuild/login.html.

2. When you visit this page for the first time, you will be prompted to enter your Earthlink user name (for example, ssubotnick) and your Earthlink password. Then you must click on the Login button.

3. Next, you will be presented with an agreement, which outlines proper and improper use of the web site space. To continue, you must click on "I Accept."

4. After this, you will be presented with the Site Preferences Wizard, which asks you to enter your choices for font styles and to choose a skill level. "Beginner" will give you simplified menu choices; "advanced" will give you more detailed options. When you are done setting your preferences, you must click on the Finished button at the bottom of the screen.

5. Last, you will be shown a preview of your page layout. You can either confirm the design by clicking on the Finished button again, or you can return to the Settings Wizard by clicking on the Cancel button.

6. Once your site is created, you will see it in an "edit" view. There are a number of Edit buttons on the page preview which allow you to change the content of the page, including text, images, and links.

7. To place an animation in your web site, click on the Edit button next to the sample image. You will be taken to a screen that prompts you to browse through your hard disc to look for a JPEG or GIF file. When you have located the file and selected it, click on Finish. It will take some time to upload the file to the web server. After the animation is uploaded, it will play each time your web site is visited.

8. To put your site on the Web, you must click on the Publish button at the top of the screen. You will be taken to a new browser window that says, "Congratulations," and displays your web site address (for example, http://home.earthlink.net/~ssubotnick). There is also a link to return to Click-N-Build.

9. There are buttons at the top of the screen for working on your site.

- **Preferences:** Click on this button to set your skill level (beginner or advanced), enter your contact information, and select basic font style and size. When you are done, click on the Finished button at the bottom of the screen to return to your site layout.

- **Preview:** Clicking on this button will show you how your page will look on the Web. To return to the layout view, click on the same button, which is now labeled Edit.

- **Publish:** Click on this button to upload your site to the web server and make it available to the public.

- **Help:** This button will open a new browser window with a list of help contents. When you are done, close the window.

- **Add Page:** This button will allow you to add a new page to your web site (you can add up to four pages). By default your first page is called your home page. You will be prompted to enter a new, unique, name for each additional page. Once you have created each additional page, you will be prompted to design its layout. Return to your home page by clicking on Home at the top of the page layout.

- **Remove Page:** This button will delete the page you are currently looking at. It will work on any additional page, but you will not be able to delete your home page this way.

- **Change Layout:** This button will allow you to edit your page design (font style, etc.).

- **Change Color:** This button will allow you to change the color of your text. The three choices are "text," "link," and "visited." *Links* are words that take viewers to another

page when they click on that text; they are differentiated from regular text by their color. After a link has been clicked on, it is considered a *visited* link; by changing visited links' color, the viewer knows which links they have used.

- **Reset Page:** This button will allow you to change your page's layout to the default settings; the page will revert to the original generic layout.
- **Site Maintenance:** Clicking this button will display a list of the folders and files in your site, along with their size and how much free space you have left. You can then rename files, create new folders, and reorganize files.
- **Remove Site:** This button will give you the option of deleting your entire site. After the site has been erased, you can start building a new site from scratch.

building your own site

Another way to establish a site is to buy space on a web server. In exchange for paying a monthly fee, you are given space on a server, a web site address, and a telephone number to connect to the server. Choosing a host can be daunting because there are so many businesses offering this service. Fortunately, there are trade magazines and guides on the Web that discuss what to look for in a host. Read through some of these before signing on with a particular company (see Chapter 9 for suggestions). The cost of this service varies widely depending on various factors, including how much space you require and the amount of traffic you expect. On average, you can expect to pay between $20 and $50 a month for a site suitable for showing animation. The basic advantage of these sites over a free web site is their flexibility. For example, you can buy more space as you need it, and you will probably have greater latitude in the types of files you can show on your site (QuickTime, Shockwave, etc.). If you don't mind learning web design software programs, you may enjoy the control that maintaining your own site gives you.

There are a number of software applications available that attempt to make the process of building your own site as easy as possible. Adobe GoLive and Macromedia Dreamweaver are two of the most commonly used programs to build web sites. Neither requires programming skill, and both are cross-platform (they run on the Mac and the PC). The process of building your own site starts with creating a new site on your computer's hard drive using a web design application. Once you have created your site, you will then create a page (or pages) that you will place in the site. The pages will have some combination of text, images, animations, and an email link. The last step is to upload the site to a host server so it can be seen on the Web. You will use special software, called FTP software, to send your files to the web server. FTP stands for File Transport Protocol; it is a standard way of encoding information so that all computers on the Web can send and receive files. Programs such as Adobe GoLive and Dreamweaver include FTP software. As an example, I will review the process of making a simple site in Adobe GoLive.

Make a new site.

1. Open Adobe GoLive. You will see a blank document titled "untitled.html"; close that window by choosing File>Close.
2. Choose File>New Site>Blank. Navigate to where you want to save the new site on your hard drive. Click on the New Folder button and type in a name for it (for example, "Sub-

otnickAnimationFolder"). Then type in a title for your new site (for example, "Subotnick-Animation"). Select your new folder and click on the Choose button. When you click on Choose, a new window will open, titled (in this case) "SubotnickAnimation.site." The site window shows the contents of your web site. For now, it will show only one document, "index.html." This document is your default page.

3. Next, add your animation and image files to your site. Do this by dragging the icons of these files from their original folders onto your new site window. This will copy the files to your site's folder, and you will see the file icons appear in the site window.

Enter the settings for communicating with your web server.

1. Choose Edit>Preferences, and expand the "Network" options by clicking on the triangle next to the Network icon.
2. In the choices that appear, select FTP Server, and then click on the New button; enter the following information for your host's web server:
 ● Server = the domain name of your web server (for example, ftp-www.earthlink.net)
 ● Directory = this may be blank, or it may be a specific directory on the server
 ● Username = your name on this server (for example, ssubotnick)
 ● Password = your password for this server (choose with your host's help)
3. Click on OK.
4. With your site open, choose Site>Settings. In the Settings window, select the icon for FTP & WebDAV server. Click on the pop-up menu next to the field labeled Server, and drag it to your web server. When you release the mouse button, all the information for that server should appear in the site settings window. Click on OK. Now the web server information has been applied to your site.

When you look at your site window after this last step, you should see that your window has been divided into two sections. The left section shows the contents of your site files on your hard disc, and the right section shows the contents of your files on the server. For now, the right section will be blank because you are not yet connected to your web server.

Make a web page.

1. Double-click your default web page icon ("index.html") to open it. You will see a window that shows the contents of your page; for now, it is blank.
2. Name the page in the box at the top of the document window; for example, "Home."

Format your page and add text, images, and animation.

1. Make sure the Objects window and the Inspector window are open.
2. Drag a Layout Grid object from the Objects window to your page; resize the grid by dragging the blue handles on its right and bottom sides. The Layout Grid allows you to place text and images anywhere in the page.
3. To add text to your web page, drag a Layout Text Box object from the Objects window onto your page, and then type into the text box as if it were a word processor. You can change things such as the font, style, size, and color in the Type menu.

4. To add an image to your page, drag an Image object from the Object window onto your page. With the Image object selected, look at the Inspector window to make sure the Basic tab is selected. Then click on the folder (Browse) icon next to the Source name and select the image file you want to add (it is important that all image and animation files are stored in the site folder). Click on Open to assign the selected image to the Image object and you should see the image in your page.

5. To add an animation to your page, drag the SWF object, the QuickTime object, or the Real object to your page. The choice of objects will depend on the type of animation file you are adding: SWF is for a Shockwave file, QuickTime is for a QuickTime file, and Real is for a Real Media streaming file. After you have added the correct object, use the Browse icon to select the animation you are adding to your page.

 Note: Shockwave files can be resized in your page, but QuickTime files will be displayed at their original size.

Add an email link. This involves two steps: first, create an email link, then add it to your page.

1. Click on the Site window to make it active, and then click on the External tab at the top of the window. This will show a new view of the Site window where you will put the email address. To begin with, this area will be blank.

2. Choose Window>Objects to open the Objects Palette. This will open a small window containing a palette of different icons.

3. Click on the triangle pop-up menu at the upper right of the Object Palette and drag down to Site. You will see a new group of icons appear in the palette.

4. The Address icon has a picture of a head in profile. Drag this icon from the Objects palette into the Site window (not the web page). You will see a new item in the Site window under External. Under the name column it will be listed as "untitled address"; across from it under the URL column it will be listed as "mailto:untitled@1/."

5. To edit the email address, choose Window>Inspector. This will open a small window containing the email information. Retype the name; this will be the email linking text that will eventually appear in your page. The name could be your name, or a phrase such as "contact me." In the URL box, enter your full email address after "mailto:" (for example, mailto:ssubotnick@earthlink.net). When you are done, press the Enter key.

6. To put the email link on your page, drag the email icon from the site window into your page document. It will appear as blue, underlined text. When you preview your page in a browser, clicking on the blue text will open an email program so you can send a message to the email address you specified.

Preview the web page in a browser.

1. To see a preview of your page in a web browser, choose Special>Show in Browser>Netscape (or Internet Explorer). This will open your page in the selected browser so you can see how your page will look on the Web. Simply close the browser when you are done previewing your page.

2. If you do not see a web browser in the menu, choose Edit>Preferences and then select the Browsers icon. Click on the Select all button to find all the browsers installed on your

hard disc; then click on the box next to the browsers you want to include in GoLive's list of choices. Click on the OK button to leave Preferences.

Upload your site.

1. Choose Site>FTP Server>connect. GoLive will automatically connect to the web server you entered earlier and show you a list of any files on the server in the right-hand section of your site window.
2. Drag your site files from the left section of your site window (your local drive) to the right section of your site window (the web server) into a folder named "www." The "www" folder contains all the files that will appear in your site. You should see a progress window appear showing you how long it is taking to upload the files. When it is done, your files are on the server and can be visited by anyone who has the Web address where your files are stored.

Advertise your site. Once you have created a web site you will want people to visit it.

- Identify other sites you think should link to your site, and then contact the managers of those sites to see if they will create a link to your site address. For example, if you come across a site that mentions independent animators' web sites, contact them to ask if they will include your site in their listings.
- Add your web address (URL) to search engines for free. A *search engine* is a web application that will look for sites related to keywords typed in by the user. Some popular search engines include google.com, altavista.com, excite.com, and about.com. For example, add your site to google.com by going to www.google.com/addurl.html and entering your site's URL along with a brief description.
- If you are very serious about advertising through search engines, you can find a submission service to add your site to many search engines at once. Most will charge you a fee, but some will do this for free.
- Include important descriptions and keywords in your page's meta tags. A *meta tag* is a part of your html document that can contain a description of your site and a list of keywords that relate to your site. You may make it easier for a user to find your site through a search engine that supports meta tags by including good meta tags. To edit your page's meta tag, you will need to edit the document in html. The html meta tag command for a description might look like this: ⟨META name = "description" content = "Animation by Steven Subotnick"⟩. The html meta tag command for keywords might look something like this: ⟨META name = "keywords" content = "animation, independent, Steven Subotnick"⟩.

summary

- Animation distribution options include festivals, Web showcases, Microcinema, and direct distribution.
- Formats include hard drives, CD or DVD discs, videotape, and the Web.
- Whenever possible, decide on a distribution format early in the production process; it will save time and effort later when you are ready to output your project.

My personal work is something I refer to as "found object animation." I usually spend a great deal of time frequenting yard sales, swap meets, thrift stores, and diving into the occasional dumpster to collect objects that appeal to me on some level. There is a long incubation period before the accumulated junk turns into a film, but judging from the lack of room in my garage I'm long overdue for the next one.

Dave Fain

chapter 9

resources

Hopefully, this book will have sparked your desire to make your own animation. This last section is devoted to pointing the way to several types of resources for the animator. Please note that all listings within each section are in alphabetical order, not in order of importance. If you would like to do more research in any of the following areas yourself, you can type in headings from this chapter in a search site such as Google (www.google.com). The information on the Web is always changing, and may provide you with more current information as well as an opportunity to discover your own informative sites about animation.

learning about animation

The first section contains information about education in animation. It includes lists of schools in North America and the United Kingdom, organizations dealing with animation, and a selection of helpful books and magazines.

some of the top animation schools

For those interested in pursuing animation as a career path, schools are a good choice for training and education. In the broadest terms, there are two types of animation instruction: vocational and aesthetic. Vocational training tends to focus on a specialty such as 3D computer animation or character animation, and places more weight on exercises that demonstrate particular skills than on finished projects. Vocational instruction concentrates on preparing students for a career in the animation industry. Aesthetic instruction concentrates on developing students as animation artists. Aesthetic training tends to be less specialized, encouraging more experimentation and wider knowledge of the medium, and usually requiring completion of a graduation project that demonstrates the individual's artistic vision. Most schools combine both approaches, but with varying degrees of emphasis. The following is a list of some of the top animation schools in North America, the United Kingdom, and Europe. For a more complete list of animation schools, a good guide is the *AWN School Directory* (www.awn.com). My list of schools in the United Kingdom and Europe is based in part on the Student Animation Festival at Ottawa's selections for the "Best Animation School Competition" in the years 1997, 1999, and 2001 (www.awn.com/ottawa/safo).

United States

Academy of Art College offers animation training in two undergraduate majors: illustration and computer arts.

> 79 New Montgomery Street
> San Francisco, CA 94105
> Tel: 800-544-2787
> www.academyart.edu

California Institute of the Arts (Cal Arts) offers animation in two programs: character animation, an undergraduate program, and experimental animation, both an undergraduate and graduate program.

24700 McBean Parkway
Valencia, CA 91355
Tel: 805-255-1050
www.calarts.edu

Harvard University VES (Visual & Environmental Studies) department offers several undergraduate animation courses taught by visiting animators.

Department of Visual & Environmental Studies
Carpenter Center for the Visual Arts
24 Quincy Street
Cambridge, MA 02138
Tel: 617-495-3251
www.fas.harvard.edu

New York University Tisch School of the Arts offers animation courses to both undergraduate and graduate students.

The Animation Program
21 Broadway (8th floor)
New York, NY 10003
Tel: 212-998-1700
www.nyu.edu/tisch

Pratt Institute offers undergraduate animation courses in the media arts program.

200 Willoughby Avenue
Brooklyn, NY 11205
Tel: 718-636-3600
www.pratt.edu

Rhode Island School of Design offers undergraduate animation courses in the Film/Animation/Video department.

2 College Street
Providence, RI 02903
Tel: 401-454-6100
www.risd.edu

Ringling School of Art and Design offers computer animation training to undergraduates.

2700 North Tamiami Trail
Sarasota, FL 34234
Tel: 813-359-7523
www.rsad.edu

Rochester Institute of Technology offers computer animation courses within the School of Film & Animation.

School of Film and Animation
70 Lomb Memorial Drive
Rochester, NY 14623
Tel: 716-475-6175
www.rit.edu/~sofa

Rocky Mountain College of Art and Design offers undergraduate animation courses.

6875 E. Evans Avenue
Denver, CO 80224
Tel: 303-753-6046
www.rmcad.edu

San Francisco State University offers an undergraduate concentration in animation within the Cinema major.

1600 Holloway Avenue
San Francisco, CA 94132
Tel: 415-338-6510
www.cinema.sfsu.edu

Savannah College of Art & Design offers both undergraduate and graduate programs in computer animation.

342 Bull Street
Savannah, GA 31401
Tel: 800-869-7223
www.scad.edu

School of the Art Institute of Chicago offers animation courses within the department of Film, Video, and New Media.

37 South Wabash Avenue
Chicago, IL 60603
Tel: 312-899-1232
www.artic.edu

School of Visual Arts offers an undergraduate major in animation with an emphasis on character animation.

209 West 23rd Street
New York, NY 10010
Tel: 212-679-7350
www.schoolofvisualarts.edu

University of the Arts offers an undergraduate major in animation.

320 South Broad Street
Philadelphia, PA 19102
Tel: 215-717-6000
www.uarts.edu

University of California at Los Angeles offers both undergraduate and graduate courses in animation.

> Animation Workshop, Department of Film and Television
> P.O. Box 951622
> Los Angeles, CA 90095
> Tel: 310-206-8441
> http://animation.filmtv.ucla.edu

University of Southern California School of Cinema-Television offers both undergraduate and graduate courses in animation.

> Division of Animation & Digital Arts
> 850 West 34th Street
> Los Angeles, CA 90089
> Tel: 213-740-3985
> www-cntv.usc.edu

Canada

Algonquin College offers a two-year certificate program in commercial animation.

> 1385 Woodroffe Avenue
> Nepean, Ontario K2G 1V8
> Tel: 613-737-4723 Ext. 7708
> www.algonquinc.on.ca

Concordia University offers an undergraduate major in animation.

> 1455 de Maisonneuve Blvd. W.
> Montreal, Quebec H3G 1M8
> Tel: 514-848-2424
> http://cinema.concordia.ca

Emily Carr Institute of Art & Design offers undergraduate courses in animation through the Media Arts department.

> 1399 Johnston Street, Granville Island
> Vancouver, BC V6H 3R9
> Tel: 604-844-3800
> www.eciad.bc.ca

Sheridan College offers a three-year undergraduate program in animation and a one-year graduate program in computer animation.

> 1430 Trafalgar Road
> Oakville, Ontario L6H 2L1
> Tel: 905-845-9430
> www.sheridanc.on.ca

Vancouver Institute of Media Arts offers one-year and two-year programs, and summer courses in classical and computer animation.

> 837 Beatty Street
> Vancouver, BC V6B 2M6
> Tel: 604-682-2787
> www.vanarts.com

Vancouver Film School offers courses in 2D animation as well as 3D animation and special effects.

> 198 West Hastings St., Suite 200
> Vancouver BC V6B 1H2
> Tel: 604-685-5808
> www.vfs.com

Europe

Atelier de Production de La Cambre, Belgium (La Cambre), offers a five-year program of study, with the first three years devoted to training in film animation, and the last two years devoted to making films.

> 21 Abbey of Cambers
> 1000 Brussels
> BELGIUM
> Tel: +32 2 648 96 19
> www.lacambre.be

Ecole Nationale Superieure des Arts Decoratifs (ENSAD) offers an undergraduate course in animation.

> 31 Ulm Street
> Paris 5th
> FRANCE
> Tel: 01 42 34 97 00
> www.ensad.fr

Edinburgh School of Art offers both undergraduate and graduate course work in animation.

> Lauriston Place
> Edinburgh, Scotland
> UK
> EH3 9DF
> Tel: 0131 221 6000
> www.eca.ac.uk

Eindwerken Film & Animatiefilm, Departement Koninklijke Academie voor Schone Kunsten Hogeschool Gent (KASK) offers a four-year program of study in animation.

J. Kluyskensstraat 6
9000 Gent
BELGIUM
Tel: (09)266 08 85
www.hogent.be

Royal College of Art, United Kingdom, offers a graduate course in animation.

Kensington Gore
London SW7 2EU
UK
Tel: +44 20 7590 4444
www.rca.ac.uk

Turku Arts Academy, Finland, offers an undergraduate course of study in animation.

Sepankatu 3
20700 Turku
FINLAND
Tel: 358 10 55 350
www.turkuamk.fi

Volda College offers undergraduate courses in animation.

P. O. Box 500
N-6101 Volda
NORWAY
Tel: +47 70 07 50 00
www.hivolda.no

organizations

Organizations allow people interested in the same topic to connect with each other and share information. The primary international organization for animators is ASIFA (Association Internationale du Film d'Animation). ASIFA was founded in 1957 in France, and is devoted to the support of animation as an art and communication form. Members typically join a local chapter and then pay an additional fee for international membership. Benefits include information about screenings, festivals, job opportunities, seminars, animation articles, and more. Because the chapters are run by volunteers, the officers may change frequently. Check the various ASIFA chapter web sites for updated contact information. Here is the current contact information for ASIFA International, ASIFA Canada, as well as several of the local chapters in the United States.

ASIFA-Atlanta
c/o Louis Hertz
747 Courtenay Drive NE
Atlanta, GA 30306
USA
Tel: 404-875-7157
www.asifa-atlanta.com

ASIFA Central
c/o Deanna Morse
School of Communications, Lake Superior Hall
Grand Valley State University
Allendale, MI 49401
USA
Tel: 616-895-3101
email: Deanna Morse asifa@asifa.org
www.asifa.org/animate

ASIFA Colorado
c/o Edward Bakst
Rocky Mountain College of Art and Design
6875 E. Evans Avenue
Denver, CO 80224
USA
Tel: 800-888-2787
email: EBakst@rmcad.edu
www.asifa-colorado.org

ASIFA-East
c/o Michael Sporn Animation
632 Broadway, 4th Floor
New York, NY 10012
USA
www.yrd.com/asifa

ASIFA-Hollywood
Antran Manoogian, President
721 S. Victory Blvd.
Burbank, CA 91502
USA
Tel: 818-842-8330
www.asifa-hollywood.org

ASIFA Northwest
c/o Direct Animation
P.O. Box 25756
Portland, OR 97298
USA
www.teleport.com/~asifa/

ASIFA-San Francisco
P.O. Box 14516
San Francisco, CA 94114
USA
email: Karl Cohen karlcohen@earthlink.net
www.awn.com/asifa-sf

ASIFA Canada
Case postale 5226
St-Laurent, Quebec H4L 4Z8
CANADA
www.awn.com/asifa-canada

ASIFA International
ASIFA Secretary General
Vesna Dovnikovic
Hrvatskog proljeca 36
10040 Zagreb
CROATIA
Tel/Fax: +0385 -1- 299 13 95; email: secretary@asifa.net
or:
ASIFA Treasurer
Pierre Azuelos
56 rue du Mas de Perrette
34070. Montpellier
FRANCE
Fax: +33 (0) 467.73.52.26; email: azuelos@asifa.net
http://asifa.net/

Association for Independent Video & Filmmakers (AIVF) is a nonprofit organization that offers support and resources to independent film and video makers. Membership includes a subscription to *The Independent*, which contains articles about people, technology, and events, as well as an excellent list of upcoming film, video, and animation festivals.

304 Hudson Street, 6th floor
New York, NY 10013
USA
Tel: 212-807-1400
www.aivf.org

Iota Center is a nonprofit organization dedicated to preserving and promoting the art of sound, light, and movement in all its many forms.

3765 Cardiff Avenue #305
Los Angeles, CA 90034
USA
Tel: 310-842-8704
www.iotacenter.org

Quickdraw Animation Society is a nonprofit organization run by Canadian animators.

201-351 11th Ave SW
Calgary, Alberta T2R 0C7
CANADA
www.awn.com/qas

Toronto Animated Image Society (TAIS) is a nonprofit group interested in the art of anima-
tion. Members meet to watch animated films, hear presentations on the art of animation,
promote the art of animation, and socialize.

> c/o Arachnid Studios
> #2-333 Willow Avenue
> Toronto, ON M4E 3K6
> CANADA
> Tel: 416-699-1693
> www.awn.com/tais/

Women In Animation, Inc. (WIA) is a nonprofit organization devoted to the concerns of
women involved in the art and industry of animation.

> P.O. Box 17706
> Encino, California 91416
> USA
> Tel: 818-759-9596
> email: info@womeninanimation.org
> www.womeninanimation.org

books

There are a number of books on the market that cover animation techniques, history, and
criticism, as well as computer references. Focal Press has also created a new line of tech-
nical reference books about making animation (of which this book is a part) called the Focal
Press Visual Effects and Animation line; you can find more information about these and
other related books at www.focalpress.com.

The 5 C's of Cinematography: Motion Picture Filming Techniques, by Joseph Mascelli;
Silman-James Press; 1998; ISBN 187950541X.
Concepts and techniques of live-action directing; also a good reference for storyboarding.

Animation: 2-D & Beyond, by Jayne Pilling; Allworth Press; 2001; ISBN 2880464455.
A survey of contemporary animators, their work, and their working methods.

The Animation Book: The New Digital Edition, by Kit Laybourne; Three Rivers Press; 1998;
ISBN 0517886022.
Describes various steps in animation production; originally written for filmmakers, it has
been updated to include digital tools.

Animation from Script to Screen, by Shamus Culhane; St. Martin's Press; 1988; ISBN
0315021623.
A veteran animator shares his knowledge gained from a career at the Disney Studio.

The Animator's Workbook: Step-by-Step Techniques of Drawn Animation, by Tony White;
Watson-Guptill Publications; 1988; ISBN 0823002292.
Concepts of and exercises in drawn animation techniques.

Art in Motion: Animation Aesthetics, by Maureen Furniss; John Libbey & Company, Ltd.; 1998; ISBN 186462039.
A discussion of animation aesthetics and concepts.

Cartoons: One Hundred Years of Cinema Animation, by Giannalberto Bendazzi; John Libbey & Company, Ltd.; 1994; ISBN 0861964454.
The most encyclopedic international animation history book available.

Comics & Sequential Art, by Will Eisner; Poorhouse; 1985; ISBN 0961472812.
A classic book about the art of comic books and visual storytelling; many topics also apply to animation, such as storyboarding, character acting, and composition.

Creating 3-D Animation: The Aardman Book of Filmmaking, by Peter Lord and Brian Sibley; Harry N. Abrams, Inc.; 1998; ISBN 0810919966.
Describes clay puppet techniques used by the studio that animates Wallace and Gromit.

Experimental Animation: Origins of a New Art, by Robert Russett & Cecile Starr; Da Capo Press, Inc.; 1988; ISBN 0306803142.
Animation history and conversations with experimental animators, past and present.

Film Directing Shot by Shot: Visualizing from Concept to Screen, by Steven D. Katz; Focal Press; 1991; ISBN 0941188108.
A recent book on live-action directing.

Make Your Own Animated Movies and Videotapes, by Yvonne Andersen; Little, Brown & Co.; 1991; ISBN 0316039411.
Describes inexpensive film and video techniques clearly and concisely.

Understanding Animation, by Paul Wells; Routledge; 1998; ISBN 0415115973.
Another book about animation aesthetics and concepts.

Understanding Comics: The Invisible Art, by Scott McCloud; HarperPerennial; 1994; ISBN 006097625X.
Another reference that describes the art of comics (completely in comic book form).

magazines

Magazines and e-zines may offer more topical and current information than that in books. Some of these periodicals are highly focused on a particular aspect of animation, video, or digital information; others cover a broader range of topics. One of the best animation periodicals on the Web is awn.com. This site includes current news as well as an extensive database of archived material.

Animation Journal is a peer-reviewed scholarly journal about animation theory and aesthetics.

AJ Press
43 Statehouse Place
Irvine, CA 92602
USA
Tel: 714-744-7018; Fax: 714-544-4838
email: editor@animationjournal.com www.animationjournal.com

Animation Magazine contains news and articles about the animation industry; available on the Web or in print.

> 30101 Agoura Court, Suite 110
> Agoura, CA 91301
> USA
> Tel: 818-991-2884; Fax: 818-991-3773
> email: info@animationmagazine.net
> www.animationmagazine.net

Animation World Network Magazine is an online magazine that includes a wealth of information, including articles, a school database, job opportunities, industry news, upcoming festivals, and links to other resources; available on the Web or as a .pdf download.

> AWN Inc.
> 6525 Sunset Boulevard, Garden Suite 10
> Hollywood, CA 90028
> USA
> Tel: 323-464-7805; Fax: 323-466-6614
> email: editor@awn.com
> http://mag.awn.com/

Keyboard is dedicated to digital sound recording, including digital instruments, software, and computers.

> www.keyboardonline.com

Plateau is an international quarterly bulletin on animated film, edited by the Institute for the Animated Image in Brussels, Belgium; available in print.

> Ivan D'hondt & Luc Joris
> Bac, Institute of the Animated Image
> Bondgenotenstraat 52
> B-1190 Brussels
> BELGIUM
> Tel: +(32) 2 343 65 61; Fax: +(32) 343 78 83
> email: bac.anima@online.be
> www.awn.com/plateau

Visual Magic contains news on and resources for special effects and 2D and 3D computer animation; available online at Animation World Network's web site.

> email: vmm@awn.com
> http://visualmagic.awn.com/

educational web sites

These sites provide useful information about various topics, including stop-motion animation, flipbooks, and lists of other animation web sites.

Amy Kravitz and Steven Subotnick
This is my web site, which includes information related to this book.

www.kravitzandsubotnick.com

Animation World Network
This site includes many resources related to animation (festivals, reviews, news, schools, etc.).

www.awn.com

Ani-mato
The site of animator Eric Nystorm, it includes instruction, information, and links.

www.sci.fi/~animato

Leslie Bishko Animation
This is the site of animator and teacher Leslie Bishko; it includes useful links to other sites.

www.eciad.bc.ca/~lbishko

Random Motion
The site of animator and teacher Ruth Hayes; it includes instruction, information, and links.

www.randommotion.com

StopMotionAnimation.com
This site is devoted to sharing information about making stop-motion animation.

www.stopmotionanimation.com

Yamamura's Animation Page
The site of animator Koji Yamamura contains a variety of information, links, animations, and graphics of his own, as well as others.

www.jade.dti.ne.jp/~yam/

making animation

The second section in this chapter lists resources for making animation, including vendors of supplies, hardware, and software as well as lists of service providers for connection to the Internet, web hosting, tape and disc duplication, and motion picture laboratories.

vendors of animation supplies

Animation supplies include peg bars, punched paper, cels, paints, brushes, and light tables. There are only two large suppliers in North America: Cartoon Colour in the United States,

and Chromacolour in Canada. I also include two manufacturers of armatures for people interested specifically in puppet animation. Armatures can be expensive, so you should research puppet animation in books and on the Web before you buy an armature.

Andrew Simmons is a maker of armatures for stop-motion puppet animation.

Red Gable
Orchard Dell, West Chiltington
West Sussex, RH20 2LB
UK
Tel: 01798 812805
email: sales@animationsupplies.net
www.animationsupplies.net

Armaverse is a maker of armatures for stop-motion puppet animation.

Armaverse Armatures
906 E. Walnut St.
Lebanon, IN 46052
USA
email: armaverse@in-motion.net
www.armaverse.com

Cartoon Colour Co., Inc. sells animation supplies and equipment.

9024 Lindblade Street
Culver City, CA 90232
USA
Tel: 800-523-3665; Fax: 310-838-2531
email: cartooncolor@earthlink.net
www.cartooncolour.com

Chromacolour sells animation supplies and equipment.

Chromacolour International 1410
28th Street. NE
Calgary AB, T2A 7W6
CANADA
Tel: 403-250-5880, Fax: 403-250-7194
email: info@chromacolour.com
www.chromacolour.com

hardware and equipment vendors

This is a list of suppliers of equipment used to produce animation in the home digital studio. For the most part, this means computer hardware, but it also includes specialized equipment such as the Lunchbox Sync, mini DV camcorders, and microphones. In addition to the company web sites listed here, you can do some comparative shopping for specific

items at web sites such as www.bizrate.com, www.dealtime.com, www.crutchfield.com, www.macmall.com, and www.pcmall.com.

Animation Toolworks, Inc. is the maker of the Lunchbox Sync, a dedicated video animation tool.

> 18484 SW Parrett Mountain Road
> Sherwood, OR 97140
> USA
> Tel: 877-625-6438
> email: info@animationtoolworks.com
> www.animationtoolworks.com

Apple Computer is the site for Macintosh computers, hardware, software, and news.

> www.apple.com

Bogen Photo is the maker of Bogen tripods.

> www.bogenphoto.com

CanonDV is maker of Canon DV camcorders.

> www.canondv.com

Cartoon Colour sells animation supplies and equipment, including punches, light tables, etc.

> www.cartooncolour.com

Chromacolour sells animation supplies and equipment, including punches, light tables, etc.

> www.chromacolour.com

Compaq Computer is a major manufacturer of PC computers.

> www.compaq.com

Dell Computer is a major manufacturer of PC computers.

> www.dell.com

Digidesign is the maker of ProTools sound cards and software for both Mac and PC.

> www.digidesign.com

FrameThief is the maker of inexpensive frame-by-frame capture software; works with a FireWire DV camcorder.

> www.framethief.com

Mackie is a maker of audio equipment, including the 1202 VLZ PRO mixer and the XDR MicPreamp.

www.mackie.com

Marantz is a maker of audio cassette recorders and other audio equipment.

www.marantz.com

Matrox is a maker of video cards, digitizers, and graphics chips for the PC.

www.matrox.com

Midiman is the maker of the Audiophile sound card for both Mac and PC.

www.midiman.net

Nvidia is the maker of GeForce graphics cards.

www.nvidia.com

Pinnacle Systems is a maker of video digitizers and video editing software for the PC.

www.pinnaclesys.com

Shure is a maker of audio equipment, including the SM48 microphone.

www.shure.com

Sony is the maker of Sony DV camcorders.

www.sonystyle.com/digitalimaging

Soundblaster is a maker of the Sound Blaster sound card for PC.

www.soundblaster.com

Tascam is a maker of DAT recorders, including the DA-P1 DAT recorder.

www.tascam.com

software vendors

This list includes the makers of major software applications used in this book, as well as others. I also list a few inexpensive alternatives. Please note that I have made specific mention when software will run only on the PC or the Mac; if no special mention is made, the software will run on both platforms. In addition to these company web sites, you can also visit web sites such as www.8thstreet.com (for sound software), www.macmall.com, and www.pcmall.com.

Adobe is the maker of Photoshop, Premiere, After Effects, GoLive, Illustrator, and other applications.

www.adobe.com

Apple Compunter is the maker of Macintosh operating systems, QuickTime, DVD Studio Pro, Final Cut Pro, and other applications; most of Apple's software is designed for the Mac only, but versions of QuickTime will run on any computer platform (Mac, PC, etc.).

www.apple.com

Bias is the maker of Peak, sound editing software for the Mac, and Deck, multitrack recording and editing software for the Mac.

www.bias-inc.com

DigiCel is the maker of Flipbook, testing and animation drawing software for PC only.

www.digicel.com

Digidesign is the source for ProTools Free sound editing and mixing software.

www.digidesign.com

Discreet is the source for Cleaner compression software.

www.discreet.com

InterVideo is a maker of video production software including WinProducer, a low-cost video editing application for the PC only.

www.intervideo.com

Macromedia is the maker of Flash, DreamWeaver, Director, and other applications.

www.macromedia.com

Microsoft is the maker of Windows operating systems, Windows Media Player, Internet Explorer, and other applications.

www.microsoft.com

Morton Subotnick is the maker of Making More Music and other interactive music composition CDs.

www.creatingmusic.com

Procreate is the source for Painter.

www.procreate.com

Roxio is a maker of CD and DVD burning software for the Mac (Toast) and PC (Easy CD Creator).

www.roxio.com

Sonic Foundry is the maker of Acid Pro for creating music tracks out of sound loops, Sound Forge for editing sound waveforms, and other audio software, all PC only.

www.sonicfoundry.com

Steinberg is the maker of Cubase, audio recording and editing software for both Mac and PC.

www.steinberg.net

Stop Motion Pro is the maker of Stop Motion Pro, an inexpensive and easy-to-use PC-only application for capturing and editing stop-motion animation.

www.stopmotionpro.com

Syntrillium Software Corp. is the maker of Cool Edit Pro, and other PC-only sound recording and editing software.

www.syntrillium.com

Twelve Tone Systems is the source for Cakewalk sound editing and mixing software.

www.cakewalk.com

internet service providers and web hosts

The two most widely used web browsers are Netscape Navigator and Microsoft Internet Explorer, which run on both Macs and PCs. Usually, you will get a free copy of both browsers when you sign up with an Internet service provider, but you can also download the browser software (and updates).

Free web site hosts offer limited space and will usually put ads on your site. Paid web site hosts charge a monthly fee; the amount you pay is based on the size of the site and the number of services you require. Prices and recommended ISPs and web hosts will change; for general advice as well as comparison shopping for ISPs and web hosts, you can check out a number of web sites. A good place to start is www.cnet.com/internet.

Microsoft Internet Explorer is web browser software for either Mac or PC.

www.microsoft.com

Netscape Navigator is web browser software for either Mac or PC.

www.netscape.com

America OnLine is an ISP for both Macs and PCs; it uses its own Internet browser software and will provide free web site space for its members.

Tel: 800-827-6364
www.aol.com

Earthlink Network is an ISP for both Macs and PCs and is usable with either Netscape Navigator or Internet Explorer; will provide free web site space for its members.

Tel: 800-395-8425
www.earthlink.net

150 m Free Web Space provides free web site hosting up to 150 MB; they place banner ads on your site.

http://150m.com

BraveNet provides free web site hosting up to 100 MB; they place banner ads on your site.

www.bravenet.com

Aplus.net provides paid web site hosting; this company can also be your ISP, providing dial-up web connection as well as web site hosting and web building tools for an extra fee.

www.aplus.net

Hostway.com provides paid web site hosting but provides no dial-up access; includes web site building tools.

www.hostway.com

tape and disc duplication services

These are companies that specialize in making bulk copies of videotapes, CDs, and DVDs. This type of company may also offer other services such as converting NTSC to PAL for distribution in Europe, and converting material on VHS tape to DVD. There are many such companies offering a wide variety of services, so shop around on the Web and in the phonebook to find one that offers the services you need. Researching any of the following companies will give you an idea of services and prices.

The Duplication Center of America
15870 Bernardo Center Drive
San Diego, CA 92127
USA
Tel: 858-675-9050; Fax: 858-675-7660
www.duplicationcenter.com

Failsafe Media Co.
475 Capital Drive
Lake Zurich, IL 60047
USA
Tel: 847-719-0000; Fax: 847-719-0200
www.failsafeinc.com

Video Transfer
580 Harrison Avenue
Boston, MA 02118
USA
Tel: 617-247-0100; Fax: 617-247-1365
www.vtiboston.com

Canada Disc & Tape Inc.
Bay 7, 215-36 Avenue N.E.
Calgary, AB T2E 2L4
CANADA
Tel: 403-277-9292; email: office@candisc.com
www.candisc.com

CVB Duplication
179a Bilton Rd.
Perivale, Middlesex UB6 7HQ
UK
Tel: 020-8991-2610; Fax: 020-8997-0180
email: sales@cvbduplication.co.uk
www.cvbduplication.co.uk

motion picture laboratories

This list is primarily for people interested in making 35 mm motion picture film prints for
theatrical distribution. Be sure to talk with several labs (the closer to you the better) about
your project plans and the costs involved. The lab personnel will tell you about their ser-
vices and will give you advice about preparing your project for film printing. Call around
to get a sense of which lab you would feel most comfortable working with. Most of the fol-
lowing are full service labs, meaning that they can deal with film, video, audio, and digital
needs.

Alpha Cine Laboratory
1001 Lenora Street
Seattle, WA 98121
USA
Tel: 206-682-8230; Fax: 206-682-6649
www.alphacine.com

Colorlab
5708 Arundel Avenue
Rockville, MD 20852
USA
Tel: 301-770-2128; Fax: 301-816-0798
www.colorlab.com

DuArt Film Lab
245 West 55th Street
New York, NY 10019
USA
Tel: 212-757-4580
www.duart.com

DV Film specializes in transfers from DV tape and digital files to motion picture film.
Dominion Pictures—DVFilm
2317 Spring Wagon Lane
Austin, TX 78728
USA
Tel: 512-252-2343; Fax: 512-252-2343
www.dvfilm.com

Fotokem
2800 W. Olive Avenue
Burbank, CA 91505
USA
Tel: 818-846-3101, ext. 264; Fax: 818-841-4928
www.fotokem.com

Rocky Mountain Film Lab
560 Geneva Street
Aurora, CO 80010
USA
Tel: 303-364-6444; Fax: 303-340-3449
www.rockymountainfilm.com

Medallion/P.F.A. Film & Video
111 Peter St. 9th Floor
Toronto, ON M5V 2H1
CANADA
Tel: 416-593-0556; Fax: 416-593-7201
www.compt.com

The Local Lab Film Services Ltd.
4634A 6A Street NE
Calgary, Alberta T2E 4B5
CANADA
Tel: 403-277-3092; Fax: 403-277-3092

Soho Images
8-14 Meard St.
London W1V 3HR
UK
Tel: +44 (0) 171-437-0831; Fax: +44 (0) 171-734-9471
www.sohogroup.com

Film & Photo Design
13 Colville Road, South Acton Industrial Estate
London W3 8BL
UK
Tel: +44 (0) 181-992-0037; Fax: +44 (0) 181-993-2409
www.film-photo.demon.co.uk

Bucks Motion Picture Lab, Ltd.
714 Banbury Avenue
Slough, Berks SL1 4LH
UK
Tel: +44 (0) 1753-501500; Fax: +44 (0) 1753-691762
www.bucks.co.uk

Swiss Effects specializes in transfers from digital files and DV tape to motion picture
film.
Thurgauerstr. 40
CH-8050 Zurich
SWITZERLAND
Tel: 41-1-3071010; Fax: 41-1-3071019; email: info@swisseffects.ch
New York Tel: 212-727-3695
email: jpoynton@swisseffects.ch
www.swisseffects.ch

seeing and showing animation

This last section lists places to see animation and show your own work, including film and
video festivals, the Microcinema alternative, Web showcases, and conferences. I also list
distributors of animation on videotape and DVD.

film and video festivals

Attend film and video festivals to see work, show work, and meet other animators, film-
makers, and videomakers. There is no better educational and inspirational way to learn
about animation than to attend festivals. Check the *Independent* (requires a subscription)
for a list of upcoming festivals, or check on the Web, starting with www.awn.com and
www.filmfestivals.com.

Annecy International Animation Festival
Cica, 6 Avenue des Iles
BP 399, 74 000 Annecy Cedex
FRANCE
Tel: (33) 04 50 10 09 00; Fax: (33) 04 50 10 09 70
www.annecy.org

Black Maria Film & Video Festival
c/o Department of Media Arts
New Jersey City University
Fries Hall MA 112
2039 Kennedy Boulevard
Jersey City, NJ 07305
USA
Tel: 201-200-2043; Fax: 201-200-3490
http://ellserver1.njcu.edu/TAEBMFF/bmff/bmff_home.html

Hiroshima International Animation Festival
4-17 Kako-machi, Naka-ku, Hiroshima 730-0812
JAPAN
Tel: 81-82-245-0245; Fax: 81-82-245-0246
www.urban.ne.jp

Holland Animation Film Festival
Hoogt 4
3512 GW Utrecht
NETHERLANDS
Tel: +31 30 2331733; Fax: +31 30 2331079
www.awn.com/haff

Nashville Independent Film Festival
P.O. Box 24330
Nashville, TN 37202-4330
USA
Tel: 615-742-2500; Fax: 615-742-1004
www.nashvillefilmfestival.org

New York Animation Festival
P.O. Box 1513
New York, NY 10009
USA
Tel: 212-982-7781, Fax: 212-260-0912
www.nyaf.org

Ottawa International Animation Festival
2 Daly Avenue, Suite 120

Ottawa, ON K1N 6E2
CANADA
Tel: 613-232-8769; Fax: 613-232-6315
www.awn.com/ottawa

Student Animation Festival at Ottawa
2 Daly Avenue, Suite 120
Ottawa, ON K1N 6E2
CANADA
Tel: 613-232-8769, Fax: 613-232-6315
www.awn.com/ottawa/safo

Stuttgart International Animated Film Festival
Breitscheidstr. 4
D-70174 Stuttgart
GERMANY
www.itfs.de

UFVA Student Film Festival
Department of Film & Media Arts
Temple University
Philadelphia, PA 19122
USA
Tel: 215-923-3532; Fax: 215-204-6740
www.temple.edu/nextframe

World Animation Celebration & World Internet Animation Celebration
30101 Agoura Court, Suite 110
Agoura Hills, CA 91301
USA
Tel: 818-575-9615; Fax: 818-575-9620
www.wacfest.com

Zagreb World Festival of Animated Films
Kneza Mislav 18
10000 Zagreb
CROATIA
Tel: 385 1 46 11 808; Fax: 385 1 46 11 807
www.animafest.hr

9th Annual New York Digital Salon (Web festival)
School of Visual Arts
209 East 23rd Street
New York, NY 10010
USA
Tel: 212-592-2532; Fax: 212-592-2509
www.sva.edu/salon

Art In Motion (Web festival) is an international festival on multimedia hosted by the Southern California School of Fine Arts. It features works in time-based media: film, video, digital video, animation, installations, web sites, CD-ROM, and sound pieces.

USC School of Fine Arts
Watt Hall, Rm.103
University Park
Los Angeles, CA 90089
USA
Tel: 213-740-ARTS; Fax: 213-740-8938; email: aim@usc.edu
www.usc.edu/aim

RESFEST/RES Media Group (Web festival)
601 West 26th Street, 11th Floor
New York, NY 10001
USA
Tel: 212-217-1154; Fax: 212-937-7134
email: resfest@resfest.com
www.resfest.com

Microcinema and Web showcases

Microcinema is a company name and a term that refers to a variety of alternative screening venues for independent and experimental work. These venues include art galleries, museums, schools, and filmmaker collectives, as well as film and video festivals in which curators want to organize special screenings.

There are many kinds of showcases that show animation on the Web. Some are promotional sites for hardware and software makers; others are devoted to specialized content, such as student work or humor. Some of them will take just about anything that is submitted, and others are by invitation only. The following is a partial list. As you surf the Web to find the right showcases for your work, be sure to read the fine print before you submit anything (see Chapter 8).

Microcinema, Inc. cooperates with partners to show experimental cinema at various intimate screening locations; accepts submissions.

www.microcinema.com

AtomShockwave shows animations and live action; primarily by invitation.

www.atomfilms.com; www.shockwave.com

Bijou Cafe shows a constantly changing selection of streaming files.

www.bijoucafe.com

The Bit Screen shows a constantly changing selection of streaming files.

www.thebitscreen.com

Eveo Films shows short works including animation and live action.

www.eveofilms.com

IFILM shows shorts and features, including animation and live action.

www.ifilm.net

I Want My FlashTV specializes in showing independently produced Flash animations.

www.iwantmyflashtv.com

Film Roman's Level 13 shows animation; if selected, you must sign a contract controlling distribution rights.

www.level13.net

Flicker is a resource for experimental cinema; includes still images of artist's works.

www.hi-beam.net

Student Reel shows student animation and live action; accepts submissions.

www.studentreel.com

Undergroundfilm shows documentaries, fiction, and animation; accepts submissions.

www.undergroundfilm.com

conferences

FlashForward is a conference and film festival devoted entirely to work created with Macromedia Flash.

www.flashforward2002.com

SIGGRAPH is an organization devoted to the development of computer art and technology (including animation); conferences are held in a different city each year.

www.siggraph.org

Society for Animation Studies. In addition to maintaining a web site and publishing a journal, the SAS meets annually to share papers and promote discussion of animation aesthetics; the conference is held in a different city each year.

www.awn.com/sas

distributors

The following two sources sell animation on VHS and DVD. Facets has a collection of various types of animation, both historical and contemporary, and the National Film Board of Canada has an extensive collection of animation produced for the NFB.

Facets Multi-Media has a large and varied collection of animation as well as live-action work; view holdings online.

1517 West Fullerton Avenue
Chicago, IL 60614
USA
Tel: 773-281-9075; Fax: 773-929-5437
email: sales@facets.org
www.facets.org

National Film Board of Canada has a large collection of animation as well as live-action work produced by the NFB.

From Canada, order online at www.nfb.ca.

From the USA, look at a catalog online at www.nfb.ca; then order from:

National Film Board of Canada
350, Fifth Avenue, Suite 4820
New York, NY 10118
USA
Tel: 212-629-8890; Fax: 212-629-8502
email: newyork@nfb.ca
www.nfb.ca

From the UK, look at a catalog online at www.nfb.ca; then order from:

National Film Board of Canada
Canada House Trafalgar Square
London SW1Y 5BJ
UK
Tel: + 44 (0)20 7258 6480; Fax: + 44 (0)20 7258 6532
email: london@nfb.ca
www.nfb.ca

appendix: cd-rom contents

Technical Examples:

1. Hairy Birds—scanning drawings
2. Crab—scanning cutouts
3. Seashells—scanning objects
4. Frog—metamorphosis
5. Walk—walk cycle
6. Crow—panning layers
7. Naomi's Birds—animating loops
8. Waving—acting
9. Dizzy—rotoscoping
10. Fruit Salad—stop-motion objects
11. Boy & Dog—stop-motion puppets
12. Dance—animating to music
13. Forecast—animating lip sync
14. Sneeze—Foley sound
15. Hannah's Birds—sound mix

Gallery Clips:

1. "Play Off"—Yvonne Andersen
2. "Film Loop"—George Griffin
3. "Father and Daughter"—Michael Dudok de Wit
4. "Singing Sticks"—Christine Panushka
5. "The Gentle Spirit"—Piotr Dumala
6. "Roost"—Amy Kravitz
7. "Hairyman"—Steven Subotnick
8. "333"—Baerbel Neubauer
9. "When the Day Breaks"—Wendy Tilby and Amanda Forbis
10. "Oral Hygiene"—Dave Fain
11. "Faith and Patience"—Sheila Sofian
12. "Met State"—Bryan Papciak
13. "Fable"—Dan Sousa
14. "Teasing"—Tim Miller
15. "Warnival"—Roque Ballesteros
16. "Tongues and Taxis"—Mike Overbeck

index

AfterEffects, 59
 proxies, 165
AIFF, 144
Aihara, Nobuhiro, 24
Alexeieff, Alexander, 16
analog video vs. digital video, 36
Andersen, Yvonne, 5–6, 21
Anderson, David, 26
Angel, The, 74–80
animatics, 101–103
animation
 costs involved, 54–61
 definitions, 2–5
 evolution of animation tools, 34–38
 importance of techniques and materials,
 84–85
 three basic principles of animation,
 82–84
 time it takes, 61–63
 two basic ways of working, 95
animation distributors, 200–201
animation punch, 58
animation schools, 176
animation techniques, 84–89
ASIFA, 182
aspect ratios, 91
audio channels, 159
audio file formats (AIFF and WAV), 144
audio ports, 43

backgrounds and sets, 103–104
Baker, Mark, 29
Ballesteros, Roque, 11
Bartosch, Berthold, 15–16
Bergqvist, Stig, 31
bit depth, 159
bitmap graphics and vector graphics, 129–130
books and magazines, 184–186
"Boy and Dog," 136–140
Breer, Robert, 19

cassette tape recorder, 48, 58
CD/DVD drive, 42
Chitruk, Fjodor, 18
codecs, 94–95, 159
Cohl, Emile, 14
computer
 costs, 54–55
 definition of terms, 42–43, 56
 Mac or PC, 43, 51, 54–55
 processing speed, 42
conferences, 200
copyright, 140–141
CPU, 56
"Crab," 113–116
"Crow," 125–129
CRT display. See monitor
Cubase, 60
cutout animation, 86, 113–114

"Dance," 141–142
DAT recorder, 48, 58
data rate, 159
Deck, 60
delivery style, 159
DeNooijer, Paul and Menno, 23
digital files to film, 91, 93, 165
digital studio
 advantages and disadvantages, 39–40
 costs, 54–60
 my digital studio, 41–46
 setting up your own studio, 50–51
digital versatile disc, 38
digital video, 37
distribution options, 152. *See also* output
 examples
 direct distribution, 156–158
 festivals, 152–154
 Microcinema, 154
 web showcases, 154–156
"Dizzy," 133–135

downloading vs. streaming, 94, 166–167
dpi, 91–92
drawing, 88
drawing tablet, 44, 57
Dreamweaver, 60
Driessen, Paul, 22
Dudok de Wit, Michael, 6, 26–27
Dumala, Piotr, 7–8, 28–29
duplication service, 61
DV, 37
DVD formats, 38
DVD Studio Pro, 45, 60
DVDit!, 60

EasyCD Creator, 60
editing
 picture in Premiere, 116–117
 sound in ProTools, 148–150
Engel, Jules, 18
Ethernet, 43
evolving cycles, 97–98

Fain, David, 8
festivals, 152–154, 196–199
field size, 165
Fierlinger, Paul, 21–22
file format, 94–95, 159
film and video festivals, 152–154, 196–199
film laboratory, 194
Final Cut Pro, 59
FireWire, 37–38
Fischinger, Oskar, 16
Flash
 animation examples, 119–135
 cost, 59
 screen, 119–121
Flipbook, 60
Foley recording, 145
Forbis, Amanda, 9, 30–31
"Forecast," 143–145
format choices, 90–91
frame rates, 92
frame size, 159
"Frog," 119–122
"Fruit Salad," 135–136

Gianini, Giulio, 19–20
GIF, 94
Glabicki, Paul, 26

GoLive, 45, 60
Griffin, George, 6, 23

"Hairy Birds," 111–113
"Hannah's Peacocks," 146–150
hardware and equipment
 costs, 57–59
 used in this book, 44–45
headphones, 58
Hebert, Pierre, 24
Hubley, John and Faith, 17–18

i.Link. See FireWire
ideas
 a case study, 74–80
 definition, 68
 developing ideas, 70–74
 examples, 69
IEEE 1394. See FireWire
Illustrator, 59
improvised animation, 95–98
in-betweening, 105–106
internet, 38
internet service provider (ISP), 61, 192–193

JPEG, 94

Kentridge, William, 27–28
keyframing, 104–105
Kovalyov, Igor, 27
Kravitz, Amy, 7, 29
Kuri, Yoji, 20

Lamb, Derek, 22
LCD display. See monitor
Leaf, Caroline, 24
Lenica, Jan, 20
light box, 58–59, 89
lights, 44, 58
lip sync, 143–144
Lunchbox Sync, 46, 59
Luzatti, Emanuele, 19–20
Lye, Len, 16–17

Making More Music, 45, 60
managing money and time, 63–65

McCay, Winsor, 14–15
McLaren, Norman, 17
Media Cleaner, 60
meta tag, 173
metamorphosis, 121–122
mic cable, 47
mic preamp, 48
Microcinema International, 154, 199
microphone, 48, 58
MIDI, 141
 keyboard, 48
 sequencing, 49
Miller, Tim, 10
mini RCA cable, 47
MiniDV camcorder, 44, 57
mixer, 48, 58
modem, 43, 56
monitor, 43, 57
motion picture film
 choosing a scanning resolution, 165
 history, 35
multitrack recording and mixing, 49
music composition, 49

naming files, 111
"Naomi's Birds," 129–132
Netscape Composer, 60
Neubauer, Baerbel, 8, 30
Norstein, Yuri, 22–23

object animation, 85, 116
Odell, Jonas, 31
operating system
 for the Macintosh, 45
 for the PC, 45, 56
organizations, 181
output examples, 158–159. See also
 distribution options
 for playback on a CD-R or DVD-R, 160
 for playback on a DVD-V, 161
 for playback on a hard drive, 159
 for playback on motion picture film, 165
 for playback on videotape, 163
 for playback on the web, 166
Overbeck, Mike, 11

Painter, 59
panning layers, 128

Panushka, Christine, 7, 28
Papciak, Bryan, 10
Park, Nick, 29
Parker, Claire, 16
Parn, Priit, 25
Pavlatova, Michaela, 31
Peak, 60
peg bar, 89
Perlman, Janet, 27
persistence of vision, 35
Phenakistiscope, 34–35
phono plug, 47
PhotoShop, 45, 59
Pitt, Suzan, 23–24
pixilation, 87
planned animation, 98–106
planning a project
 format suggestions, 93
 length and format considerations, 90–91
 setting goals, 89–90
Plympton, Bill, 25
portable audio recorder, 48
ppi, 91–92
Premiere, 45, 59
printer, 44, 57
production process, 106–107
progressive download vs. real-time streaming,
 94, 166–167
ProTools Free, 45, 59
 screen, 148
puppets, 86–87, 137–138

Quay, Stephen and Timothy, 25
Quicktime, 94–95
Quicktime Pro, 46
Quinn, Joanna, 31–32

RAM, 42
RCA cable, 47
registering drawings, 88–89, 111–112
registration points, 82
Reineger, Lotte, 16
Richter, Hans, 15
Ring, Borge, 19
Rose, Kathy, 25–26
rotoscoping, 87–88, 134

Sapegin, Pjotr, 28
scanner, 44, 57

scanning
 examples, 111–119
 for film and video, 91–92
 resolution, 91–92
schedules. *See* work habits
screen sizes, 92
search engine, 173
"Seashells," 116–119
Servais, Raoul, 20
services, 61, 193–196
showing animation. *See* distribution options
"Sneeze," 145–146
Sofian, Sheila, 9
software
 costs, 59–60
 used in this book, 45–46
sound
 definitions of animation sound, 4–5
 digitized vs. synthesized, 48
 example setups, 49–50
 production examples, 140–150
 production tools, 47–50
sound card, 48, 58
Sound Forge, 60
Sousa, Dan, 10
speakers, 48, 58
squash and stretch, 133
Starewich, Ladislas, 15
Stop Motion Pro, 60
stop-motion examples, 135–140
storyboarding, 98–101
straight-ahead animation, 96–97
Sullivan, Chris, 30
supplies and services
 animation supplies, 187–188
 hardware and equipment, 188–190
 ISPs and web hosts, 192–193
 motion picture laboratories, 194
 software, 190–192
 tape and disc duplication, 193–194
Svankmajer, Jan, 21
SWF, 94

Tezuka, Osamu, 21
Thaumatrope, 34

TIFF, 94
Tilby, Wendy, 8–9, 30–31
time lapse, 88
timing, 4, 83–84
Toast Titanium, 45
transfer house, 61, 165
tripod, 44, 58
Trnka, Jiri, 17

under-the-camera techniques, 96
USB, 43

VHS, 58
voice recorder, 48

"Walk," 123–125
walk cycle, 124
WAV, 144
waveform editing, 49
"Waving," 132–133
web, 38
web festivals, 152
web host, 61, 192–193
web showcase, 155–156, 199–200
web sites
 building personal, 167–173
 educational, 186–187
Whitney, John and James, 18–19
WinProducer2, 60
work habits, 64, 70

XLR cable, 47

Yamamura, Koji, 32

Zip drive, 42